E5 - 25

HEALEY'S
EYE

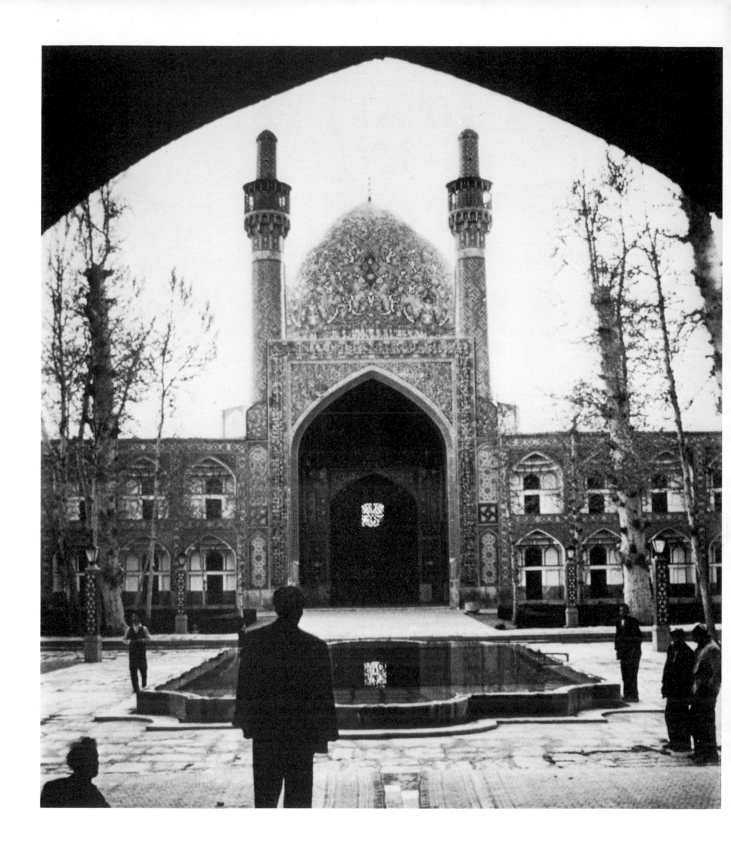

HEALEY'S EYE

EYE

A PHOTOGRAPHIC MEMOIR
BY DENIS HEALEY

JONATHAN CAPE
THIRTY BEDFORD SQUARE LONDON

by the same author

THE CURTAIN FALLS (1951)
NEW FABIAN ESSAYS (1952)
NEUTRALISM (1955)
FABIAN INTERNATIONAL ESSAYS (1956)
A NEUTRAL BELT IN EUROPE (1958)
NATO AND AMERICAN SECURITY (1959)
THE RACE AGAINST THE H BOMB (1960)
LABOUR BRITAIN AND THE WORLD (1963)

The author and publishers are grateful for permission to reproduce the following quotations: to Editions Horizon la France libre (1942), for three lines from 'Le Crève-coeur' by Louis Aragon on page 18; to the Trustees for the Copyrights of the late Dylan Thomas, and to J. M. Dent and Sons Ltd and New Directions Inc., for three lines from 'Fern Hill' by Dylan Thomas on page 30; for eight lines from 'The Choice' by W. B. Yeats on page 63; and for the extract from Aperture, Inc., History of Photography Series, Book One, copyright © 1976, Henri Cartier-Bresson, Aperture, Inc., A. Robert Delpire, Editeur, published by Aperture, Inc., New York.

First published 1980
Copyright © Denis Healey 1980
Jonathan Cape Ltd, 30 Bedford Square, London WC1

British Library Cataloguing in Publication Data
Healey, Denis
Healey's eye.
1. Healey, Denis 2. Statesmen – Great Britain –
Biography
I. Title
941.085′092′4 DA591.H38
ISBN 0 224 01793 4

Printed in England by
Jolly & Barber Ltd, Rugby, Warwickshire

To my mother

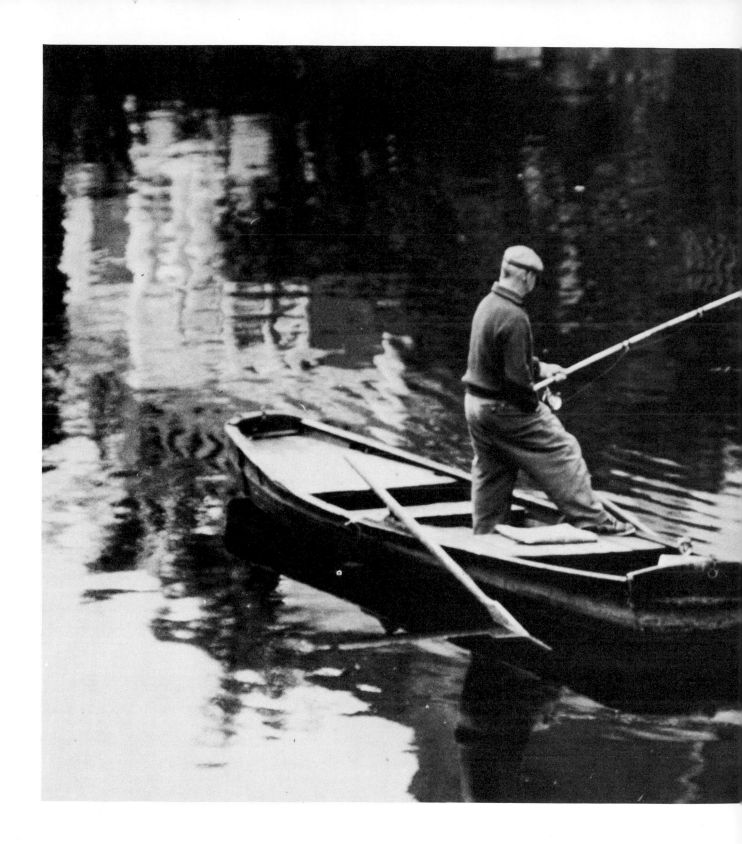

Contents

Left, *fisherman on the Loing, France;* page 2, *Muslim Seminary in Isfahan*

Prologue

This is a book partly about photography, partly about the world, and partly about me. It is a journey with a camera through his own time and space by a man who has been a politician for most of his life. The time starts in 1917 with a Zeppelin over Blackheath. It spans the Second World War. And it covers the generation of troubled peace since then in which hundreds of thousands have died in smaller wars. Its world is not complete — I have not yet seen anything, for instance, of the Indian sub-continent except its airports.

It is not a book about politics, although I have some political stories to tell, and some opinions to offer. In the days before photography, when Goya produced his great series of etchings on 'The Disasters of War' he gave one particularly horrifying plate the title 'This I have seen'. There are no horrors here. But I do write of what I have seen and have been able to record in photographs.

What I have wanted most of all is to share some of my own good fortune in seeing so much of the world with those who may not have had the same opportunity, and to share my own delight in taking pictures with others who have a camera but have perhaps not yet realised what they can do with it.

I have lived through a revolution in photography. When I was a child, my father had to use bulky and breakable glass plates for his negatives. Today, for the first time in history, anyone can make an accurate record of what they see. In many Western countries two families out of three now have a camera. Technology has removed most of the practical difficulties which used to discourage people from making full use of it. Modern films can reproduce in colour or black and white whatever the lens can see in almost any light. Automatic exposure, automatic flash, even automatic focussing are now available for those who mistrust their own ability. All that is needed is to look and see — and choose the right moment to press the button.

You needed skill and patience to take pictures in the old days. But the ability to see and choose the moment has not significantly improved in all those years. Some of the greatest of all pictures were taken in the dawn of photography over a century ago, not just in the studio, like the haunting portraits of Julia

My first photograph, of my brother Terry aged 8, taken during the Easter holidays 1928

Cameron, but on the battlefields of the Crimea and the American Civil War by men such as Roger Fenton and Matthew Brady.

So after I have described how I have used my various cameras over the fifty years since I first took a picture of my little brother with a ten-and-sixpenny Box Brownie, I have tried to explain what I think are the special problems you face when you try to *take* a picture with your camera rather than *make* it with pencil and paint, and why I think a 35mm single-lens reflex will help you best to overcome them if you are an amateur like myself.

Many books about photography are written by full-time professionals who do not seem to realise that the average amateur cannot afford to take more than one photograph of a single scene, and often has to snatch a few seconds in the middle of doing something else to take a photograph at all. I am an amateur writing for amateurs, with all of good and ill which that implies.

You cannot spend a lifetime with your camera without sometimes wondering whether all this picture-taking is really worth the time and effort and expense. Would you have done better to devote your energies to something else? So in the last chapter I have tried to stand back a little and think about what it is which makes photography so different both from life and from an art like painting. If these questions do not bother you, you can skip this chapter. Maybe you will come back to it later on.

Years ago when Winston Churchill was out of office, he wrote two essays on his favourite hobby, because he wanted to communicate his excitement to others who might never have thought of taking it up. They were later published as a book and illustrated with his own work. In my opinion that book, *Painting as a Pastime*, is still by far the best guide you can give to anyone who is wondering whether to embark on the world of paint and canvas. Churchill's intense exhilaration in the physical manipulation of colour blazes from every page. Where he has scaled the mountain peak I do not see why I should not explore the foothills.

1 Early Days

Your camera provides inexhaustible fodder for nostalgia. Nothing focusses your memories of childhood more sharply than a photograph.

Until I was five I lived in a wooden bungalow on a Great War housing estate facing Shooters Hill at Well Hall in South East London. Frankie Howerd lived on the same estate a few years later. My father worked in the First World War as an engineer at Woolwich Arsenal. I remember him telling me how a Zeppelin came down in flames like a great meteor over Blackheath. He collected the splinters of anti-aircraft shells which fell on our roof.

Like most children in those days I was photographed in a studio for posterity — the picture of innocence in a white suit: I can still feel the buttons in my fingers as I fastened the trousers on to the shirt. My father had just bought himself an old bellows camera which used glass plates for negatives. He was always taking pictures of myself and my friends in the little garden around the bungalow.

The patch of artichokes by the path was a jungle forest through which I hunted tigers with Robin Fulton, my closest friend. His father had been a sniper in the War and won the King's Prize three times at Bisley for rifle shooting. Robin was later to win the King's Prize himself. He now runs a gunsmith's at Bisley. My greatest pleasure was to sit in the garden with a sheet of white paper on the wooden table in front of me, a row of coloured chalks by my right hand and at my left hand a plate of glistening white apple segments — 'peeled, cut and cored,' as we used to say.

Later we moved to Yorkshire when my father was appointed Principal of Keighley Technical College. I was disappointed to find that contrary to what my parents told me, they did not speak an entirely

Studio portrait, aged 5

different language there — just a few odd words like 'lake' for play, 'spice' for sweets and 'tart' for girl. 'Have you looked int' bakers today?' we would ask. 'They've got tarts int' window without bloomers on!'

Compared with the geometrical regularity of our housing estate in Well Hall, Yorkshire was a romantic but sombre country. We lived on a steep hill by a stone-paved snicket at Riddlesden on the edge of Ilkley Moor. I spent all my spare time on the moors, tumbling down the wiry tussocks of moor grass in the pot-holes where men had quite recently dug for surface coal, climbing the black millstone grit of the Doubler Stones, walking from Windgate Nick along

11

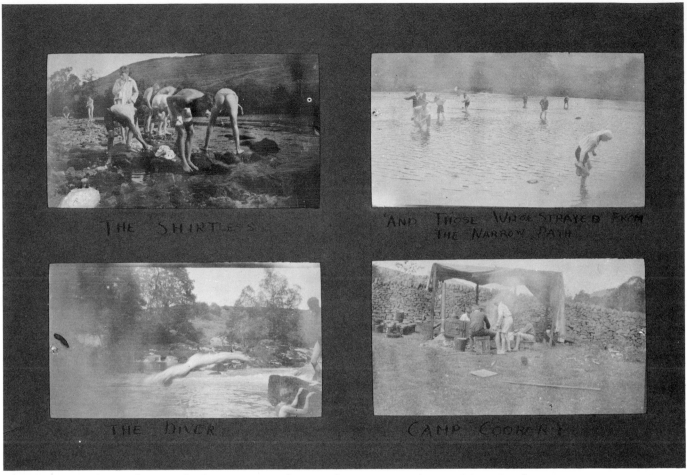

The images are captioned within the photographs:

THE SHIRTLESS

'AND THOSE WHO STRAYED FROM THE NARROW PATH'

THE DIVER

CAMP COOKERY

Pages from an album: above, *school camp at Appletreewick, 1929;* opposite, *a visit to London*

the ridge above Ilkley past the Swastika Stone of pre-Celtic times, plunging through the sodden peat and heather at Keighley Gate.

For my mother, who came from Gloucestershire, the highwayman was always 'riding, riding, riding over the purple moor'. For me the moors called up rather the dark mysticism of Emily Brontë — more Irish than Yorkshire as her sister Charlotte was more Yorkshire than Irish:

Often rebuked yet always back returning
To those first feelings that were born with me,
And leaving busy chase of wealth and learning
For idle dreams of things which cannot be:

I'll walk where my own nature would be leading:
It vexes me to choose another guide:
Where the grey flocks in ferny glens are feeding,
Where the wild wind blows on the mountain side.

Bill Brandt's photographs of the Brontë country have perfectly captured this aspect of Yorkshire, as Fay Godwin has done in her photographs for Ted Hughes's poems *Remains of Elmet*.

It was as a boy of eleven in Yorkshire that I began my own love affair with photography. The object of my passion was a Brownie 2A box camera costing 10*s.* 6*d*. It had a single shutter speed of about a thirtieth of a second and took slow Verichrome or

Selochrome roll film; so it was impossible to photograph anything moving. Because it had a single fixed lens it was not easy to take photographs of things less than ten feet away, although you could get a greater depth of focus by pulling up a metal strip with different-sized holes in front of the lens to reduce the aperture. But the photographs it took in sunlight were all right.

More exciting than just taking the pictures was developing the film in the dark under the stairs by holding both ends and seesawing it through a tank of developer. Then you printed the negative in the open air on daylight paper in a little wooden frame, finally developing and fixing the print under the stairs again so that it came out a golden brown which faded all too easily.

By this time I had won a County Minor scholarship to Bradford Grammar School nine miles away. I travelled at first by train where the big boys beat the little boys with the window strap, until I acquired a lifelong scar on the second knuckle of my right hand by punching one of the big boys' heads through the glass of the carriage door. Later we travelled by double-decker bus where the great game was throwing one another's school caps out of the window on the top deck.

"SONNY BOY"

THE TEMPTER

THE FOUNTAIN

HOUSES OF PARLIAMENT

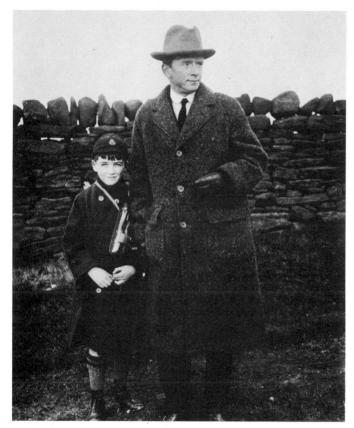

Aged 7, with my father at Keighley Tarn

Bradford was an excellent grammar school, immensely proud of its scholastic record and of old boys like William Rothenstein and Humbert Wolfe. Alan Bullock was two years ahead of me, a brilliant boy whose father was the local Unitarian Minister and ran the city's Literary Society. The Bullocks had recently come to Bradford from somewhere in the South of England. Alan himself still retains a trace of West Country accent. To us Yorkshire boys in those days he seemed almost a visitor from another planet — an eccentric bohemian of offbeat brilliance with an extraordinarily wide range of knowledge and interest, capable of quoting Wagner's letters and James Joyce in the same sentence. The music of time has transformed him into a symbol of middle-of-the-road solidity — Mercutio to Murgatroyd in half a lifetime. I recall our classics master writing at the

bottom of one of his Latin proses the word '*Omasum*'. We looked it up in Smith's *Latin Dictionary* to discover it was a Gallic word meaning 'bullock's tripe'.

Taking photographs in school was of course forbidden. But I managed to rig up a dummy exercise book with my camera inside and took a few dim photographs of Sixth Classical with it. On the other hand our school camp by the Wharfe near Appletreewick gave me plenty of scope for pictures. For the rest of my life Wharfedale at Whitsuntide has been my dream of the English countryside at its most beautiful — the hilly meadows full of buttercups, primroses and cowslips, woods of beech and larch floating in a sea of scented bluebells, the cool clear brown water of the Wharfe itself sliding towards the rocks from which it crashed into a natural swimming-pool and the day-long walks we took down the valley through Bolton Woods to the Strid then up through the bracken-filled Valley of Desolation, over the moors to Simon's Seat and down again back to camp.

By this time I had become a committed painter in water-colours. I also took up pastel painting with an old man living in a mansion at Silsden. He was Alex Keighley, one of the pioneers of British photography. His own photographs were typical of Vic-

Sixth Classical at Bradford Grammar, 1935

torian taste — picturesque landscapes of scenes in Montenegro with fuzzy outlines made to look as much like an oil painting as possible. But he was a patient and enthusiastic teacher. I greatly enjoyed our expeditions up the dales beyond Skipton where for a penny each we bought hot pork pies which squirted fragrant juice over your cheeks and chin.

I won a scholarship to Balliol in 1936 and in the summer between school and Oxford had the best holiday of my early life — five weeks on a bicycle travelling through the Low Countries and Germany to see Max Reinhardt's great production of Goethe's *Faust* at Salzburg. I slept in barns or in youth hostels which then charged only one penny for the night and a penny for breakfast — so the whole holiday cost me only £5. It was the year of the Olympic Games, when the Nazi dictatorship had been slightly relaxed, at least for foreigners. But every village had its copy of the filthy anti-semitic newspaper *Der Stürmer* on display. I had taken little interest in politics at school apart from resigning from the OTC as a pacifist, an action which brought me a lot of trouble with my teachers. But the approach of Fascism had turned me into what I believed to be a Communist and I argued my ideas fiercely in the youth hostels. Many of the young Germans I met were still proud to describe themselves as anti-Nazis, mainly Social Democrats or Catholics. Years later in a conversation with Franz-Josef Strauss I discovered that he had been staying at the youth hostel in Munich at the same time as myself.

The Spanish Civil War broke out while I was in Germany and the Oxford of my time was inevitably dominated by politics. At Balliol the Conservatives included Ted Heath, Julian Amery, Hugh Fraser, Maurice Macmillan, David James and Tony Kershaw — all fellow MPs today. Roy Jenkins, Niall MacDermot, David Ginsberg, Nico Henderson and myself were Labour, though I joined the Communist Party in 1937 and remained a member until the war broke out. Tony Crosland was next door at Trinity. In the Oxford by-election of 1938, Ted Heath and I fought shoulder to shoulder to prevent Quintin Hogg from being elected on the appeasement ticket when Sandy Lindsay, the Master of Balliol, was candidate for the Popular Front. We lost.

But my interest in music, literature and painting was still as strong as ever. I introduced Iris Murdoch to Samuel Beckett's first novel, *Murphy*. As Chairman of the Labour Club I organised a series of lectures on Greek Drama and Society in which Gilbert Murray, E. R. Dodds, George Thompson and Russell Meiggs were the lecturers.

Ted Heath as organ scholar was mainly responsible for running the Balliol concerts in which George Malcolm, now a brilliant harpsichordist, played the piano — using Haydn's exquisite Divertimento with Variations as his regular encore. Shocked at the lack of interest in the visual arts I helped to set up the New Oxford Art Society which organised one of the first Surrealist exhibitions in Britain. Niall MacDermot and I assembled the paintings mainly from private collectors in London, particularly Roland Penrose and E. L. T. Mesens. We had to put velvet curtains over Magritte's 'Le Viol' for fear of shocking the ladies of North Oxford. We also organised an exhibition of the paintings and etchings which Picasso did during the period of his great mural 'Guernica'. The mural itself was far too large for us to transport or insure. The etchings, of his best Minotaur period, were for sale at £5 each. But few of us could afford the money at that time, certainly not I. I got Anthony Blunt from Cambridge to lecture on Poussin, without the slightest suspicion that he was even distantly interested in politics.

By this time I had acquired a folding Agfa Vest-Pocket camera which had speeds up to 1/100 second, an iris aperture and a focussing mechanism which operated by moving the front assembly backwards and forwards on a rack. Film speeds were also getting faster. I took few photographs at Oxford itself but

15

many during the long summer vacations when I went abroad cycling or hitch-hiking in France.

My first summer in 1937 took me to the Pyrenees in a car which a friend and I bought for £10 and which worked only intermittently since the water somehow got into the oil. I took my heavy old Rudge-Whitworth bike strapped to the side as a lifeboat and indeed returned the whole way by bicycle. On my way home I found myself cycling through the little Norman village of Giverny where Claude Monet spent his declining years. When I found out where his garden was I climbed over the wall to take photographs of the lily pool where he painted his great series of 'Nymphéas'.

The goal of our journey that summer was a small farm in the Pyrenees, Mas de la Coume, outside the village of Mosset near Prades. It had been bought derelict a few years earlier by some English Quakers for settling a family of Social Democrat refugees from Germany — Pitt Kruger, his wife Yves, their little daughter Jamine and their baby Kiki. Pitt, a thin slight intellectual with a delicate sensitive head, was the first school teacher to have been dismissed by the Nazis in East Prussia. He had left Germany three days after the Reichstag Fire. He had worked on silhouette films with Lotte Reininger and had come to know Fritz Lang. As I was passionately keen on cinema this was for me a stupendous qualification. His wife Yves was a pretty Swiss-French girl who sang 'My Heart Ever Faithful' as she worked around the farm. They were my first real contact with the culture of Weimar which Hitler destroyed — a couple of quite remarkable goodness and charm. I spent my time there helping them on the farm, eating the bottled sunlight in their magnificent cherries, talking far into the night or listening to Pitt playing the flute and Yves singing Bach or Schubert. I went again to their farm the following summer and then lost contact for over thirty years.

In 1970 my wife and I were touring the Pyrenees and decided to see if the Krugers were still at their

The Kruger family, 1937

farm. This time a well-made concrete drive led from the road where thirty-two years before our car had slipped off a track of crumbling clay. A swimming pool was set into the hillside and the farm itself was spick and span. Pitt and Yves now ran a small private school mainly for the children of well-known musicians such as the guitarist Yepes and the conductor Markevitch. They had looked after the children of the Dalai Lama after his flight from Tibet and were thought to be Bolsheviks when they made them work for the first time with their hands. In the summer holidays they ran seminars for mathematicians and astronomers. Jamine was now a woman of thirty-five — a good violinist married to a professional cellist in Germany.

But the intervening years had been very different. The village priest had denounced Pitt to the Pétain regime as a Communist and he was sent to a concentration camp in Germany. Yves and the children had fled into the scrub during his arrest. She heard no more of him for five years. As the war was ending he had been taken from the concentration camp and put into a punishment battalion to fight the Russians. The Russians captured him and put him in a

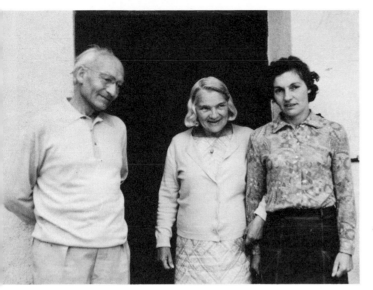

. . . and in 1970

prisoner of war camp near Leningrad where he remained for three years, finally returning home when Yves had given him up for dead. I found our reunion unutterably moving.

My last holiday from Oxford was in 1939 just before the war broke out. I had a travelling scholarship to Greece and used the opportunity to walk round as much of the country as I could manage in a month — mainly the Peloponnese and the area between Delphi and Thebes. I had intended to join a yacht crewed by some undergraduate friends and Professor Collingwood. He wrote an account of the journey in *The First Mate's Log* — the first time my name appeared in a book. But a series of accidents prevented the yacht from reaching the Piraeus while I was there so I made my own journey round the islands by cargo boat and finally returned to Marseilles travelling steerage in a steamer of the Anglo-Egyptian Mail Line. We fed literally on the scraps from the tables of the higher classes, and a rat ran backwards and forwards along a pipe above my bunk. Tom Dunbabin, who later organised the Resistance in Crete, was then at the British School in Athens, where I remember a young New Zealander

describing with emotion how he had stood at Mycenae on the precise spot where Clytemnestra stood when she hit Agamemnon with the axe as he was stepping out of the bath. The whole journey was a most exciting experience, overhung by knowledge of the approaching war. Indeed I was arrested at Eleusis because some little boys denounced me as a German spy when I was taking a photograph across the bay. They knew I was a German spy because I was wearing shorts!

Forty years later my wife and I repeated that journey to Greece, this time motoring round the Peloponnese and flying to Mykonos and Santorin. It was as beautiful as ever — apart from Athens, now shrieking with traffic and stifling in smog.

I left the Communist Party and volunteered for the Artillery when the war broke out, but after waiting three months to be called up was sent back to finish my degree at Oxford. It was an odd period. Most of us believed that we would be killed in the war and I started the gruelling twenty-four papers of the final examination for Greats on that hot summer day when the German motor cyclists

Mykonos, 1939

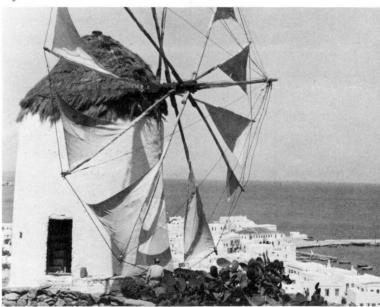

roared into Abbeville just across the Channel.

O mois des floraisons, mois des métamorphoses
Mai qui fut sans nuages et juin poignardé,
Je n'oublierai jamais les lilas et les roses.

Louis Aragon wrote this under the occupation. It translates roughly as:

O months of flowerings, months of
 transformations
May of cloudless skies and June struck down
 with a knife
I will never forget the lilacs and the roses.

In the event my stay in the Artillery was short-lived. I ruptured myself on my field training course and after the operation was sent to the depot in Woolwich to await a posting. One night a stick of bombs fell on the depot and an early roll-call found hundreds missing — fortunately most of them were simply spending the night with their families or girl-friends in London.

I was sent from Woolwich to replace a drunken bombardier as a railway checker on Swindon Station. It was there I learned a lifelong distrust of statistics. I was expected to count the number of servicemen and -women getting off every train, getting on every train and, for some obscure reason, getting off and on again. I used to make up the number of those getting off and on and also the number of those getting on — there was no other way for a convalescent to do it on eight platforms in the blackout. I salved my conscience by asking the ticket collector at the barrier to give me the number of those getting off every train. After three weeks I discovered he made up his figures too! But the war effort in Southern Command did not suffer visibly on this account.

Some months later I was commissioned as a sapper in Movement Control and volunteered for Combined Operations, serving with the Americans in the North African landing at Arzeu, with a British Beach Group for the landing in Sicily, and as the Military Landing Officer with the assault brigades for landings in Southern Italy and Anzio.

Like most young officers, I hoped to end the war with a Leica camera and a Luger automatic. Unfortunately neither came my way, although I did finish up with a Schmeisser machine pistol and an amphibious jeep, neither of which was really suitable for taking home. There was not much scope for photography in North Africa. Film was hard to come by and almost impossible to get developed. But I did succeed in taking some pictures of King George VI during his visit to the Headquarters of 78 Division at Guelma. When the rumour spread in our mess that some great personage was to visit us, bets were laid mainly on Winston Churchill and the King. We had

King George VI at Guelma, Algeria

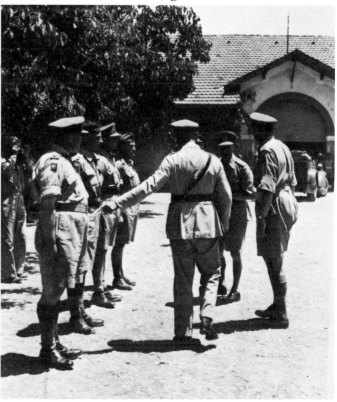

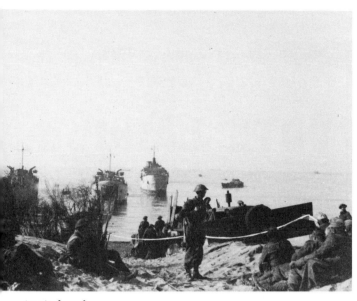

Anzio beach

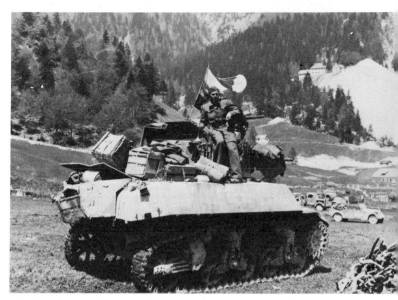

A Yugoslav partisan tank near Trieste

a boisterous young Field Security Officer with us called Dennis Bloodworth, whose claims to know Chinese were always regarded as so much eye-wash by the rest of us. I believe, however, they were true. Certainly he married an attractive Chinese girl after the war and has served as the *Observer*'s correspondent in Singapore ever since. On this occasion he took bets from all of us that King George was not the great man in question, refusing fairly enough to pay up when in fact King George arrived, on the grounds that he had only been doing his duty as security officer.

On the landing in Sicily I dropped my camera on the beach where it fell for some seconds in a pool of salt water. It was never the same again. But I did succeed in taking a few photographs at Anzio and quite a number during the closing days of the war when I carried out a somewhat unofficial reconnaissance into Austria. It was an odd experience to find oneself in the middle of the German Army when the armistice was finally declared. The ditches were filled with military litter, since many German soldiers simply started walking home, throwing away first their helmets, then their guns, then the rest of

their equipment as the sun rose higher in the sky.

I found Tony Crosland in a field across the frontier where he was Intelligence Officer to his division. He looked very dashing in his parachutist's purple beret. Then I spent an extraordinary night in Klagenfurt as the German troops were retreating from the British in the west, the Hungarians were retreating from the Russians in the east, and the Cetniks were retreating from the Yugoslav partisans in the south. I managed to take some photographs of the partisan columns as they moved into Gorizia.

In Naples I made a lifelong friend of my colonel, Jack Donaldson, who later became Jim Callaghan's Minister of the Arts; his wife Frankie was daughter of the playwright Freddie Lonsdale and was to write the masterly life of Edward VIII. Together Jack and I set up a small music society for the British Army in Naples, seeking out the first violin of the San Carlo Opera so that he could assemble a quartet. Among my other colonels were some I came to know a good deal better in later life — Marcus Sieff, then Port Commandant in Messina and now head of Marks and Spencer's, Denis Greenhill, later Permanent Secretary of the Foreign Office, and Val Duncan, later

19

Chairman of Rio Tinto Zinc. Elwyn Jones, Jim Callaghan's Lord Chancellor, was a colleague of mine in Florence, as were David Hunt, later High Commissioner in Cyprus and Nigeria and 'Brain of Britain', and debonair Jack Profumo, who piloted the aircraft which flew to Switzerland to arrange the surrender of the German Armies in Italy. One of my more improbable fellow officers was Billy Chappell the ballet dancer and stage designer.

In early 1945 I was adopted in my absence as Labour candidate for the safe Conservative seat of Pudsey and Otley. My brigadier sent me to deliver some documents at the War Office just in time for me to attend the pre-election conference of the Labour Party in Blackpool. The Conference heard many other young men whose speeches were fired with their knowledge of the sacrifices made by the resistance movements in Europe during the war.

John Freeman and I both spoke in our army uniforms. Our speeches were well received by all sections of the Party although by modern standards they would be regarded as extreme Left. Harold Laski, Hugh Dalton and Philip Noel-Baker each asked me separately to apply for the job of International Secretary at Transport House if, as expected, I failed to win my seat. In fact we came close to winning, reducing the Conservative majority to just over 1,000 votes. I then returned to the Army in Italy to decide my future. It was not an easy choice.

The Army wanted me to join David Hunt and a small team of officers with academic backgrounds to write the official history of the Italian campaign at a castle in the Austrian Alps, shooting chamois in my spare time. But I was anxious to get home to my family and to my girl-friend, Edna Edmunds, who had been close to me ever since we left Oxford in 1940. Merton College wanted me to take up a sort of fellowship I had been awarded just as I entered the Army. This was attractive since I very much wanted to write a book about the philosophy of art. But I had discovered that I thought well only under stress

General Election, 1945.
Polling Day, Thursday, July 5th

VOTE LABOUR

MAJOR DENIS
HEALEY
B.A. (Oxon.)

Printed by Wm. Walker & Sons (Otley) Ltd. and published by
W. J. Prichard, Election Agent, 1, Harrogate Road, Rawdon, nr. Leeds.

Pudsey and Otley election card

and was likely to go to seed if I spent my life at a university. So I applied for the job at Transport House. At that time my political interest was overwhelmingly in foreign affairs. I was determined to do what I could to prevent the Second World War from leading to a third. There was no better place to try than in the Labour movement.

I got the job just before Christmas 1945 and in the same week left the Army and married Edna.

Transport House at that time was full of young

men like myself who were determined to make a better world and ready to accept a substantial financial sacrifice in the process. Michael Young ran the Research Department with a unique mixture of intellectual imagination and social commitment. The Labour Party literature was designed by Michael Middleton, who finally succumbed to offers of many times his Transport House salary to become art editor of *Lilliput* and later head of the Civic Trust. Before long Michael Young was joined in the Research Department by Wilfred Fienburgh who had also just left the Army. He had an exceptional talent for writing, like Roy Hattersley today; *No Love for Johnny* is still perhaps the best British political novel since the war. His early death in a car accident was a loss for literature no less than for politics. Peter Shore then took his place. Gerry Reynolds was the first head of our new department on Local Government. He too died tragically young, when he was my deputy at the Ministry of Defence.

At the beginning I was both head and tail of the International Department, with no assistance except from Chris Howie, a charming but elderly lady who had been secretary to my predecessor since the First World War and, as an early Fabian, had known Bernard Shaw. By the end I had acquired one deputy and a specialist on colonial affairs. I started with a salary of £7 a week. As my wife was earning £11 a week as a teacher, until we started our family we were able to go regularly to the theatre, which was at a peak of perfection in those post-war years. Laurence Olivier, Ralph Richardson, Alec Guinness, Sybil Thorndike and Margaret Leighton were playing together at the Old Vic, where on the same evening Olivier performed his brilliant double act as Oedipus Rex and Mr Puff in Sheridan's *The Critic* — which saw him at the climax swinging on the curtain from a box into the middle of the stage.

My six years as International Secretary of the Labour Party gave me an invaluable insight both into the Labour movement as a whole and into international affairs, particularly in Europe. I was responsible not only for interpreting the Labour Government's foreign policy to the movement in the country but also for re-establishing relations between the Labour Party and the Socialist parties in Europe and other parts of the world.

The older generation of European Socialist leaders whom I then came to know were a true aristocracy of the spirit with interests far wider than party politics; many of them had been prominent at the founding of their parties in the years before the First World War. Leon Blum of France was a lawyer of great culture and humanity who had been Prime Minister of the Popular Front in the 1930s. Louis de Brouckère and Camille Huysmans, who represented the Belgian

Wedding day, 21st December 1945

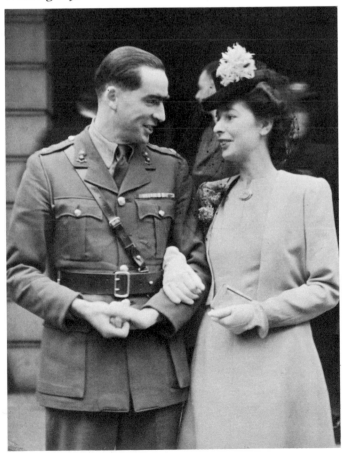

Socialists, had both played central roles in the Second International. De Brouckère was a tall, erect old man rather like Darwin with a long white beard on a powerful head; he was also a mathematician of international standing. Huysmans by comparison was a sinuous and feline personality whose long black cloak and floppy velvet tie would have fitted him well for a part in *La Bohème*. The editor of the Norwegian Labour paper, for which I was to write a weekly article for some twenty years, was Martin Tranmael, a close friend of the disgraced Bolshevik leader Bukharin; he had taken the Norwegian Labour Party both into and out of the Comintern in the 1920s. The Italian Socialists, led by Nenni and Saragat, were often accompanied by an ancient Russian revolutionary, Angelica Balabanoff, who was said to have been Mussolini's mistress while he was still a Socialist. Renner was President of Austria and General Körner the Mayor of Vienna, both men of immense charm and distinction. It was a privilege to know them all.

The next generation of European Socialist leaders was scarred by war and imprisonment. Kurt Schumacher, the charismatic leader of the German Social Democratic Party, had lost an arm and an eye and was soon to lose a leg in a London hospital. His ravaged figure and bloodshot eye gave him the aspect of a revolutionary Frederick the Great. Adam Ciolkoz, the leader of the Polish Socialist Party in exile, had spent years in solitary confinement chained to the wall of a dungeon by the Baltic. Koos Vorrink, who led the Dutch Socialists away from Marxism towards the British type of Labour Party, had been in a concentration camp. Many others, like Erich Ollenhauer and Paolo Treves, were refugees in England during the war and I had come to know them well in the months before they went home.

One of my responsibilities on behalf of the nascent Socialist International was to do what I could to encourage greater unity among the Italian Socialists. So I found myself back again in Italy within a few months of leaving the Army, on a delegation led by Harold Laski to the Congress of the Socialist Party in Florence. Laski's standing abroad was greater than it ever became at home, because he was not only a leading theorist of Democratic Socialism but also the representative of a victorious Labour Party in a victorious Britain. Once we had crossed the Alps into Italy we were met at every station by crowds of working people loaded with bouquets of flowers.

The Florence Congress was an unhappy affair, and a few months later I was back in Italy once more to attend the conference in Rome at which the Socialist Party finally split. This time my companion was Harry Earnshaw, the leader of the textile trade union of Beamers, Twisters and Drawers. We paid a courtesy visit to the Pope in the Vatican.

'I know you are a member of the National Executive Committee of the British Labour Party,' said the Pope to Harry. 'You must recognise that you carry a great responsibility.'

'Aye, Pope,' said Harry. 'And so do you.'

At the end of our audience the Pope opened a drawer in his desk and said to Harry, 'I understand you are not a Roman Catholic yourself, Mr Earnshaw, but no doubt you have friends who are. Would you like me to bless a rosary which you can take back with you?'

'Aye,' said Harry.

'I have black ones or white ones,' said the Pope. 'Which would you prefer?'

'Oh, I reckon I'll have one of each,' was the reply.

Another of my responsibilities was to help the remaining Socialist parties in Eastern Europe to resist Communist demands for fusion. It was a hopeless task, except in West Berlin where the Western occupying powers were able to give skilful and effective backing to a tough-minded Social Democratic Party under Mayor Ernst Reuter, himself a former Communist. By the middle of 1948 all the Socialist parties behind the Iron Curtain had been liquidated and my friends were either in prison or exile, apart from a

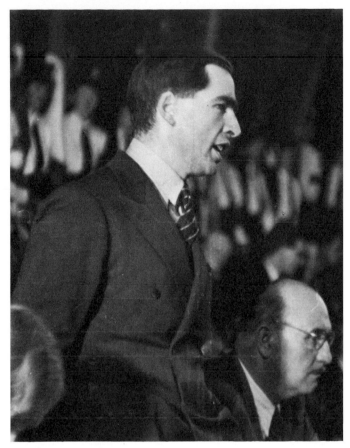

Speaking in Budapest, 1946

Dalton was an impressive man with a fine presence and a voice which boomed so loud he never needed a telephone. He had immense intellectual ability allied with flaws of character which prevented him from reaching the very pinnacle of politics. His emotional development had been arrested for good when many of his friends, among them Rupert Brooke, were killed in the First World War. The death of his only child when both he and his wife were away from home on political business created a lasting estrangement between them. He was much distrusted by his colleagues, one of whom described his eyes as 'green pools of insincerity'. But he was immensely helpful to younger men. Besides myself, Hugh Gaitskell, Jim Callaghan and Tony Crosland all owed much to his encouragement and support. Long walks, particularly in the mountains, were his passion. But he could not bear Switzerland because it had been neutral in two world wars. 'I must breathe the air where a man has fought for freedom,' he would declaim. But whatever his faults he produced in his three volumes of memoirs the best single account of the Labour Party's history from the First World War until he left politics in 1960.

He had an intense dislike for Herbert Morrison and Manny Shinwell, which they reciprocated, but he worked well with Harold Laski because they shared a common devotion to the Zionist cause. My sense of the damage done to the Labour Party by the personal cliques which surrounded so many of the Ministers in the Attlee Government is one reason why I have always steered clear of cliques myself.

Interpreting Ernest Bevin's foreign policy to the Party was not an easy or popular responsibility. Many of the most active Party workers were either pacifist or sentimentally pro-Russian. They could not accept that power had a role to play in international affairs. Bevin himself found it difficult to describe his objectives systematically. Indeed his speeches to annual Conference, which he did not begin to prepare until he arrived at the NEC hotel the

handful who for various reasons had supported fusion with the Communists. Many of these, like Jiri Hajek who later became Czech Foreign Minister, in turn fell foul of the Communists, particularly when Soviet policy turned anti-semitic.

It was an education in itself for me to attend the monthly meetings of the Labour Party's National Executive Committee in the eighth-floor boardroom at Transport House, which has seen so much political drama. Cripps and Bevin, the most important Ministers in the Government after Attlee himself, never stood for the National Executive Committee in those years. Hugh Dalton, however, was an active member and as Chairman of the International Committee was my immediate boss. Herbert Morrison, Aneurin Bevan and Manny Shinwell were also members.

previous night, were almost unintelligible on paper, although their meaning was unmistakable when he thundered them out in Conference itself. He was a man of natural genius whom, with Franklin D. Roosevelt, I have always regarded as the model of a constructive democrat.

He was also immensely loyal to those who gave him loyalty. One of the issues on which I had always disagreed with his Foreign Office officials was their attitude towards the Italian Socialist Party, which had split at the Congress in Rome in 1946. The leader of the breakaway party, Giuseppe Saragat, later to become the President of Italy, had accused the Labour Government of being anti-Italian and wanting to make Tripolitania a British colony. My firm rebuttal of this absurd charge at the Congress of the Socialist Party in Turin enraged the Italian Prime Minister, De Gasperi, who called in the British Ambassador, Sir Victor Mallet, and told him to protest in the strongest terms to London about what I had said.

Ernest Bevin sent for me. I was still under thirty at the time and the thought of a stand-up row with the great man was not appealing. Nevertheless I was certain I had been right in my remarks, so I sent Bevin the full text of my words saying that it spoke for itself. Next morning I was ushered into the great room overlooking St James's Park. Bevin sent his Private Secretary out and asked me to sit down. In his soft Somerset voice he asked me whether I had anything to add to what I had written in my letter.

'No, I don't think so,' I replied.

'All right then,' said Ernie, 'I'll tell Mallet to stop whining!'

I saw much less of the Prime Minister, and indeed he was not easy to talk to. Wilfred Fienburgh once said that a conversation with an ordinary person was like a game of tennis, while a conversation with Attlee was like throwing biscuits to a dog. But Attlee was a skilful leader of an extremely difficult and mettlesome team. He owed a great deal to Bevin's unflagging loyalty, and knew it.

My responsibility for interpreting Bevin's foreign policy to the movement led me all over the country to local constituency parties and to Party schools. It also brought me into hot water more than once, particularly when my pamphlet 'Cards on the Table' was the subject of a heated debate at the Margate Conference in 1947, and Hugh Dalton did not admit to having cleared it for publication until the argument was practically over.

During these years my interest in photography flagged. My work was all-absorbing and my corroded Vest-Pocket camera did not offer any irresistible temptation. But in the early 1950s an American friend introduced me to a cheap 35mm camera, the Argus C3, and I began to realise what could be done with it. About the same time Kodachrome colour film became easily available and a new dimension opened up before me. In 1952 I decided to become an MP after rejecting opportunities in academic life and journalism. Since then, my politics and my photography have moved together; but like any amateur I give my private life first claim on my camera.

2 Family Album

I suppose the main reason why people first buy cameras is to photograph their family. Like all amateurs I have built a great library of family pictures — of my wife, my parents and, above all, my children and grandchildren.

Jenny was born in 1948, Tim a year later and Cressida, the baby of our family, after a five-year gap. I have photographed them regularly for thirty years — Jenny as a podgy red-faced infant, a lively schoolgirl, a slim bride and now a mother; Tim on his first faltering steps as a child, as a lithe young gymnast, singing on television in the school choir and through the student years when his face disappeared behind long lank hair, a drooping moustache and enormous spectacles, until he too became a father and the hair retreated back to his ears; Cressida

Boating in Epping Forest

Cressida

Tim

Jenny

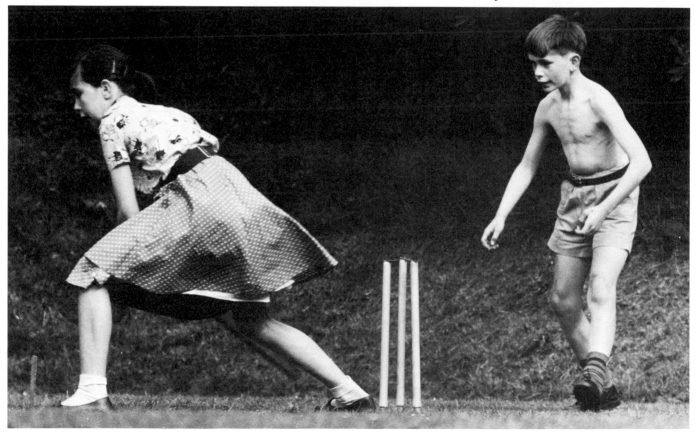

from babyhood through her tomboy youth and the confusions of adolescence to happiness in San Francisco.

Above all I have photographed our family on holiday, managing at least once a year to include myself in the picture, usually picnicking in the Alps, by using the self-timing mechanism in the camera. This gives you some ten seconds after pressing the button before the shutter actually moves — enough time to race over rocks and heather counting 'Mississippi one, Mississippi two' — to the side of your wife and compose your face in a suitable expression before you hear the click. If your camera does not have a built-in self-timing mechanism, you can buy a cheap accessory to do the job. I find it useful not only when I want to include myself in a picture but also to prevent the camera shaking when it is not firmly fixed.

We spent all our family holidays camping. For many years our love of sand and surf took us to Treyarnon Bay in North Cornwall until it became too crowded to be worth enduring the bad weather which is so common in August. 1956 saw us camping abroad for the first time. We had just bought our first car, a brand new Hillman Husky estate. Jenny and Tim slept in the back of the car, Edna and I in a

Far left, *Jenny;* left, *Tim;* below, *Cressida*

small ridge tent with Cressida beside us in my army canvas bath. She was scarcely a year old and much less trouble than her brother and sister since she could not yet walk.

The weather was appalling most of the time. We passed through Austria on the way to Yugoslavia and spent a few days on a farm near Klagenfurt, where my war had ended. I took a picture there of Jenny and Tim drawing on the table under the apple trees while one of the farm girls was shelling peas. I tried to convey in it some flavour of the words in which two hundred years ago a Devon parson, Thomas Traherne, described his own childhood:

The corn was orient and immortal wheat, which never should be reaped, nor was ever sown … The green trees when I saw them first through one of the gates transported and ravished me, their sweetness and unusual beauty made my heart to leap and almost mad with ecstasy, they were such strange and wonderful things … Eternity was manifest in the light of the day, and something infinite behind everything appeared.

Dylan Thomas has conveyed the same mystical joy of childhood in some of his last poems:

And honoured among wagons I was prince of the apple towns
And once below a time I lordly had the trees and leaves
Trail with daisies and barley down the rivers of the windfall light.

This 'windfall light' is ideal for photographing children, particularly amid grass or flowers which glow like the fuzz on the child's arms when photographed with the light behind them.

Later on Edna and I bought an inflatable igloo tent and the children inherited the ridge tent. I also contrived a cubical canvas contraption we called the palanquin, which served well for cooking unless there was a breath of wind, when it invariably collapsed. Thus equipped we developed a pattern which lasted for the fifteen years the family took holidays together: a week by a lake in the Alps — either Annecy or the head of Lake Geneva near Montreux until it became too polluted — then a week in the high mountains and a final week, if we could afford the time, in Italy either by one of the northern lakes or by the sea.

In England, where the weather was often so bad in the summer holidays, I think Edna, like most wives, found camping simply housework under appalling conditions. There is nothing quite so dampening to your *joie de vivre* as a sudden torrent of boiling fat on your naked foot when the aluminium saucepan falls off the primus stove in heavy rain. But in the Alps or Italy, where we often had bad weather too, such experiences were more than offset by the bracing mountain air on our day-long walks, and the blazing afternoons by the Mediterranean.

The highpoint of our holiday always came in the last week — a long walk on my birthday, August 30th, starting in early morning and getting back to camp well after dark. Most memorable of all was the day in the Aosta valley when we climbed to snow level in the Gran Paradiso and watched the herds of *stambecchi*, mountain goats only found in that part of the Alps, as they slowly descended for the night to warmer pastures, butting one another with their enormous curved horns. On the way down at dusk I used my extra-long lens to take a lovely picture of the snows of Monte Rosa glowing pink in the Alpenglüh with the moon almost touching the mountain.

My growing library of family colour slides has led to our Christmas slide show becoming a family institution. As dark sets in after the interminable dinner we gather round the Christmas tree and for

My father

30

an hour or so relive our life together, my children shouting with recognition as some favourite episode appears, the grandchildren saved from boredom by their presents, my mother alert to the last but my father dozing off before the programme is half way through.

I now make a point of buying a record of local songs and music wherever I go in the world. When I show my slides I can play the appropriate records simultaneously on the gramophone — Burl Ives or the Beatles for the children when young, Yves Montand or Juliette Greco for France, yodelling songs for the Alps, and of course a throbbing Neapolitan tenor with mandolins for Italy.

I suspect I was not the only parent to shake his children's confidence in his judgment by predicting when the Beatles first appeared that they would not last beyond the following Easter. To expiate my crime I took photographs of Tim and Jenny which I mounted on their record sleeve of 'With the Beatles' so that they too could join the immortals.

Edna in Cornwall

It is now many years since I had time to develop and print my own photographs. But when I was less busy I found black and white as exciting as colour for family pictures, because a fast film like Tri X enables you to catch the critical moment naturally even in the dullest light. The slow speed of colour film will compel you to use flash at, say, a Christmas party. But for natural photographs flash should be avoided wherever possible, not only because the lighting appears artificial but also because the flash itself may be disturbing to children and make them self-conscious. Even the smallest boy or girl learns all too quickly to adopt for the camera what we call the 'false smile' — a rictus of stupefying dishonesty.

A camera can also be used to recapture images of your past. I have often returned to the scenes of my own boyhood in Keighley and Wharfedale to try to recreate something of my childhood.

Little has changed. The moorland walks are bare and beautiful as ever. The Riddlesden bus still waits at the Willow Tree Inn to take you down to Keighley. The snicket steps by the beck are as steep as I found them as a boy when I hurried home from the fish-and-chip shop on Bradford Road munching my scallops — a slice of fish between two slices of potato fried in crunchy batter and dripping with vinegar. And the Leeds–Liverpool canal still lies along the contour of the hill, dividing the village where we lived from the town. The canal played a great part in my boyhood. We used to race our bikes up and down the mountainous coal tips where the barges unloaded. We hunted minnows in the shadow of the boathouses where one of my father's teachers, Mr Town, kept a motor boat on which too rarely he took us for trips on the canal, down the miraculous ladder of locks at Bingley and back again. And if I was late for school in Bradford, it was always because the swing-bridge at Granby Lane was open to let the barges pass; I would watch the double-decker draw up at the bus stop on the other side and move on again without me.

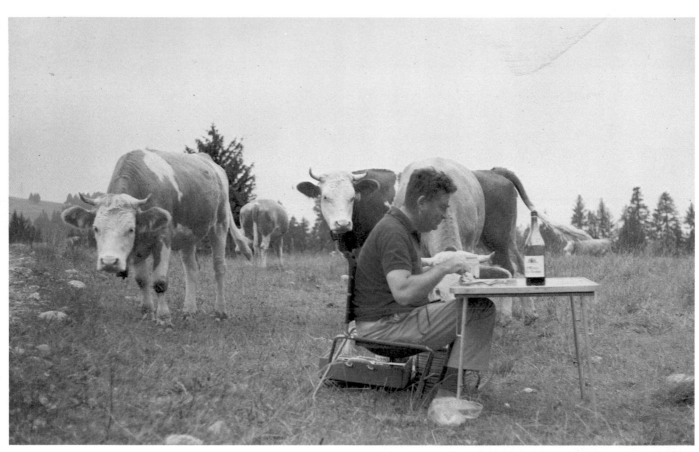

Picnicking in Switzerland: self-portrait with self-timer

Camping in Grindelwald, from the igloo tent

The great annual event of my boyhood was Keighley Gala; its climax was an ascent by intrepid aviators in a gas-filled balloon which too often came down in the sewage farm a few miles away. After the procession you were free to sample the coconut shies, the roundabouts, the sickening swing-boat, and later the dodgems. When Edna was teaching at the Girls' Grammar School at the beginning of the war, before we were married, one of her pupils saw us riding together on the roundabout. The girl developed a deadly jealousy of me and for her next composition gave Edna a ballad of all too topical a nature which ended with the words:

A Heinkel flying overhead
Swooped down and shot her lover dead.

33

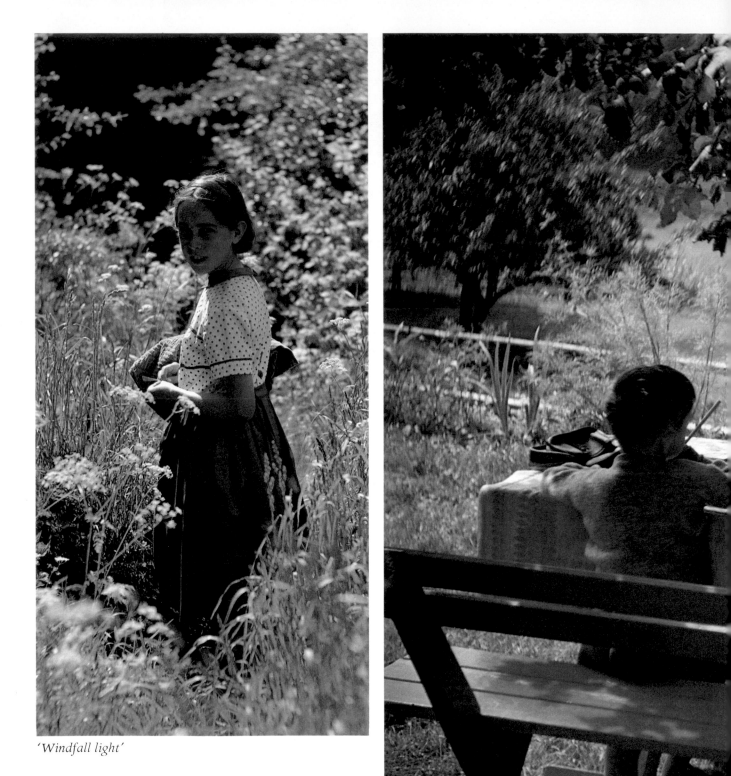

'Windfall light'

On the farm near Klagenfurt

34

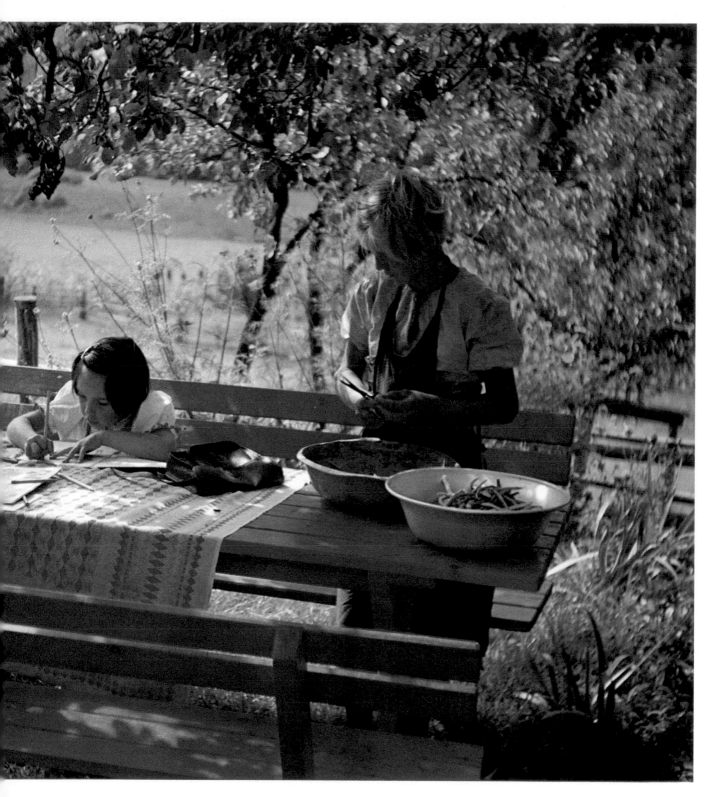

Wishful thinking! A few years ago I opened the Gala myself and Edna crowned the Queen.

Once on the way back from a Labour Party Conference at Blackpool I called in to see my Auntie Maggie in Todmorden. She was still living in the two-room back to back house with the closet at the bottom of the street, where she and my father were born.

For my mother's sake as well as my own I have also taken pictures of Newnham on Severn, the lovely village on the edge of the Forest of Dean where her father was station-master — they still had a station in those days. From my grandparents' little house above the river we trotted down to paddle in the muddy waters of Severn Beach in the shadow of the church on the cliff, where both now lie for ever.

A few years ago when I went to the Isle of Man to speak at a Trade Union meeting, I took an afternoon off to see if I could photograph the fisherman's

Left, *Auntie Maggie*; below, *the Riddlesden bus*; above right, *the canal at Riddlesden*; below right, *Rivock Edge near Keighley*

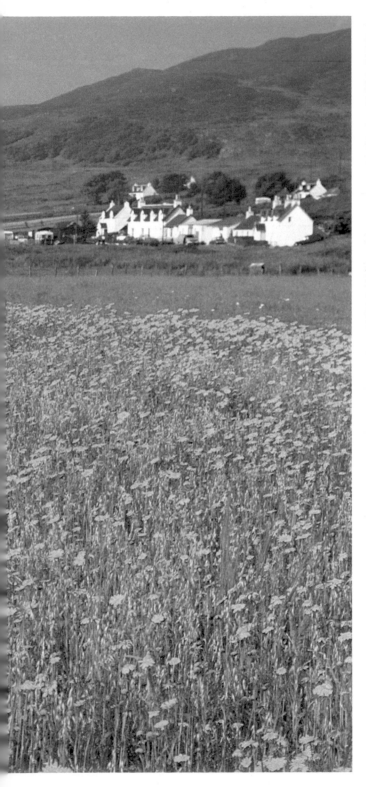

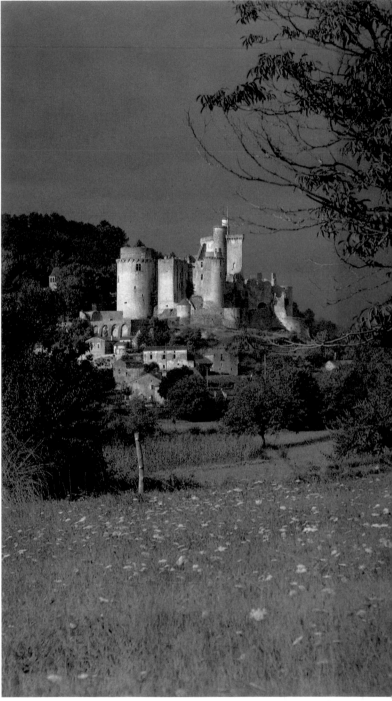

Bonaguil, Central France

Kilchoan, West Highlands

39

cottage at which my father and mother innocently stayed just before they were married in 1914. My grandmother did not speak to her daughter for months afterwards! Beyond all expectation I succeeded in finding the very cottage just above Fleshwick Bay, completely unchanged after over sixty years. You may remember the television camera playing the same trick in the lovely film of *Cider with Rosie*, which ends with the writer, Laurie Lee, as he is today, watching a little boy, as he then was, scampering up the woodland lane he knew as a child.

Presenting childhood and old age side by side in the same person is one of the camera's many services to nostalgia. You can compare the face of a little girl with the same face in an old lady etched and refined by wisdom and experience.

Since the children left school and began taking holidays on their own, Edna and I have given up camping. But we still find the old pattern ideal — a few days by a lake, a few days in the mountains, and a few days by the sea. That is why we have so thoroughly explored Central and Southern France, Northern Italy and the whole Alpine region from Annecy to the Dolomites. In recent years we have done the same in Scotland which, in anything but heavy rain, is surely the most beautiful part of Europe.

The beauty of such places for a photographer lies not just in their scenery and ancient buildings, but also in their people.

Gran Paradiso, Val d'Aosta

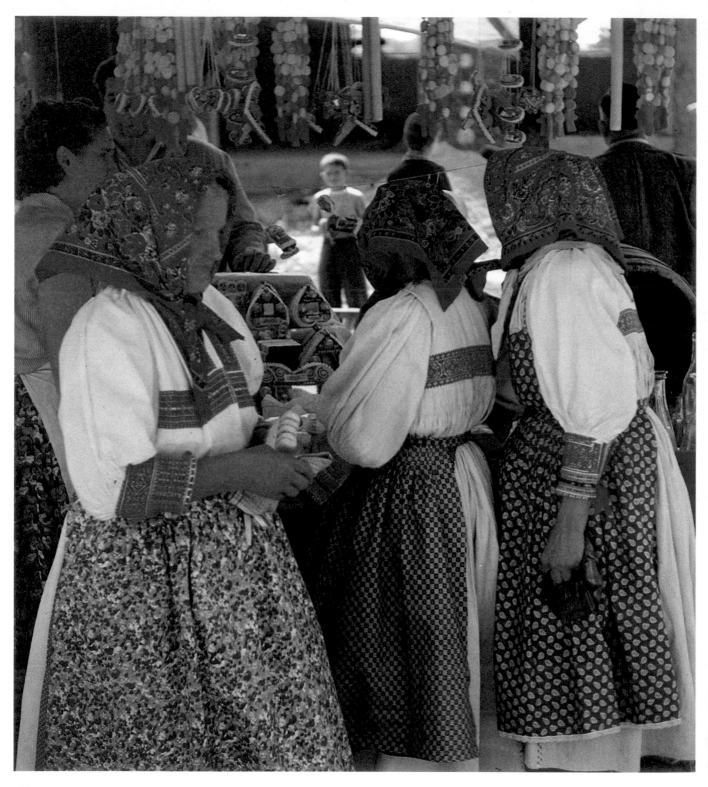

3 Work and Play

It is always best to photograph people at their daily work or play. A market place is an ideal source of pictures — although in most countries you must be there well before breakfast since the market tends to pack up an hour or two after dawn. A vegetable market is always a mass of colour, with the green of pumpkins, the yellow of melons or marrow, the red of tomatoes and radishes, and outside Europe a wealth of exotic fruits and vegetables — yams, peppers, breadfruit, pineapples — which in themselves tell you something about the life of the people concerned. A market place creates a tension between buyer and seller, or between competing buyers, which adds to the human interest of your photographs. And, in countries where the people still wear regional or traditional costumes, a market, like a church, is a good place to find them.

For the average amateur, pictures of people at work are most easily found in the open air — on the farm, in the fields, or in the fishing harbours. Here you will often see regional costumes set off against attractive colours, for example the flowery green of mountain meadows, the gold of corn, or the deep red or blue of fishing nets. Lace-makers and potters or the blacksmiths and carpenters in country villages also tend to work where your camera can reach them.

It is worth visiting the local parks to see the children's playground, the sports field, a Punch and Judy show, a family out on a picnic, or the inevitable pair of lovers. In Southern France every shaded square will contain a group of men playing bowls under the plane trees against the peeling stucco walls. Most exciting of all is a village fair where men,

Gingerbread hearts on sale at a village festival in Croatia

women and children mingle in their best clothes, eating, drinking and playing games.

I find it fascinating to compare photographs of men and women in different countries engaged in the same activity; my wife has often used my slides in lectures to illustrate the common humanity of all peoples. Photography, like politics, teaches that, like us, all people are human beings; but not all are human beings like us. In politics, alas, the differences are sometimes more important than the similarities.

My photographic interest in markets all over the world owes nothing, I fear, to a former Chancellor of the Exchequer's view of the market economy. A market place in any country is packed with colourful things and colourful people, all too busy deciding what to buy or haggling over the price to notice the photographer. But even so there are some parts of the world where it is best not to be seen taking pictures, because possession of a picture is thought to give you some magic control over the person concerned. I was once chased through the Damascus Soukh for raising my camera, and in many countries people will hide their faces to prevent you photographing them.

So you may have to take your picture with your camera at waist level, pressing the button without looking down, and hoping that no one notices what you are up to. A single-lens reflex like my Exakta Varex 2A, which can be fitted with a waist-level view-finder, is very useful on these occasions. Another suitable gadget is the so-called Mirro-Tach which screws a mirror diagonally in front of your lens so that you can point the camera in one direction and take the picture at right angles to it. It requires a lot of practice to aim your camera properly when it is

fitted with these gadgets since the image in the view-finder is reversed or upside-down.

Buying and selling are such fundamental human activities that you can learn a lot about the similarities and differences of cultures in the market. In Switzerland, where I photographed the little blonde girl, everything is spotlessly aseptic — even the vegetables seem to have been scrubbed. In Central France, where another little girl is looking after the animals while her mother is away, there is a more human warmth, with the normal amount of dirt.

You do not need to be told that Yugoslavia is a federation of different nationalities if you compare the watermelon stalls in Zagreb with the same stalls in Dubrovnik or the sparsely strewn boards of Virpazar in Montenegro.

In the Middle East the markets do not seem to have changed since the *Arabian Nights*, even though in some places the bicycle has replaced the camel or acetylene lamps are brought out at dusk.

The most fascinating markets I know are the floating markets in the Klongs outside Bangkok in Thailand. I first saw them in 1963 during a lecture tour of the Far East. When I was Defence Secretary a few years later I insisted on getting my officials out of bed at five in the morning so that we could visit them again before my first appointment at breakfast. My determination never to waste a chance of seeing

A market in Central France

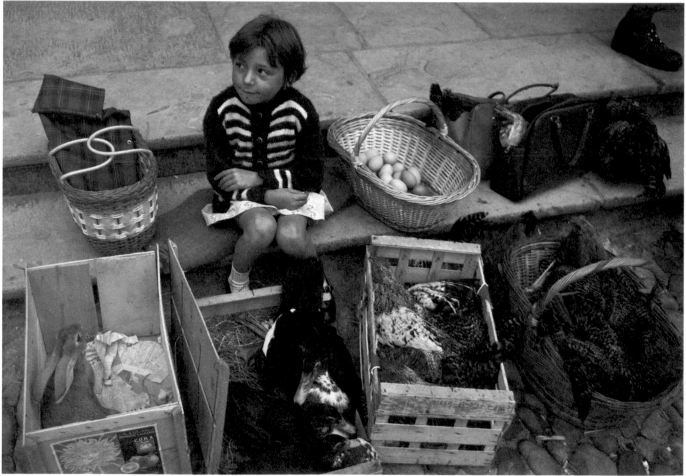

something unique wherever I went led my Private Secretary to call me 'maximum extraction Healey'.

To see the Klongs you take a motor boat across the river at dawn and enter a maze of waterways in the jungle. Before long you find houses built on wooden piles sunk into the swamp, naked children bathing from steps leading down into the chocolate-brown water, women with hats like lampshades paddling long canoes loaded with fruit and vegetables; finally you reach the centre of the settlement, an Asiatic Venice where the market is held in a babel of voices. A large punt moves from house to house picking up the children for school, and on the outskirts you may see a Buddhist monk in his saffron robes begging his breakfast by boat.

The most primitive market I saw was at Port Moresby, where I spent half an hour on the way to visit the Commonwealth War Cemetery in New Guinea. Here there was little fruit. Great bleeding hunks of giant turtle swung from hooks while stone-age faces under fuzzy hair looked on from the deep shadow of the huts where they sheltered from the tropical sun.

The gayest markets, not surprisingly, were in the Caribbean — particularly Georgetown in Guyana and Ochos Rios in Jamaica, which I visited during a Commonwealth Finance Ministers' Conference. The colour of the clothes matched the colour of the tropi-

Vevey, Switzerland

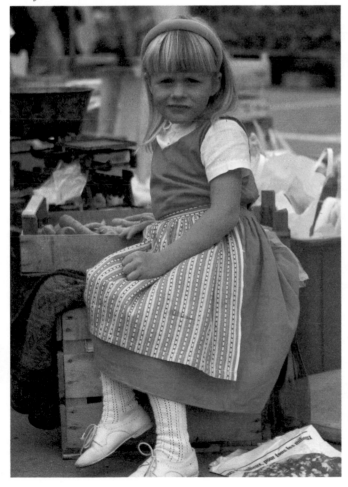

Zagreb; below, *Dubrovnik*

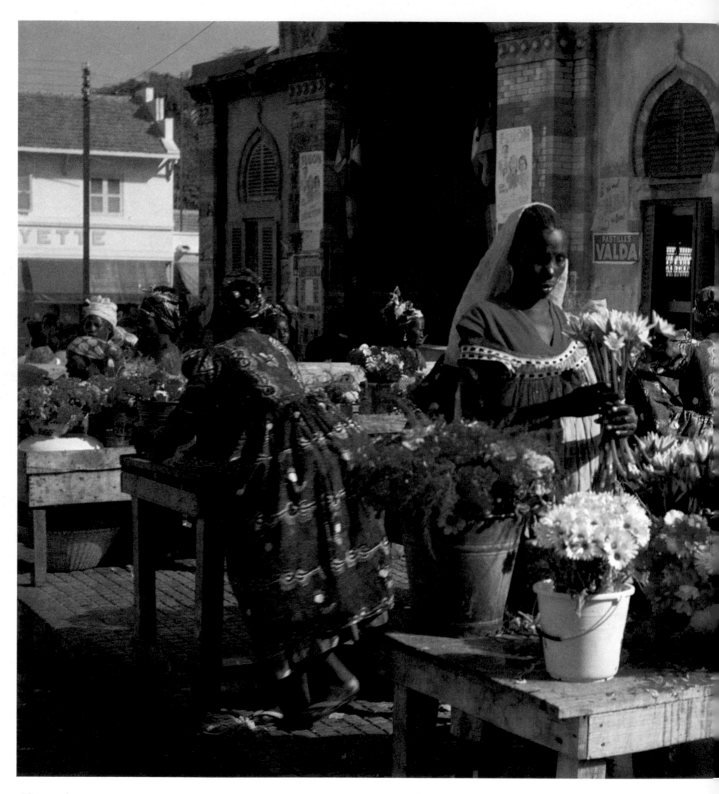

46

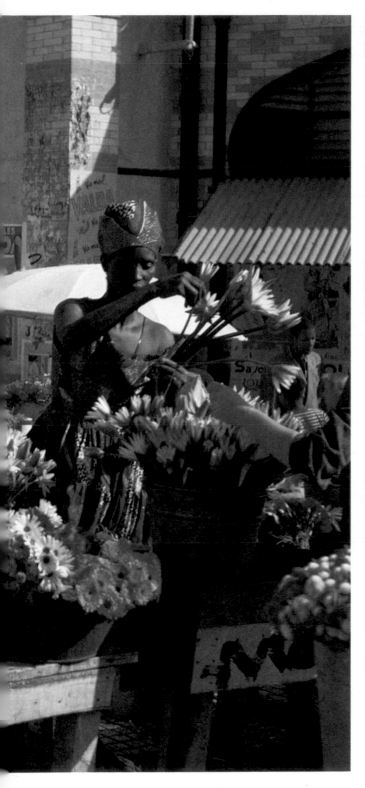

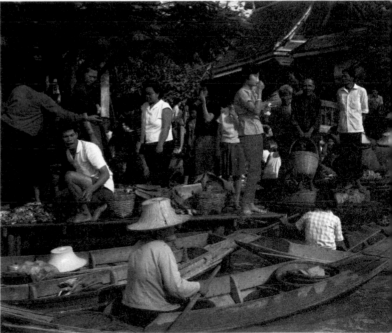

Above right, *turtle meat in Port Moresby, New Guinea;*
below right, *the Klongs of Bangkok*

Left, *Dakar, Senegal*

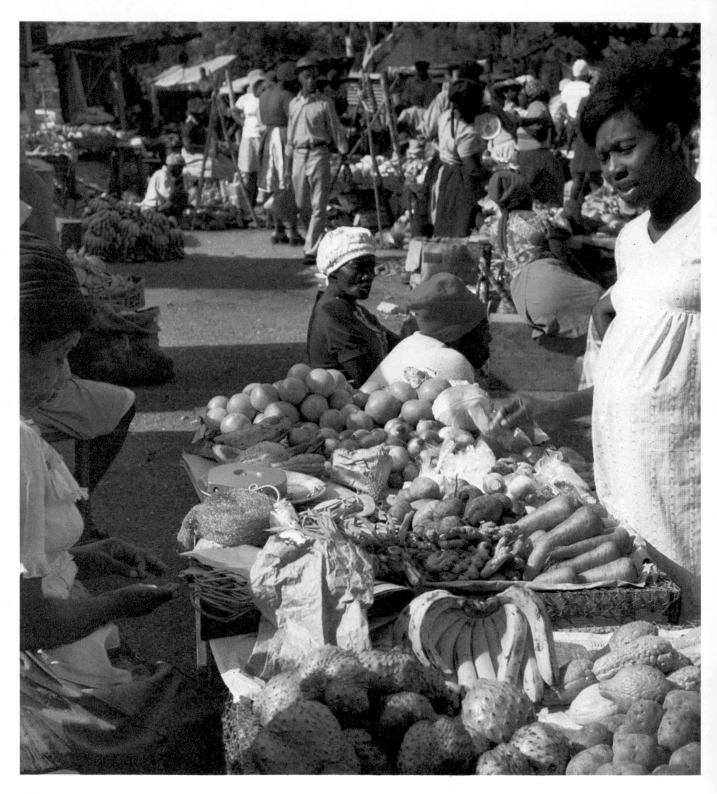

48

cal fruit and vegetables, while in Mexico the melon and paw-paw were cut to look like a skirt.

In Africa the market at Ibadan was dominated by the blue dresses of the Yoruba tribe, while in Dakar the clothing of the Wolof women copied the style of the French Second Empire.

To see people at play, there is nothing better than a public festival. You can come across festivals in the most unlikely places. In 1979 I was staying in New York to give some lectures. It was the first time since I became a Minister in 1964 that I had a few hours to myself in that great city. On the Sunday morning I decided to walk up Fifth Avenue from the Algonquin, where I was staying, to the Metropolitan Museum in Central Park — about three miles away. I found Fifth Avenue lined by crowds and blocked by police. Hidden in every side street there were gaily decorated floats with handsome dark-skinned people aboard in brilliant Latin American costumes, or dozens of uniformed drum majorettes shivering in the icy wind which blew down the tall canyons of the skyscrapers. It was Hispanic Day, when all the American communities from the Caribbean to the Cape of Good Hope join a procession round Manhattan island — dancing an energetic rumba up the avenue. I even saw Dorothy with the Cowardly Lion, the Tinman and the Scarecrow striding ahead of a fantastic banjo band in green satin and white plumes, straight from the Land of Oz.

I had a similar piece of luck as we were returning from our second visit to Yugoslavia — this time with Hugh Gaitskell and Sam Watson for political talks. Edna and I found that our aircraft did not leave Zagreb until the afternoon. I enquired whether there were any fairs in the area and was told that a village some fifteen miles away was celebrating its Saint's Day. Edna and I went out by taxi and were plunged for four hours into the Middle Ages. The village was full of peasants from the surrounding countryside in

Ocho Rios, Jamaica

their traditional Croat costumes. The village priest was holding an open air service against the wall of the little church. The field outside was covered with stalls on which hung every sort of sweetmeat — particularly the gingerbread hearts which for a thousand years young lovers have given to one another. The men were drinking mead. It was an enchanting experience and produced one of my best photographs.

There was one incident on that visit which I was unable to photograph. It happened in Ljubljana. Hugh Gaitskell was an obsessive dancer and late one evening after our official engagements were over he pestered our Yugoslav guide to find out if there was a restaurant or night club open where he could indulge his passion. After the guide had repeatedly explained that Ljubljana was only a small provincial town and nothing was open so late in August anyway, the driver of our car interrupted in Serbo-Croat. Very shamefaced, our guide at last admitted that there was in fact one place where we could perhaps dance if we insisted, but it was not really suitable. Hugh did insist, so we were all taken to the local skyscraper a building five storeys high. We took the lift to the top floor, were inspected through a spy-hole, and finally admitted to a seedy room in which a handful of morose women were sitting alone at tatty tables while a three-piece band played Palm Court music to an empty dance-floor. Nothing daunted, Hugh grabbed Edna and whisked her round the floor. Sam and I, who were dog-tired, sat watching without excitement over our flat beer as one dance followed another. Finally Sam turned to me and in his flat Durham miner's voice said, 'I don't know about you, Denis, but my pants are full of little flies.' We left.

A year or two ago we were staying at Fie in the Dolomites near Bolzano during the annual fête. After morning service in the church an enormous procession assembled in the square outside led by the smallest children, followed by girls and boys, then

49

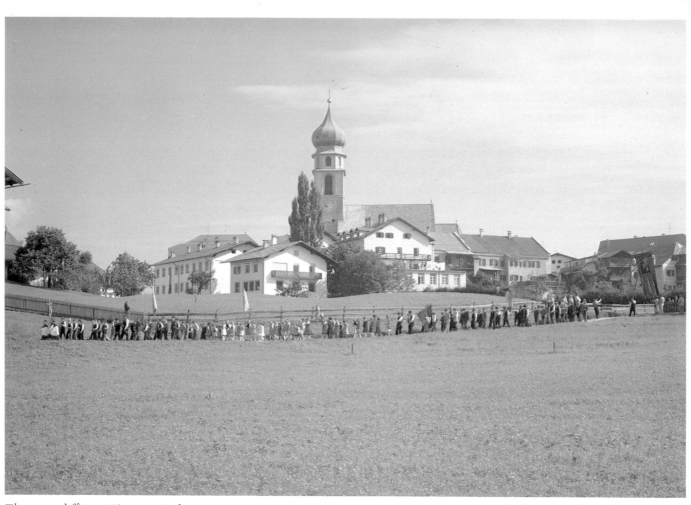

men and women separated into age groups from the maidens to the grandmothers, all in their traditional costumes. Interspersed at intervals were men carrying great banners fifteen feet high with ropes to steady them. At the centre of the procession the local Bishop walked, resplendent in his golden surplice under an embroidered canopy preceded by images of the Virgin and Child. The procession moved off through the fields and round the outlying hamlets. A short service was held before it re-entered the town and it finally dispersed into the church for a formal service.

The afternoon brought the profane part of the fête. A long caravan of gaily decorated farm carts drawn by oxen was set moving by four men cracking their long bull-whips in a nearby field. A Tyrolean brass band provided music, the musicians' hats plumed with mountain grasses which looked like ostrich feathers. The caravan stopped in a forest clearing some way beyond the village where the villagers could eat and drink at rough tables and benches as they watched the dancing or listened to the band. Roast chickens were turning on long spits in a makeshift open-air oven, and sausages were

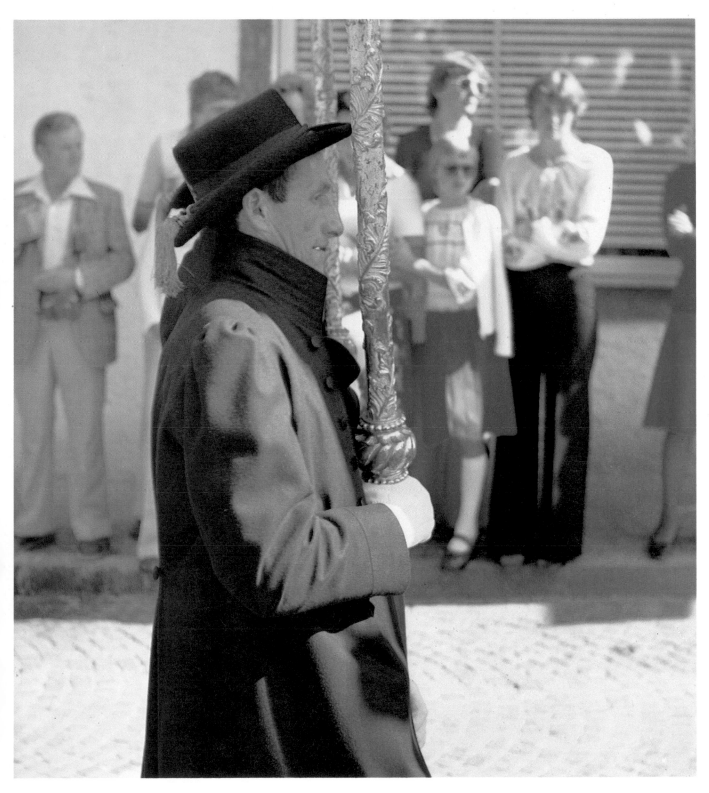

frying. The day cost me four rolls of film and was well worth it.

All over the world popular festivals tend to follow a similar pattern — a morning of church services followed by general jollification. We found it, for example, in a Corsican mountain village where the people went straight from Mass to the greasy pole and the sack race. In Singapore the religious ritual was more forbidding — a procession of young men encased in a framework of swords and skewers which pierced their skin.

The most exciting of all the festivals we visited was the Palio in Siena — the Parade of the Banner. A

Fie: below, *the trombone player;* right, *the barbecue*

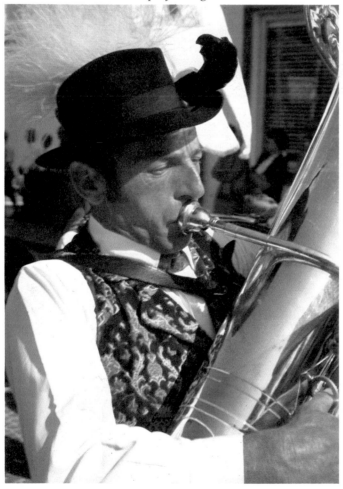

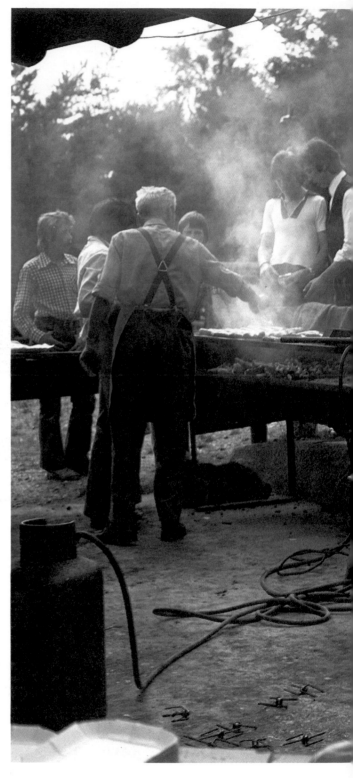

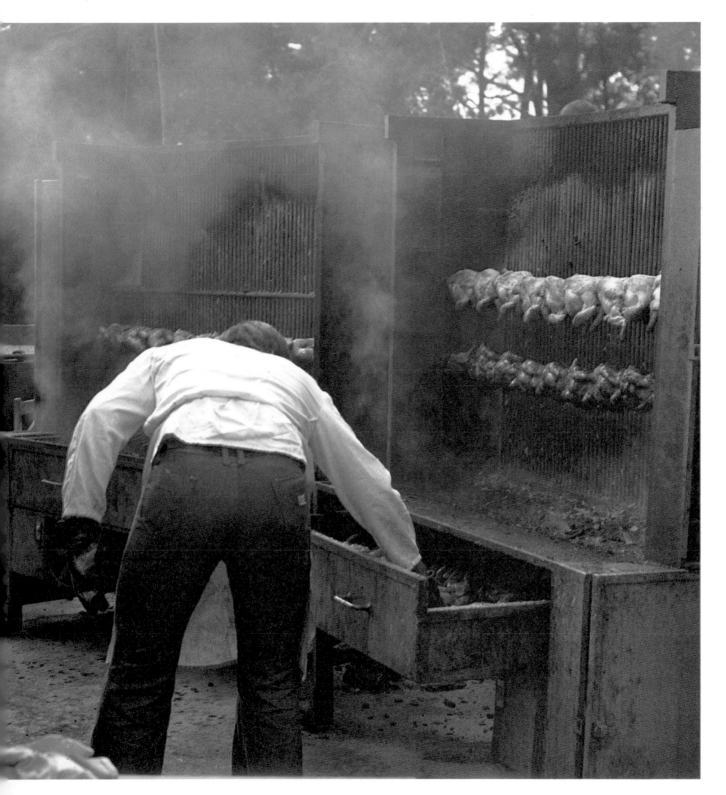

rose-red city high up in the hills of Tuscany, Siena has always been one of my favourite spots in Italy. I was stationed there in 1943, when our mess survived the winter on the best Italian Chianti liberated from the cellars of the Baron Ricasoli. One cold afternoon in October I entered an ordinary tenement building and stumbled on the Sienese paintings which had been hidden for safe keeping during the fighting — Byzantine formalism presented in the colours of pistachio and raspberry ice cream. On another occasion I made a special visit to the villa of Montegufoni some miles away because it had been the Italian home of the Sitwell family. When the old housekeeper let me in to the drawing-room I saw the Botticelli 'Venus' lit by a shaft of sunlight: the best paintings from the Uffizi Gallery in Florence were stored there during the war.

But the main glories of Siena are the great Gothic cathedral which dominates the town, striped black and white like a humbug, and the scallop-shaped piazza which slopes down to the crenellated medieval Signoria. I saw the Signoria for the first time with a shock of puzzled recognition — I had known it since boyhood in its nineteenth-century travesty as the Bradford Town Hall. It is here that they have held the horse race of the Palio ever since A.D. 1275. Sawdust is laid on the outside of the piazza so that the horses do not slip on the red brick worn smooth by the centuries. Each ward in the city is represented by its own horse, and the winning horse is treated to a banquet afterwards. The members of the wards are dressed in the costumes their ancestors wore five hundred years ago.

Edna and I took our places at nine in the morning, standing inside the track for seven hours in blazing sun. When we arrived the square was deserted except for a couple of ice-cream carts and lemonade stalls. Then came the children, waving paper banners to represent the various wards. When the race started there were thousands of spectators inside the track and more thousands in the houses and stands

outside. In fact Edna found the fumblings of the *farfalloni* too much for her and had to escape from the ring before the race.

The afternoon began with the benches against the wall of the Signoria slowly filling up with young men from each ward in their Renaissance costumes. Then the mounted Carabinieri opened the parade — each ward with its own champion in armour, white oxen pulling carts with the insignia of the ward mounted above, and guardians of the banners tossing them high into the air and catching them again.

After all this the race itself was almost an anti-climax. The tiny riders were dressed in the silk

Right, and following pages, *the Palio*
Below, *in a sidestreet*

clothes of modern jockeys. They rode so fast it was impossible to photograph them and the race was over in seconds. As usual one of the horses fell on the slippery track and had to be destroyed. As we walked back to our car we were passed by an immense young man from the ward concerned, blubbering like a child in his doublet and hose.

Our favourite spot on the French Mediterranean coast is Collioure, in the part of Catalonia which crosses the Spanish frontier. I first went there as a student with the Krugers from Mosset nearby. It was a popular haunt of French artists like Picasso and Maillol. Though it is nowadays very crowded in summer, it preserves much of its character as a fishing village. During the August festival everyone dances the Sardana in the village square under the plane trees as the Catalan band leads off with a squeaky reed instrument. At night there are fireworks over the harbour, and in the afternoon, bullfights.

The savage bulls of the Spanish peninsula have been used for fighting since ancient times and a bullfight provides spectacular material for anyone who can stomach the cruelty involved. The best place for photographing a bullfight is from a seat next to the entrance to the ring on the south side so that the sun does not shine into your lens. Then you can take pictures at close quarters of the performers as they assemble. The picadors, whose legs are armoured with steel, ride horses which are also heavily armoured with padded leather so that the bull cannot gore them. Their job is to weaken the bull's shoulders with their long pikes. The banderilleros plant ribboned darts in the shoulders to weaken it further. The killing is done by the matador alone, but only after he has performed as many passes as possible against the bull with his cape, getting as close as he can to its horns. Incidentally though the cape is red on the outside and yellow on the inside,

Before the bullfight, Collioure

58

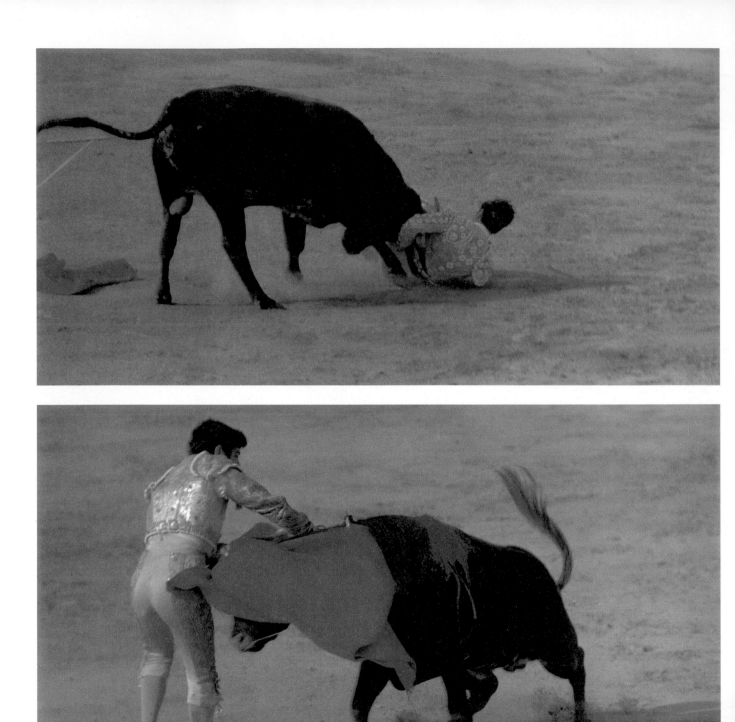

contrary to popular belief all cattle are colour blind so the bull will charge one side as readily as the other.

The matador is not allowed to use his sword except for the kill itself, when he plants it diagonally between the bull's shoulder-blades so that it causes instant death by cutting the great artery. The quality of a matador is judged as much by the grace and courage with which he executes his passes with the cape as by the skill with which he delivers the *coup de grâce*. When the bull is killed it is dragged out of the arena by a team of horses, to be cut up and sold for meat on the spot, and the matador circles the ring to receive the applause of the crowd.

I used my 225mm Dallmeyer lens for shots of the fight itself — nothing but a very long lens will give you a chance of filling the frame.

Collioure: below, *the coup de grâce*

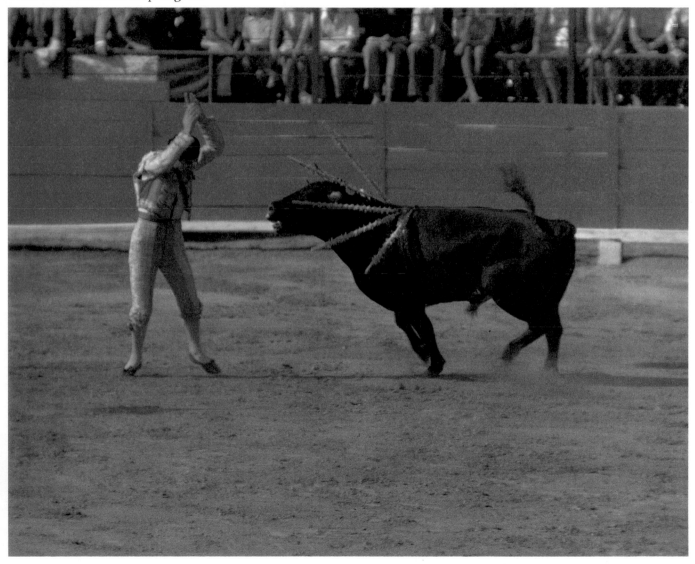

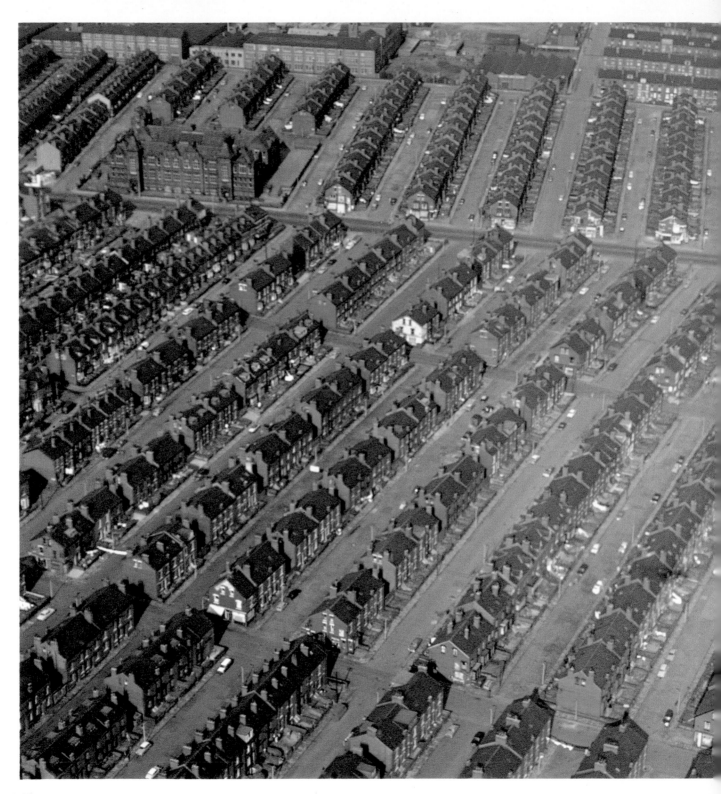

4 The World of Politics

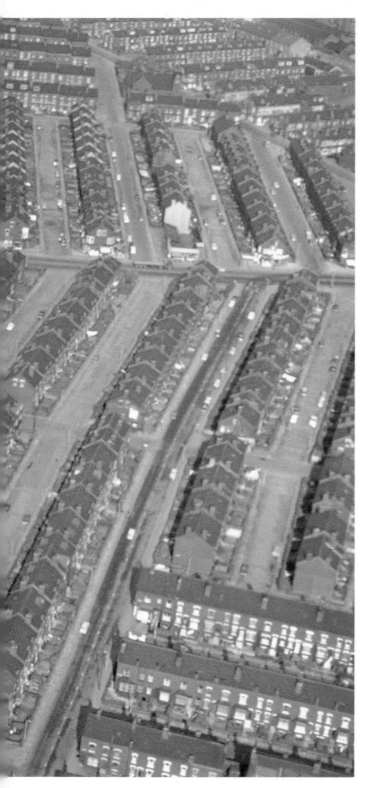

After five years as a Transport House official I hesitated a long time before deciding to become a Member of Parliament. My misgivings centred on the fear that politics was a dirty business in which ambition was subject only to the law of the jungle. Now, after nearly thirty years in Parliament, I know that from this point of view politics is no worse than any other profession — business, academic life, the arts, or even the Church. Competition for a place at the top can bring out the worst in many people. Politics differs from the other professions only because so much of it takes place in public. That is why vanity is the besetting sin of politicians.

The poet Yeats summed it up in a nutshell when he wrote:

> The intellect of man is forced to choose
> Perfection of the life, or of the work,
> And if it take the second must refuse
> A heavenly mansion, raging in the dark.
>
> When all that story's finished, what's the news?
> In luck or out the toil has left its mark:
> That old perplexity an empty purse,
> Or the day's vanity, the night's remorse.

In fact he was writing about making poems, not politics.

The main difference between politics and the other professions is that it requires a much wider range of skills. To decide what should be done a politician must have judgment and understanding; in the top departments of state a good brain is essential. Assuming you know what has to be done and

Harehills, East Leeds: my constituency

63

how to do it you then need a new set of skills — the arts of persuasion. You must be able to win the support, or at least the acquiescence, of an exceptionally wide variety of people if you are to be able to carry out your policies: the General Management Committee of your local constituency party, your colleagues in Parliament, your partners in the Government, your civil servants, and all sorts of groups outside from the Trade Unions to the Confederation of British Industry. In some departments you will have to persuade foreign politicians and peoples too.

You will often have to be content with acquiescence rather than understanding. Dean Rusk, of whom I shall have more to say later, was a professor at an American women's college before he entered government as an official of the State Department. I remember him telling me that the difference between academic life and government is the difference between arguing to a conclusion and arguing to a decision. That is a distinction which many intellectuals in politics never learn to make.

In British politics nowadays a strong physical constitution is also indispensable. Politicians tend either to die young or to live long. Though the burden is heaviest for the Minister in a top department, when the pressure for difficult intellectual decision continues through a twelve-hour day of meetings and committees, anyone in politics at any level is bound to feel the strain — and sometimes the spouse will suffer even more. But for every Gaitskell or Crosland who works himself to death there is a Churchill or a Shinwell who seems to remain alert and energetic for ever.

When I first entered Parliament in 1952 my regional whip was a Yorkshire miner called Horace Holmes. He was well over seventy at the time and the seventeenth son of a seventeenth son; his grandfather was born in 1789, the year the French Revolution broke out. I like to come across such links with history. The doyen of NATO's Ambassadors

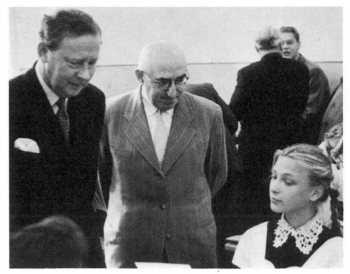

Gaitskell visits a Russian school

when I was Secretary for Defence was the Belgian Baron André de Staercke. When he was a little boy his great-aunt told him that she had wandered on to the battlefield of Waterloo as a child of four just after the fighting was over. She thought it must have been snowing because the field was covered with wadding from the muskets.

People often ask me whether when I was Chancellor of the Exchequer I did not find my additional responsibilities as a constituency Member of Parliament overwhelming. Exactly the opposite is the case. For a Minister immured in a Whitehall department your direct personal responsibility to your constituents is the one sure contact with reality — an invaluable source of strength and insight. When you have represented a single constituency for many years, you and your active Party workers develop a mutual loyalty which is a great comfort in times of trouble. My constituency in Leeds was one of a handful of seats first won by Labour in 1906. Even in 1952 when I fought my by-election, some of my supporters could remember their first Labour Member of Parliament, Jim O'Grady. One of my best friends in the constituency is an engineer, Jack Gallivan, who still works actively for the Party and his

Douggie Gabb *Jack Gallivan*

trade union at the age of ninety. My agent, Douggie Gabb, now a city councillor, has worked with me since 1952. We have had fierce disagreements on policy in many areas. But our friendship and mutual respect as human beings is far more important to both of us than our political differences. When I have a particularly difficult argument with my local Party workers, I like to tell of one of Frederick the Great's generals who, when given orders he regarded as mistaken, sent the reply: 'Please tell His Majesty that after the battle my head is at his disposal, but during the battle I propose to use it in his service.'

I usually stay in Leeds with Bernard and Rose Gillinson who were also close friends of Hugh and Dora Gaitskell. It was Bernard who bought the first picture David Hockney ever sold, while he was still a student at Bradford. Rose Gillinson has made their house a centre of cultural life in Leeds for thirty years.

It is not easy to take photographs in the middle of your political life. But opportunities often arise at conferences, particularly during time off. One of my favourite photographs was taken by a Belgian tourist when Hugh Dalton, Jim Callaghan, Tony Crosland and I were walking in the Vosges one weekend between sessions of the Council of Europe.

Nye Bevan wrote the preface to a book I produced in 1951 about the fate of the Socialists in Eastern Europe. The next year, his resignation from the Attlee Government threw us into opposite camps for the rest of the decade. But I came to know and love him just before he died when he joined Hugh Gaitskell, David Ennals and myself on a delegation to the Soviet Union. He was a romantic in every sense of the word, with a vaulting political imagination which enabled him to cast a new light on any problem. But he had some surprising blind spots; to describe Hugh Gaitskell as a 'desiccated calculating machine' was an extraordinary error of judgment.

Hugh was in fact emotional and impulsive to a degree. Allied to immense integrity of character and

George Woodcock

65

unusual intellectual power he had one great weakness — an inability to recognise that someone might disagree with him without being either a fool or a knave.

I took the picture of George Woodcock at a hotel in Middlesbrough during a General Election on a little half-frame camera. For some reason black and white often seems better than colour for portrait photographs.

Later on I was able to take photographs of my fellow Ministers at Chequers, where Prime Ministers often liked to call their Cabinet together to discuss a major problem at ease for a day or more, free from the pressures of the normal weekday agenda. I took several pictures of the fateful meeting at which we decided to call a General Election for May 1970 with, I think, only Jim Callaghan dissenting.

When I was Secretary for Defence we lived at Admiralty House in Whitehall. The building was far too big for a single family, so the ground floor was used for major Government receptions or dinners,

Below, our bedroom at Admiralty House; right, our splendid view of Trooping the Colour

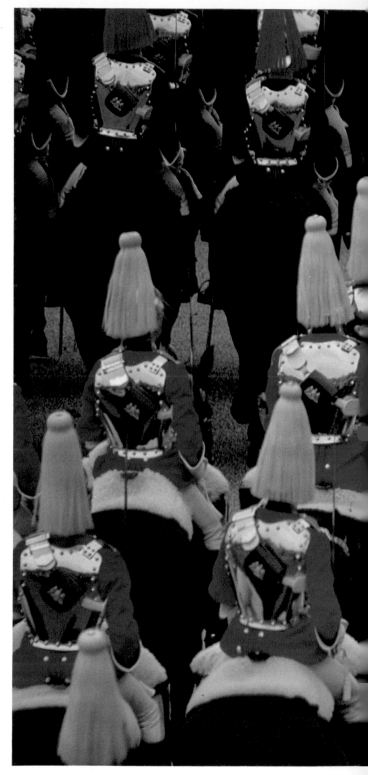

66

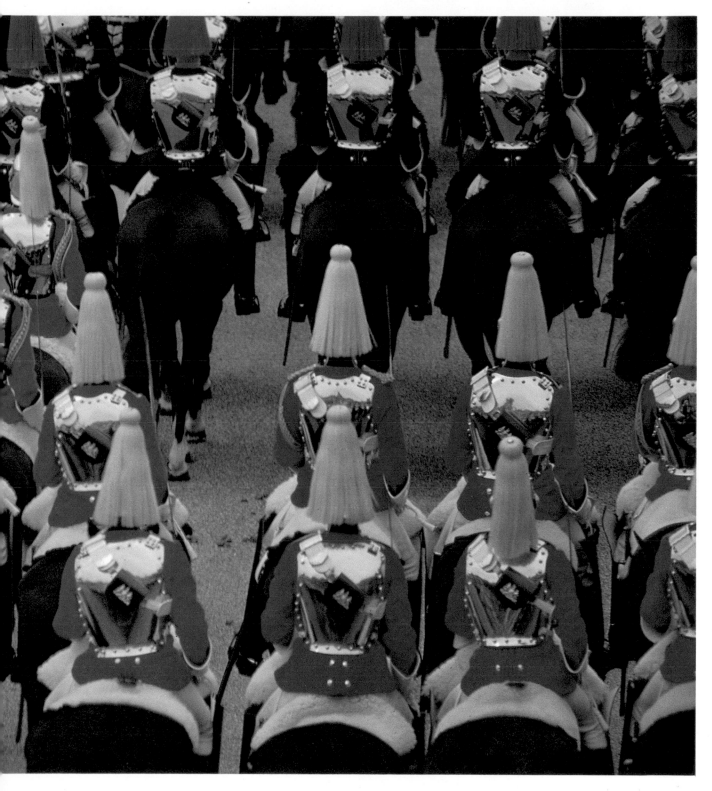

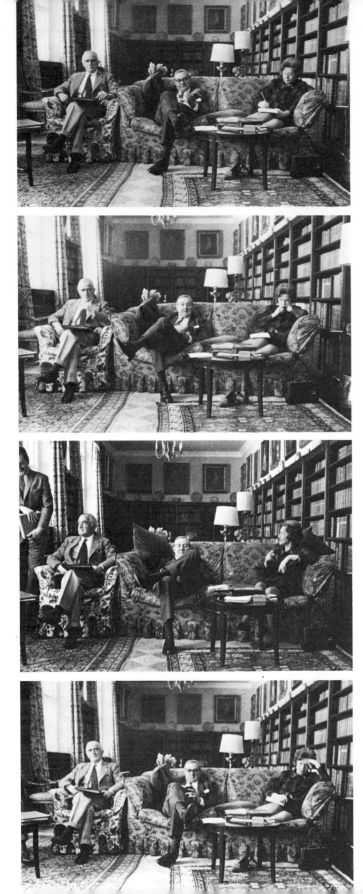

Edna and I lived on the first floor, George Thomson as Commonwealth Secretary lived with his wife and children on the second floor, while our three children lived on the top floor next to a little pied-à-terre used by Ted Short as Chief Whip.

One night Edna and I were woken at three in the morning by Ted Short in his dressing gown followed by a couple of police. Apparently he had seen shadowy figures walking past his window along the parapet. A thorough search revealed nothing unusual except a tramp who had been sleeping in the basement undetected for several nights. Who was walking along the parapet fifty feet above the ground was never discovered. My private theory is that it must have been soldiers from the Horse Guards on their way to an assignation with Wrens in the Old Admiralty Building. I fear that improved security has now put a stop to that.

Admiralty House gave us a wonderful view of Trooping the Colour — the subject of innumerable photographs. The room in which Edna and I slept had been the main bedroom for over a century when the building was the official residence of the First Lord of the Admiralty. We slept in an imposing bed facing a massive wardrobe in which Queen Mary used to keep row upon row of her toques. One bright summer morning when Edna was washing up, the girl who cleaned our flat rushed into the kitchen, her face as white as a sheet.

'There's a lady in your bed,' she gasped.

Edna calmed her down and said it was impossible.

'No, no, she has fair hair and blue eyes. I've never seen her before,' the maid insisted.

Edna went into the bedroom with the maid and found the bed empty and unwrinkled as she expected.

We never got to the bottom of the story. It has often provoked ribald comment from my friends.

The fateful Cabinet meeting at Chequers: Michael Stewart, Jim Callaghan, Barbara Castle and Tony Crosland

If the apparition really was a ghost the most likely person would be Lady Diana Duff Cooper, who had slept there when her husband was First Lord before the war. But can you have a ghost of a living person?

My first year as Defence Secretary was Lord Mountbatten's last year as Chief of Defence Staff. It was a source of amusement for both of us that some of my relatives lived in cottages outside his great castle, Classiebawn in Eire, deeply gratified that I was now his boss. He was in all senses of the word a great man, combining a royal style and presence with a democratic radicalism in thought and action. At our first grand reception in the Banqueting House after Edna had shaken the hands of five hundred attachés and their wives, with four hundred still to go, she complained to him that her hand was getting sore. He looked down at her with a twinkle in his eye. 'My great-aunt, the Empress of Russia,' he said, 'used to have a blister on the back of her hand at Easter as big as an egg where the peasants had kissed it. She never wore gloves.'

He loved to tell the story of a Conservative canvasser at Broadlands to whom he opened the door during the General Election of 1945. 'I'm Labour myself,' he told her, 'but I think my butler votes Tory.'

As Chancellor of the Exchequer I lived of course in No. 11 Downing Street, which has direct access through a connecting door to No. 10. The only time the door was ever locked was when Ramsay MacDonald was Prime Minister and Snowden was Chancellor; they could not stand one another. Living in an official ministerial house is rather like living in a museum, or in an embassy without servants. But we liked Downing Street much better than Admiralty House, since the flat was of reasonable domestic size, although sumptuously furnished. I arranged to tax myself and my successors for the privilege of living there.

David Rockefeller and Ted Heath

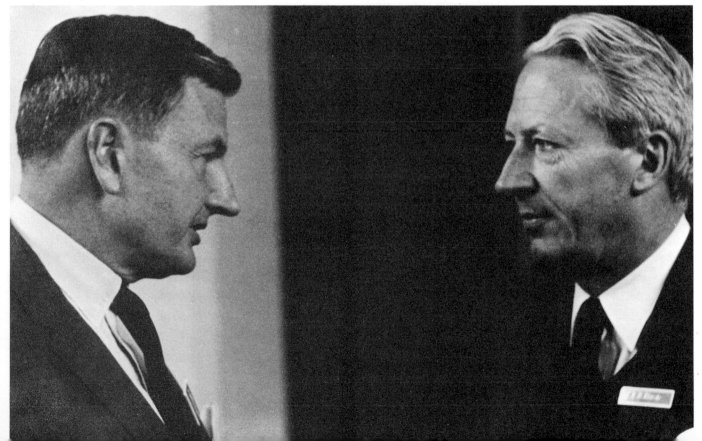

May 1979: Jim Callaghan leaves for the Palace

For a photographer the main virtue of No. 11 was that you had a wonderful view from the kitchen of visitors going in and out of No. 10. I managed to get a picture of Jim Callaghan as he left for the Palace to tender his resignation to the Queen after our defeat in 1979. His head was lit by the last rays of the declining sun. The sun had gone down when, a few minutes later, Mrs Thatcher arrived to take his place.

Inevitably I have had fewer opportunities to photograph Conservative politicians. But I took Mrs Thatcher just after she had become Prime Minister chatting at a conference in Turkey with Andrew Knight, then the newly appointed editor of the *Economist*. And I took many photographs of the most photogenic of present Conservative leaders, Lord Hailsham, when we both attended Anglo-American Parliamentary Conferences in Bermuda. The picture of Ted Heath with David Rockefeller sporting interchangeable noses was taken in Cambridge before he was Prime Minister.

Of leading foreign politicians the one I have known longest is Henry Kissinger, whom I first met in the mid-1950s when we were working independently in America and Britain on the problem of controlling nuclear war. As head of the School of Advanced International Studies in Harvard, he made a major contribution to the academic study of international affairs. But in those days he played much

… and Margaret Thatcher arrives

above right, *Lord Hailsham;* below right, *Mrs Thatcher with Andrew Knight*

less of a role in Washington than many intellectuals of his period. In September 1968 we met at the Annual Conference of the Institute of Strategic Studies in Oxford. He told me he had just been approached on behalf of Richard Nixon to see if he would serve in some capacity if Nixon won the presidential election. Henry said he was most reluctant to accept, and asked my advice. As a supporter of Nelson Rockefeller for the Republican nomination he did not feel he could switch to Nixon now. But his main concern was whether as an intellectual with little direct experience of government he could survive in the Washington environment. I told him he would survive all right. In fact he was

the greatest survivor of all time.

When Nixon paid his first visit to London after his election, Henry asked me to meet the President for breakfast at Claridges on the first day before his official engagements began. I accepted with some misgiving and was less confident than usual when I entered the presidential suite. In fact, however, it was the President who was the more nervous; he was literally sweating with anxiety. He must have been one of the most insecure personalities who ever held high office.

Both my ministerial jobs brought me into close contact with American leaders. As Secretary for Defence I had Bob McNamara as my American

Henry Kissinger

colleague for several years, and later worked closely with him as Chancellor when he was Managing Director of the World Bank. He is a man of quite exceptional energy, with a mind like a computer. But like so many people who find themselves involved in occupations which use numbers, he is liable to think that things you can count are more important than things you cannot count. This is rarely the case.

Though his obsession with statistics often led him astray when he was at the Pentagon, his passionate dedication to the abolition of international poverty has made him a most effective champion of the Third World in his present job. His successor as Secretary for Defence was Clark Clifford, the only Whig Duke still alive and living in Washington. It was Clark Clifford who managed Harry Truman's election campaign in 1948, and won against all the odds. He did more than anyone else to persuade President Johnson that the Vietnam War must be brought to an end, and is still an active background figure in Democratic Party politics, as well as a brilliantly successful lawyer. No one knows better than he where every body in Washington is buried.

After President Carter's election he told me that of all Presidents he had known, Carter was by far the cleverest. I could believe this after meeting him at several summit conferences. Besides having total mastery of his brief he was firm, courteous, and if necessary deadly in argument. President Ford, too, was far more effective at close quarters than the media led you to expect. A man of great decency and common sense, unlike some American politicians he was more convincing when he spoke off the cuff than when he was reading a brief.

The summit conference at Puerto Rico in 1976 was an odd affair, clearly directed more towards the impending presidential election in the United States than to the world economic problems it was supposed to tackle. It took place in a luxury holiday centre under the Caribbean palms. We were all put up in separate bungalows and went to the meetings in little electric beach buggies, always accompanied by American secret servicemen with revolvers and walkie-talkies. The Bonn Summit in 1979 was altogether more workmanlike, well prepared and ably conducted by Helmut Schmidt.

Some of my best friends in Washington have been the unsuccessful Democratic candidates for the Presidency. Hubert Humphrey was a man of enormous vitality, his volubility a legend. Even after the traumatic experience of being Vice-President to Johnson, he remained head and shoulders above nearly all his colleagues in the Senate for his knowledge and wisdom in world affairs. Of all Democratic politicians he was closest in his general thinking to the British Labour Party. He remained to the end an enthusiastic campaigner. Shortly before his tragic death from cancer we met at a conference in Ditchley, and took a night off to see *Romeo and Juliet*

at Stratford-upon-Avon. The moment he entered the theatre a rustle went round the American tourists in the audience and they began turning to look at him. He immediately left his seat and walked all over the theatre pressing the flesh until the lights went down.

Adlai Stevenson, though in some respects a more impressive figure, had an all too apparent ambivalence towards his political career. I went to see him at his hotel in New York when he was American representative at the United Nations and quoted to him the diatribe against platonic love written by the cavalier poet John Cleveland three hundred years ago:

> For shame thou everlasting wooer,
> Still saying grace, and ne'er fall to her!
> Love that's in contemplation placed
> Is Venus drawn but to the waist.
> Unless your flame confess its gender,
> And your parley cause surrender,
> Y'are Salamanders of a cold desire,
> That live untouched amidst the hottest fire

Adlai recognised himself well enough in the description and I was able to find a copy of Cleveland's poems to send to him shortly before he died.

George McGovern was another attractive Democrat who failed to become President. A happy accident led Edna and me to bring him together with Shirley MacLaine for the first time after the election in which she had worked hard for him. We had invited her to supper at No. 11 Downing Street after her incandescent solo performance at the Palladium. George was in town at the same time and was able to join us. Shirley MacLaine's day only begins when she has finished her evening performance. She left us at four in the morning, giving me only an hour or two for sleep before an unusually heavy Cabinet.

Dean Rusk, who was Secretary of State to Ken-

Edna and Bob McNamara on the Bosphorus

73

nedy and Johnson during the worst of the Vietnam tragedy, was much undervalued by the press, mainly, I think, because he saw his job not as a Minister making foreign policy but as an official carrying out the President's wishes in world affairs. Tall, erect, with a controlled but humorous face, he had natural dignity as an American at a time when many of his contemporaries tended either to deprecate America's inexperience or to carry a chip on their shoulder. He started as a poor boy in Alabama and joined the State Department soon after his war service, when I first met him.

Long before he became Secretary of State or head of the Rockefeller Foundation, when he was a middle-

Hubert Humphrey

Jimmy Carter at the Bonn Summit, 1979

rank official at Foggy Bottom, he told me a story about the end of the war in Asia, when he was a colonel in Intelligence in India. The American Army found itself responsible for Indochina without the slightest idea what was American policy on the area, so they cabled Washington to find out. After days of waiting they received a reply — as usual COSMIC — TOP SECRET — BURN BEFORE READING. After deciphering, the message ran as follows: 'In answer to your cable, we attach the latest definition of American policy on Indochina.' Appended was an extract from President Truman's press conference the previous day:

> *Reporter:* 'Could you tell us, Mr President, what is American policy on Indochina?'
> *President Truman:* 'I just don't want to hear any more about Indochina!'

A prophetic tale, especially from Dean Rusk at that time. As Chancellor of the Exchequer, I made a point of knowing not only my ministerial colleagues

The Puerto Rico Summit, 1976: Valéry Giscard d'Estaing, Takeo Miki, Helmut Schmidt, Gerald Ford, Jim Callaghan, Pierre Trudeau and Aldo Moro

in other countries, but also their top officials and central bankers — particularly those from the leading industrial nations, America, Japan, Germany, France and Italy, since we used to meet apart from the others once or twice a year to discuss the major economic problems of the world. The meetings were theoretically secret but usually leaked out, to the annoyance of the countries not invited. Indeed on one occasion President Carter himself was responsible for the leak since he asked Secretary Blumenthal what had happened at one of them just before his weekly press conference. By accident the microphones were already switched on, and the White House published their conversation as part of the record.

In France we used to meet either in a château made available for the purpose or in the Prime Minister's weekend residence, 'La Lanterne', in the grounds of Versailles. I reminded my colleagues of the Popular Front version of the French Revolutionary song 'La Carmagnole'. The refrain ran:

Ça ira, ça ira, ça ira, ça ira,
Tous les fascistes à la lanterne
Dansons la Carmagnole, vive le son du canon.

In Washington under President Nixon, we met on his presidential yacht, the *Sequoia*, on the Potomac. I took many pictures there of my colleagues — the Japanese Finance Minister, Fukuda, dubbed 'the

Welsh voluptuary' by one of my officials; Dr Arthur Burns, Chairman of the Federal Reserve, an Austrian Jew by birth but in appearance a crusty pipe-puffing cracker-barrel philosopher from the Middle West. Guido Carli and Paolo Baffi who succeeded him at the Bank of Italy were both true descendants of the Medici. Manfred Lahnstein, the leading German official when I left office, has a great future ahead of him. Still in his early forties, tall, stiff-backed and blond as a traditional Prussian, he is also relaxed and human. He plays the trombone in a jazz-band in his spare time, and football every Sunday.

Outside the United States I suppose most of my foreign political friends have been in Germany. I first met Willy Brandt just after the war when he returned from exile in Norway to Berlin. The Norwegian Labour paper *Arbeiderbladet* found itself unable to pay for foreign correspondents, so they asked me to do a weekly piece from London and Willy to do one from Berlin. His ceased as soon as he became Lord Mayor. Mine continued until 1964, by which time they were being taken by other newspapers of the Left in Belgium, Italy, Austria, Greece and the United States.

No postwar political leader has had so statuesque a grandeur as Willy Brandt; the photograph of him kneeling at the monument to the victims of the Warsaw ghetto is one of the great images of our time. But he has always had an uncertainty about his own role as a politician which reminds me a little of Stevenson. His personality — and that of social-democracy in general — is brilliantly described by his friend Günter Grass in that extraordinary novel *The Diary of a Snail*.

Brandt's successor as Chancellor of Germany, Helmut Schmidt, is a very different personality, although they work harmoniously together. Schmidt has been a close friend since the middle 1950s; we met one another and Henry Kissinger through our common interest in defence. He is a man of gargantuan energy and unusual vision as well as great political skill. The Labour Party Conference has never heard a better speech than the one on the Common Market he delivered in faultless English in December 1974. When he became Chancellor he invited Edna and me to his Sommerfest in the gardens of his official residence, the Palais Schaumburg. It is the German equivalent of a Buckingham Palace Garden Party — but with a difference. The atmosphere is of a village fête. Each of the Government Departments has its own side-show and stall, there are five or six dance floors, and innumerable bars. When the other guests had departed Helmut took us down to his bungalow near the Rhine where we spent several hours with some of his old friends from Hamburg. The Luftwaffe plane which had picked us up for the Sommerfest at Northolt at six in the evening took us back at eight o'clock the next morning for another hard day's work in the Treasury.

Helmut and I are both Knights of the select German Order against Political Pomposity — Wieder den Tierischen Ernst — an order established by the Aachen Carnival. My induction was a daunting experience. I turned up at four in the afternoon after a gruelling day visiting the British Army of the Rhine. For the next four hours I had to exchange witticisms in German over schnapps and a type of champagne

At Helmut Schmidt's Sommerfest

called Kalte Ente, 'cold goose'. At eight o'clock we went to a great dinner with about two thousand guests. After another four hours' drinking — this time with plenty to eat as well — I had to enter a golden cage on the platform with a jester's hat on my head and make a speech on television in German finishing with a song in the Aachen dialect. There was an audience of thirty million people, in the Low Countries as well as Germany. Drinking continued until four in the morning. At eleven next day we all met for a *Kater-frühstück* or 'hangover breakfast' of salt herring and beer. When I resumed my visit to the British Forces that afternoon my military hosts found me unusually subdued.

The picture of Marion Doenhoff was taken with a 100mm lens at one of the many Anglo-German Conferences which I attended at Königswinter. A long lens is ideal for isolating a single face among many. Countess Doenhoff is the leading lady of the German press and has been mentioned as a possible SPD candidate for the Presidency. When the war ended she escaped on horseback from her home in Prussia to the West.

As Chancellor of the Exchequer I saw a great deal of the French Prime Minister, Raymond Barre, who as a former Professor of Economics is himself mainly responsible for French economic policy. He is a man of great charm and humour with a calm impassivity under attack which must be the despair of his opponents. President Giscard chose him as Prime Minister although he had no background in French politics. Since he was unwilling to change his previous life-style he found himself continually pestered at his favourite restaurant by journalists or even members of the public who wanted his autograph. It is said that he finally asked his son, who worked as a make-up man for French television, to provide him with a suitable disguise. The next evening an unrecognisable Monsieur Barre went as usual to his restaurant and found himself even more beset by journalists and admirers than before. His son had

The Aachen Carnival

made him up to look exactly like one of the most popular French comedians.

My first encounter with Golda Meir was in 1947 when she was a leading American Zionist and still called herself Goldie Myerson. The Socialist International was meeting in Zurich just after the tragic incident of the *Exodus* — a boat full of Jewish refugees which had been stopped by the British Navy on its way to Palestine. My colleagues of the National Executive Committee found it convenient to be elsewhere, leaving me alone as a young man of twenty-nine to deal with one of the most formidable women in the world. I stood my ground as best I could, but she had a walkover. I took the photograph of her by window light when she was Prime Minister of Israel. It shows a softness in her character which was rarely apparent in her political life.

The Prime Minister of Singapore, Lee Kuan Yew, is an outstanding world statesman. He would be a natural candidate for head of any of the great international organisations if he were not by origin an overseas Chinese. He and his wife Choo were the

Raymond Barre

Lee Kuan Yew

Marion Doenhoff, editor of Die Zeit

Right, Golda Meir

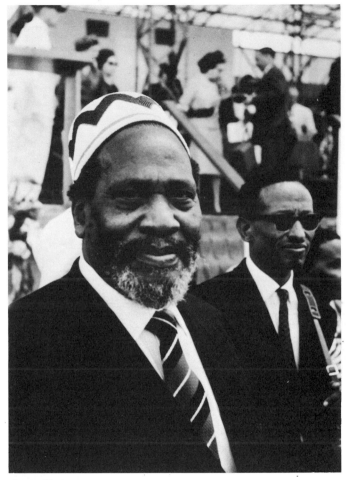

Jomo Kenyatta

celebrations for Uganda in 1962, when the ill-fated Milton Obote was installed as Prime Minister of the new state. Kenyatta's role during the Mau Mau rebellion led the High Commissioner at the time to describe him as 'a leader to darkness and death'. In fact under his leadership Kenya enjoyed a longer period of stability than any other African state has known. And contrary to many predictions, that stability has so far survived his death.

Of all the politicians I have met I think the most impressive was Chou En-lai. Edna and I had been invited to China in the spring of 1972, partly, I think, as a preparation for President Nixon's visit. We were not able to leave until October because I had to take over Roy Jenkins's vacant position as Labour Party spokesman on economic affairs.

In 1972 the Cultural Revolution was said to be in a phase of consolidation. In fact it was already being superseded by the much more liberal system we see today. Chairman Mao was still alive but only fitfully active in government. As Prime Minister, Chou En-lai was in charge of the country but he was obviously tired. I was given no time for meeting him in my programme but one evening after I had given a lecture to the Foreign Affairs Institute, I was told it would be convenient if I stayed in my hotel. At about half-past ten I was told that Prime Minister Chou would see me in the Great Hall of the Peoples off the main square in Peking. I arrived at eleven

With Chou En-lai

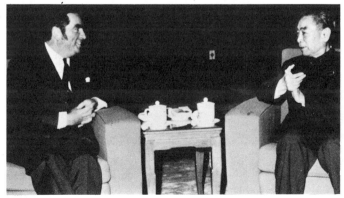

outstanding law students of their time at Cambridge after the war. Their son has followed their example. In my opinion it was Lee Kuan Yew's passionate advocacy of Commonwealth unity which turned the scale with Hugh Gaitskell and finally made him crystallise his position against British entry to the Common Market. As Defence Secretary in 1969 I had the unpleasant task of informing him that the British Cabinet had decided to withdraw our forces from Singapore altogether by 1971. He handled the resulting situation superbly and has made Singapore a model of economic progress and social welfare for the whole of South-East Asia.

I first met Jomo Kenyatta at the independence

o'clock precisely with Edna and the Ambassador and we began a conversation which lasted for four hours, with a short break in which he took medicine and we were served walnuts and candied fruits.

Small and wiry in physical appearance, he seemed recently to have suffered a stroke; his right hand was a little distorted and his speech a trifle slurred. But his mind was like a rapier and he was extraordinarily well informed about the very latest happenings in the Western world. He seemed deeply conscious of his age, referring to me as one of the young men who would later be taking over from his generation. It seemed incredible that he, like Mao, had been responsible for governing hundreds of millions of people for nearly fifty years, much of the time simultaneously engaged in fighting the Kuomintang or the Japanese. Born into a mandarin family, he had been a cadet at the Whampoa Military Academy with Chiang Kai-shek in the early 1920s. He spoke good French and German and quite passable English. Indeed the young woman who interpreted for him and had been educated in the United States did not hesitate to ask him when she was at a loss for a word — and she showed none of the embarrassment which an interpreter in the British Foreign Office would have shown in doing so.

Aneurin Bevan, taken shortly before his death

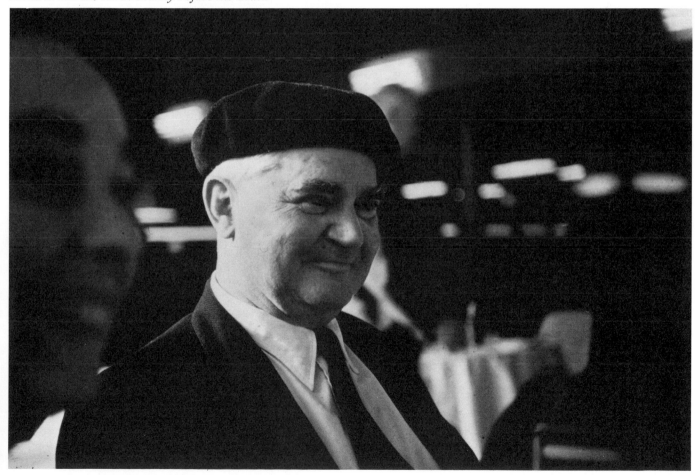

5 The Cradle of Europe

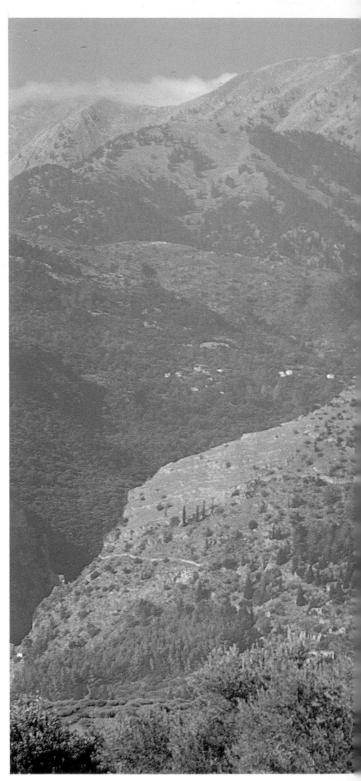

The lands bordering the Eastern Mediterranean are the cradle of Western civilisation as we know it. We got our religious faiths from Palestine, but the birthplace of our culture and philosophy is the Aegean Sea — not just the mainland of Greece, but the islands and the coast of what is now called Turkey. People say that the crystalline clarity of the light helped the ancient Greeks to think more clearly; it is not always such a boon to the photographer. The contrast between light and shade is sometimes too great for colour film, and there is none of the haze or mist which helps to create a sense of distance and three-dimensional reality in Northern Europe. The beauty of the area, natural and man-made, presents a constant challenge to your camera.

Nine years after my first visit to Greece as a student, I went back soon after the war to report on the Greek Socialist movement for the Socialist International. I went again in the late 1950s. The country had changed greatly in the interval. When I went to Delphi as a student I had to walk for a day through the mountains to reach the Byzantine monastery of Osios Lukas and then walk for another day to catch a bus at Levadia back to Athens. Now you can get to the monastery from Delphi on a first-class road in a few minutes. But the glowing colours of the mosaics still hold the same mystery as when they were made nearly two thousand years ago. Another twenty years passed before Edna and I made our latest visit in 1979. By this time the main cities were linked by fast motorways and there was a network of cheap air flights to take you almost anywhere.

When the painter Edward Lear first saw the Acropolis a hundred and fifty years ago it rose lonely

Mistra, 1979

82

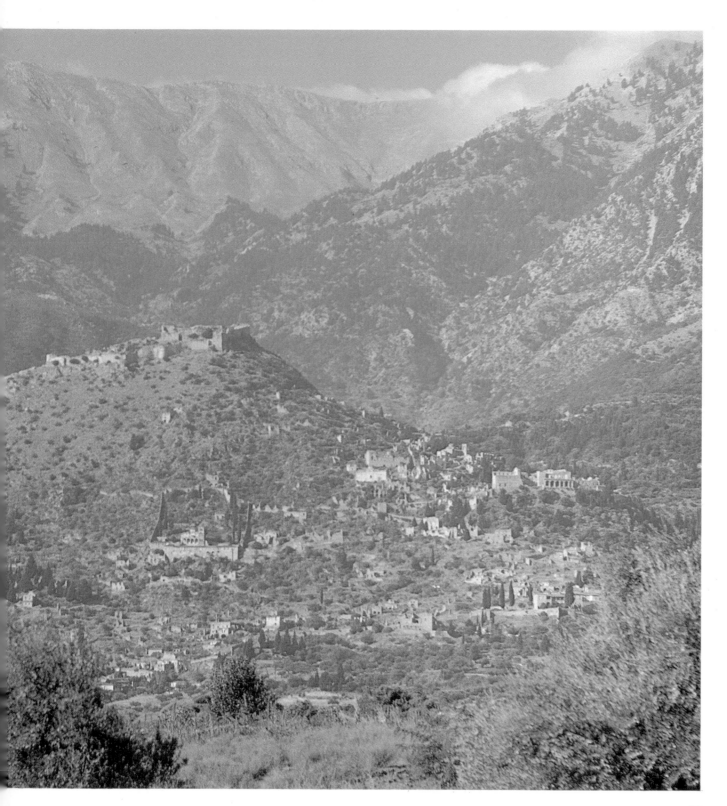

from the plain with only a small Turkish village at its foot. Athens is now a great metropolis plagued by the noise and fumes of exceptionally heavy traffic. Even the lovely old Plaka quarter just below the Acropolis has had much of its charm destroyed by garish neon-lit night-clubs and boutiques. But the Parthenon preserves its virginal purity even though its honey-coloured columns are beginning to rot under the corroding attack of sulphur dioxide — 150,000 tons a year falls on the city.

The Archaeological Museum is of stupendous quality, recently enriched by newly discovered frescoes from a buried city on Santorin which surpass even those at the Palace of Minos in Crete. But to get some sense of Greece as it was in classical times you have to travel outside Athens to the lonely temples at Sounion, Aegina or Bassae, or use your imagination in the ruins of Mycenae, Olympia or Delos. It is difficult nowadays to accept that the Elgin marbles were originally painted in bright realistic colours.

The classical remains are only part of Greece's historical heritage. It was also of course a centre of Byzantine culture, and then became part of the Venetian Empire before it fell under the control of the Turks. Little is left today of ancient Sparta, the first totalitarian state in history. It produced no culture. But on a craggy hill just outside the modern town are the remains of the ancient Byzantine city of Mistra. Though the citadel and most of the houses are in ruins the many monasteries are perfectly preserved,

The Venetian fort at Methoni

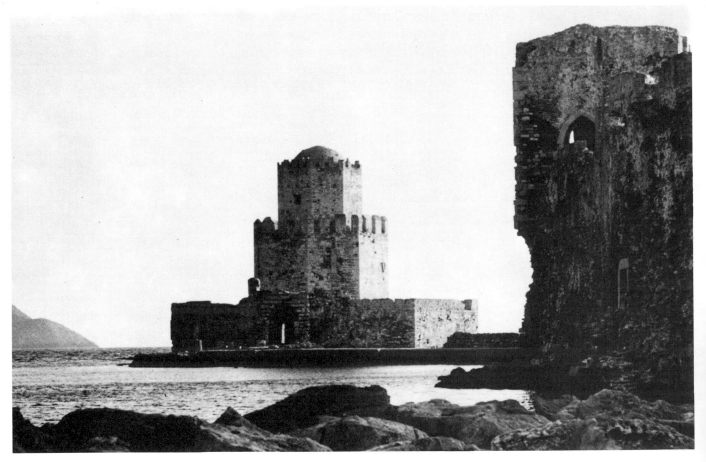

Sorting currants near Olympia, 1979

some like the convent of Pantanassa still occupied and in use.

Edna and I travelled from Mistra by car over Mount Taygetos in a couple of hours where it had taken me a long day of strenuous walking as a boy. At the top of the pass you could be in an Alpine forest. We bought a basket made of fir cones from a rosy-cheeked peasant there.

In the south-west corner of the Peloponnese we visited two architectural jewels, the ports of Koroni and Methoni where the Venetians built great forts to protect their ships as they rounded the end of the peninsula. We stayed at Pylos on the bay of Navarino where, in 1827, Admiral Codrington destroyed the whole of the Turkish fleet in the last great naval engagement fought between wooden sailing ships. Facing us across the sparkling water was the long low island of Sphacteria where a force of Spartans was wiped out during the Peloponnesian war.

It was harvest time. The grapes were being gathered everywhere, the currants laid out to dry. When I stopped to photograph a family sorting their currants in a great wooden machine they worked by hand, they pressed a great bag on us. The Greeks are among the most hospitable people in the world. They are not the greatest cooks; but you can live well enough on Souvlaki from the wayside stalls — chunks of veal spiced and roasted over charcoal on

85

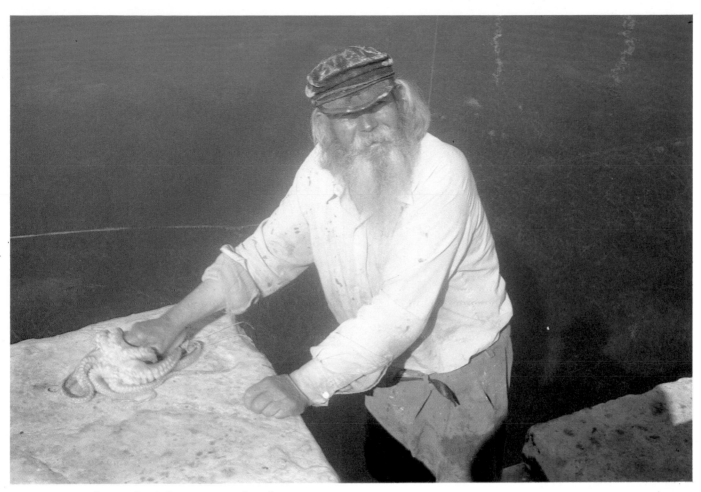

Left, *Koroni*; above, *the fisherman in Zakynthos*

long skewers of bamboo. And the seafood is excellent, particularly swordfish steaks and octopus. I took a picture of an old fisherman in Zakynthos scrubbing an octopus he had just caught against the stone of the quayside to tenderise its flesh.

Even the age of mass tourism had left the islands of Mykonos and Santorin almost as beautiful as I remembered them from forty years earlier. Mykonos has now become the most fashionable of all the islands. Its narrow alleyways are full of boutiques and jewellers who specialise in gold. It has its fair share of topless beaches and nudists. But the islanders have insisted on preserving the character of the town. There has been almost no new building. The

walls of the houses are whitewashed regularly and the doors and windows painted in bright colours. The old women sit out in their black cotton dresses and knit or gossip as the children play and the men work. And how they work! We stayed at a small hotel run by a handsome lady called Maria whose husband was up from dawn to dusk in his bakery next door. Her son-in-law, Petros, did the accounts and acted as cashier at a restaurant near by. These were his spare time jobs. He worked all day as an electrical engineer at the local power station. We arrived in Mykonos just as the sun was rising over the Cyclades. As we drove into the town from the airstrip I stopped to take a picture from the hill

Petros

above. The light was pearly and luminous. You could easily pick out the villages on the mountains of Naxos miles away across the still sea. A row of windmills stood guard above the fort. It was a scene of magical serenity.

By contrast, we flew into Santorin as the sun was setting. It is one of the most extraordinary sights in the world. The island is the rim of the crater of a drowned volcano which sank beneath the sea three thousand years ago. The capital town, Phira, runs along the edge of the crater seven hundred feet directly above the sea. The central cone of the volcano, which is still active, lies flat like a black mushroom in the middle of the bay. Earthquakes are frequent and eruptions possible at any time. Archaeologists are now accumulating evidence to suggest that Santorin may have been the lost city of Atlantis

described by Plato. It seems almost certain that the ancient civilisation of Crete seventy miles away was buried in the ash thrown up by the eruption of the volcano in Santorin in about 1500 BC. The ruins of the town of Akrotiri on the south of the island are now being painstakingly excavated under cover; in ten years' time they will rival those of Pompeii.

Edna found the island peculiarly disturbing, particularly the night we arrived. We watched the sun set across the dark bay far below us. It was like Dante's *Inferno*. Appropriately enough the strains of Strauss's 'Death and Transfiguration' floated out of the boutique behind us as we sipped our ouzo. The American wife of the Greek painter who ran our pension told us that it is normal for women who visit the island to have bad dreams. Some have found it necessary to leave after a few weeks' stay. Ghosts are often seen by peasants working in the fields at night.

Whitewashing the houses

The Aegean coast of Turkey is covered with the ruins of the ancient Greek civilisation. Indeed well over a million Greeks were still living there until 1924 when they were brutally expelled. But once you get to the interior or to Istanbul, there is no doubt you are in Asia. My work as Defence Secretary took me to Ankara for a meeting of NATO's Nuclear Planning Group, where I had to criticise Bob McNamara for his U-turn the day before on the anti-ballistic missile. Most of Ankara is a new-built capital city of no great distinction, but on a crag dominating the city there is an interesting old town. I bought a shepherd's pipe there for Tim — as I walked through the alleyways I practised playing on it and a growing crowd of little children followed behind. Photographs of this unexpected reappear-ance of the Pied Piper of Hamelin appeared in all the Turkish newspapers next day over the title 'Halk

Adamu' — Man of the People.

The old capital of Turkey, Istanbul, on the other hand is packed with interest for your camera, from the churches of ancient Byzantium to the Topkapi Palace overlooking the Bosphorus where Peter Ustinov and Melina Mercouri tried to steal the treas-ure. Since we were representing NATO, the Turkish Government arranged a full turn-out of the old im-perial band in costumes and armour dating from Renaissance times — you can see them in paintings by Bellini and Piero della Francesca. The fishing villages along the Bosphorus are no less attractive in their own way, as the fishermen land their catches and their wives mend the multi-coloured nets on the quayside.

For two thousand five hundred years Greece and Turkey have been in conflict with one another. Today the lovely island of Cyprus is at once the

Mykonos

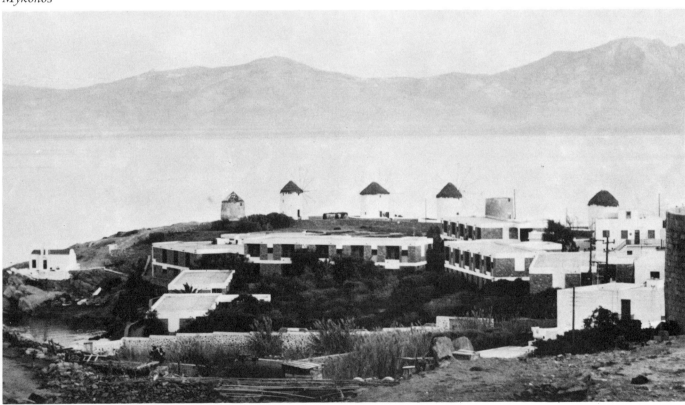

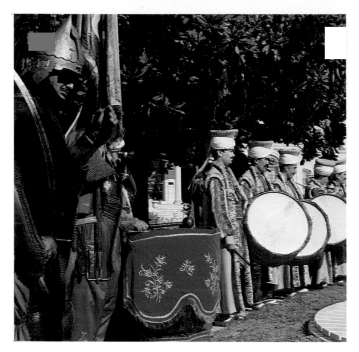

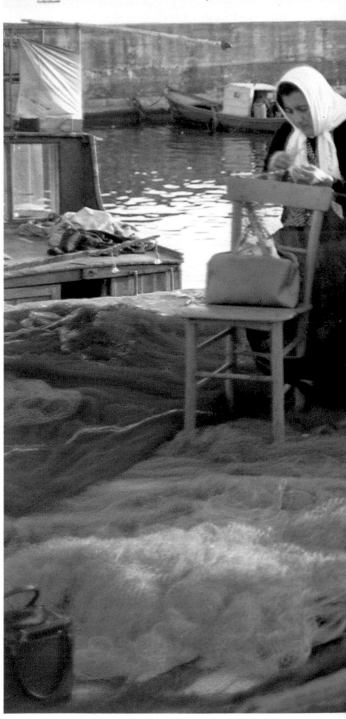

The imperial band, Istanbul; right, mending nets at Tarabya on the Bosphorus; below, in Cyprus

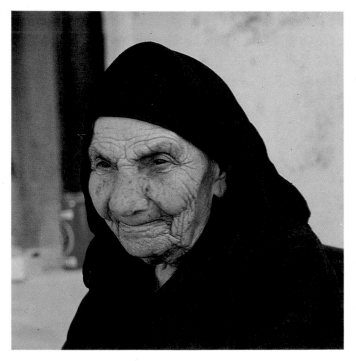

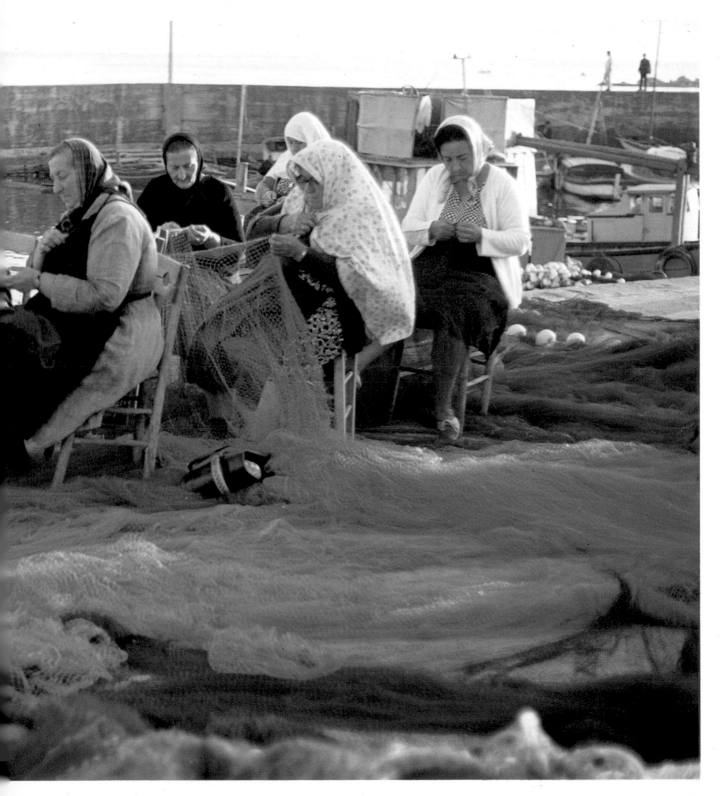

symbol and the object of their rivalry. I made many visits as Defence Secretary since Cyprus was an important British base, and we were involved in the conflict there whether we liked it or not. The Commander of the United Nations Forces at the time was Brigadier Mike Harbottle, who was responsible to the UN Secretary General and not to me. Tall, dark and wickedly handsome, he was too spirited for some of my more conventional advisers. But he showed immense skill not only in moulding soldiers from many countries into a single corps, but also in mediating in the innumerable quarrels between Turks and Greeks. After leaving Cyprus he became the security officer for the United Diamond Trust in Sierra Leone and had a leather bag full of diamonds snatched from his neck when he was delivering it to an aircraft. Legal proceedings ceased when it was discovered that the Government itself was behind the hijack.

As befits the island where Aphrodite was born from the foam of the sea, Cyprus is a lovely place. You can ski in the mountains and bathe in the sea on the same afternoon. The northern coast round Kyrenia, with the castle of Hilarion and the monastery of Bellapaix, is as beautiful as any in the world. But as in Northern Ireland, politics, nationalism and religion combine to tear it apart.

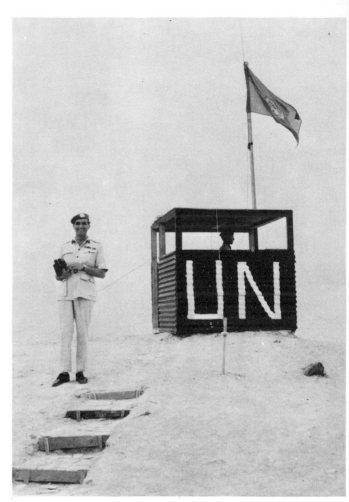

Mike Harbottle

6 Small Is Beautiful

Norway has always fascinated me politically because it is the modern equivalent of a Greek city state. Problems which worry us in Britain are reproduced there as in a crystal, with a clarity and precision we rarely know at home. In 1952, for example, the Norwegian Labour Party faced exactly the same problem as ours — a conflict on defence expenditure between a right-wing and a left-wing Minister. In Britain we had ten years of continuous agony as a result. In Norway the Prime Minister simply sacked both Ministers. One of my Norwegian friends used to tell me that if his country had had another hundred men at the Battle of Stamford Bridge half the world would now be talking Norwegian.

With a population of only four million strung out over a thousand miles of rugged coast, Norway has produced one of the greatest painters of our century in Edvard Munch and one of the greatest dramatists of all time in Henrik Ibsen. I went there for a weekend as Defence Secretary to visit the military installations in the north, flying low over the icy mountains or swooping over herds of reindeer on the frozen tundra. In the Mayor's house in Tromsö close to the Arctic Circle, stuffed with Victorian furniture and dripping with aspidistras, where Oslo was as much a distant paradise as Moscow for Chekhov's country gentry, you could feel the claustrophobia which produced Nora's rebellion in *The Doll's House*.

Ten years later Edna and I went again to Norway on a coastal steamer from Bergen to Kirkenes on the Soviet frontier. Edna was writing her book on Angela Burdett-Coutts and was anxious to pick up traces of Louis Philippe, the nineteenth-century

The cliffs of Tromsö

93

King Louis Philippe

the spring creates immense psychological strain. That is the season of suicides and nervous breakdowns.

> Oh dreadful is the check, intense the agony
> When the ear begins to hear and the eye begins
> to see;
> When the pulse begins to throb, the brain to
> think again
> The soul to feel the flesh and the flesh to feel the
> chain!

<div align="right">Emily Brontë</div>

Just so the sudden ending of a dictatorship can strain the social fabric to breaking point, as France and Iran

A Lapp, near the North Cape

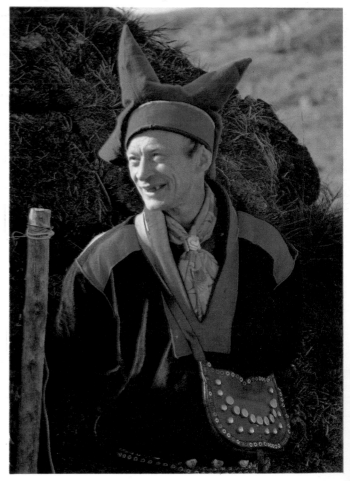

King of France, who spent a period of exile in his youth after the French Revolution travelling round Lapland. We finally succeeded, in the most improbable setting of the North Cape — a great black mountain of rock which rises perpendicular from the Arctic Ocean and is the northernmost point of land in Europe. Louis Philippe had in fact landed there during a journey in which he got a local innkeeper's daughter with child.

When he became King of France he sent a frigate round the Norwegian coast to drop in marble busts of himself as a memento wherever he had been entertained; signed photographs are simpler nowadays. We found such a bust in a little stone shrine looking straight at the North Pole, its plump white features disfigured by a blue beard, a hammer and sickle scrawled on the lapel.

People in this part of Norway have to live in the dark for the winter months without once seeing the sun. You can learn fairly quickly to adapt to the darkness at noon; but the transition to daylight in

have both seen in their time.

Further south, Holland is another example of the beauty of being small. One of the most enjoyable journeys my wife and I ever made was round the Ijsselmeer or Zuider Zee in the Netherlands. The grass was shining green, the sky a powdery blue with a handful of tiny white clouds, the buds bursting on the trees with here and there an explosion of blossom. We remember Sloten in particular — calves wandering on the grass in front of incredibly spruce little houses, a windmill turning lazily above the blue canal, everything fresh and clean like a child's picture book.

Below and right, *Vollendam*

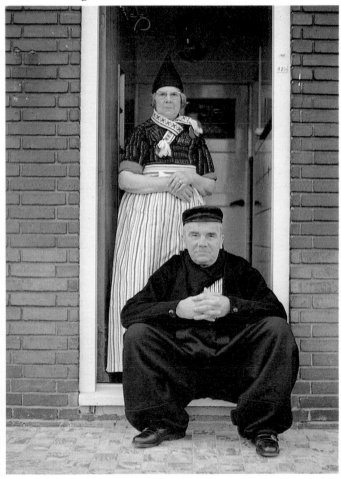

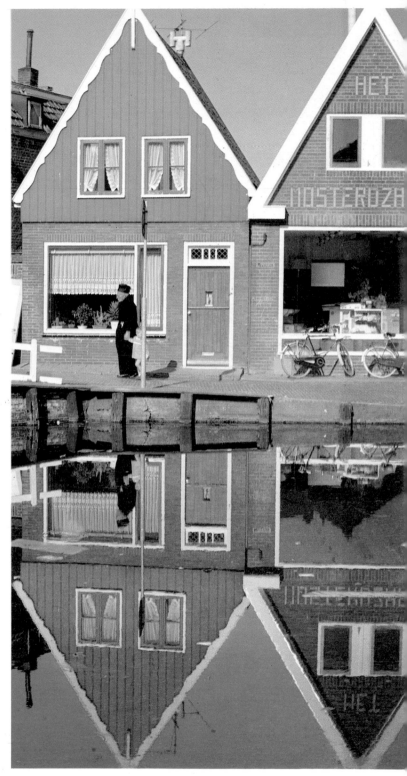

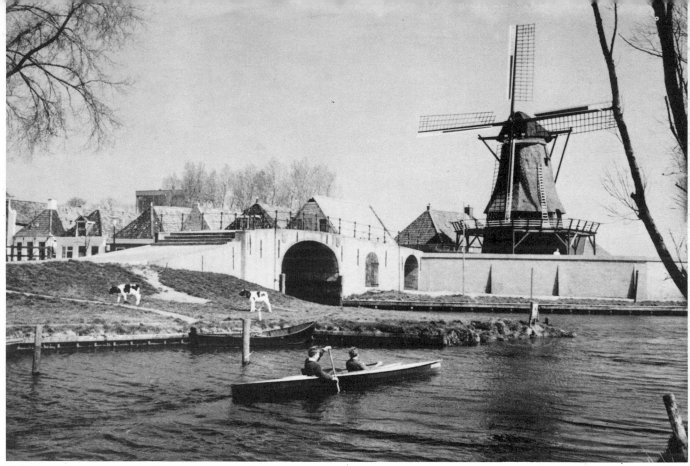

Sloten

Holland has much in common with Norway besides its size. The unyielding tenacity with which it has defended its independence over so many years is reflected in the extraordinary toughness with which the local communities inside Holland have defended themselves against national uniformity. Every village round the Zuider Zee has its own local costume, still worn on weekdays as well as Sundays. One little village, Staphorst, carries xenophobia to the point of stoning intruders from other villages. Some of them, like Urk, were islands until quite recently when land reclamation joined them up to the surrounding polders.

This fragmentation extends also to politics, where religious bigotry still plays an important role. At the first general election after the war the Dutch hierarchy threatened to excommunicate Roman Cath-olics who voted for the new Labour Party, although it had just forsworn Marxist materialism; centuries after the sectarian quarrels which gave birth to them have disappeared, the Anti-Revolutionary Party and the Christian Historical Party get their candidates elected to Parliament.

Holland, like the Scandinavian countries, has created a fascinating open air folk museum where you can see all the animals and buildings most typical of the country in natural surroundings, the interiors appropriately furnished. In Oslo the buildings are also inhabited by people in their local costumes engaged in the traditional crafts. This is not necessary in the Dutch Folk Museum at Arnhem, since all the costumes can be seen in rèal life within a day's drive.

A De Hooch courtyard in the town of Urk

7 The New World

I first visited the United States in 1947 after attending a Commonwealth Conference in Canada with Rab Butler. Since then I have been there at least once a year when out of office, financing myself by lecturing at universities and foreign affairs clubs. As a Minister, of course, I went as often as three times a year. But I had few opportunities for photography except in New York and Washington, so my pictures reflect little of the continent's natural beauty.

I had many American friends at Oxford before the war, some of whom, like television commentator Howard K. Smith and Presidential adviser Walt Rostow, I met later in my political life as well.

America is above all a land of contrasts — contrasts of scenery, of peoples and of climates. In the eastern states in spring or in the fall you can have three weeks of hot Mediterranean weather followed by four feet of snow. A few yards from the leafy grace of Greenwich Village you are in the Bowery, still perhaps the most squalid part of any Western city.

I like to search out remnants of history wherever I go in the United States, from the eighteenth-century Georgian squares north of Boston Common to colonial Williamsburg, perfectly preserved as it was three hundred years ago thanks to the Rockefeller family, where the local people still wear colonial dress and as far as possible carry on the trades of their ancestors. At Fort Kearney in Nebraska, the geographical centre of the United States, you can visit the fort of turf and timber which protected the pioneers' wagon trains from Indian attack. And in the shade of the modern city hall in Los Angeles they have preserved one street as it was in the days of Spanish rule.

Recent American history is still very close in the United States and recent European history very far away indeed. The Civil War is a living reality in the Southern states; the Crimean War is forgotten. To people in St Joseph, Missouri, Jesse James was shot only the other day, but they forget that Oscar Wilde was speaking there a week later. 'The night before Christmas' is a still a favourite American song but few Americans know that its author, Clement Moore, was the patron of Mozart's librettist, da Ponte, when he came penniless to the United States.

For me the most stimulating part of the world is the great complex of colleges and universities in Cambridge, Massachusetts, across the river from Boston. It was there that I first met both Henry Kissinger and his successor Zbig Brzezinski. It is there that I remember Ken Galbraith and Arthur Schlesinger laying the foundations for the thinking of the Kennedy years. In 1979 I met them again in New York where Arthur had recently bought a house which by accident backed on to both David Rockefeller and Richard Nixon. Although they are ten years apart in age, he and Ken Galbraith were celebrating a common birthday amid the diverse aristocracy of American Liberalism — Jimmy Wechsler, almost the only American ex-Communist with the courage to stand up to McCarthy, Lauren Bacall, Jackie Onassis and Washington's three leading political hostesses. Leonard Bernstein had written them a canon on the words History, Economy. I fear they made a total botch of singing it when he sat down at the piano.

Many of my best friends in New York have been members of the Jewish intellectual mafia, who were brought up by Sidney Hook as tough social democrats and won their literary spurs writing for the *New Leader* or *Socialist Commentary*. Many of them have drifted steadily to the Right over the years, partly, perhaps, because the physical threat to Israel, which embodied so many of their early ideals, introduced them to the seductive temptations of power politics. It was Danny Bell, founder of the concept of

the post-industrial society, who took me to what was for years my favourite restaurant in New York, the Chinese Rathskeller. One September I went to visit it again and found the whole block had been taken away and replaced since my previous visit.

For a photographer the skyscrapers have inexhaustible attraction; but they present many problems. Because your mind knows that the walls of skyscrapers run parallel up to the sky, you do not notice how perspective makes them converge because the top is so much further away than the bottom. This convergence is unavoidable when you photograph them from the ground. Sometimes you can make a virtue of this necessity. But if you really want the walls to appear parallel, you have to photograph them with a long lens from some distance away. The great American photographer Lionel Feininger photographs New York from across the river in New Jersey using a very long lens indeed. You get the same impression that the walls are converging, of course, when you photograph a skyscraper from the top looking down, and this can sometimes produce photographs of great drama. But it is worth remembering the basic principle that it is often better to photograph part than a whole, because the imagination will fill in what the lens does not record.

Skyscrapers are most beautiful at dusk when the windows are lit up in differing colours and patterns and their outline is still visible against a luminous sky. Base your exposure on the brightness of the

Colonial Williamsburg, Virginia

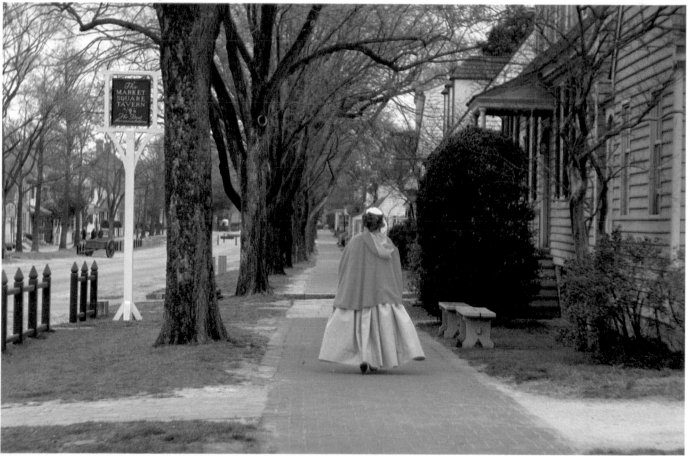

Left, *highrise window-cleaning;* above, *Park Avenue, New York, from the Waldorf Hotel by day and by night*

rooms or the meter will present you with a photograph which is far too light in colour.

The western parts of Washington make it visually the most attractive capital city in the world, particularly where the great park runs along the Potomac from the Lincoln Memorial to the Capitol. It is beautiful in the fall when 'nature's got his tragic buskin on' and early frosts have turned the trees to gold and crimson. But it is most beautiful of all at Easter when Tidal Basin is a sea of cherry blossom and the Japanese come from all over the United States to admire it.

The British Embassy on Massachusetts Avenue beyond Rock Creek was well designed by Lutyens before the war and has a particularly lovely garden in which sculptures by Henry Moore, Barbara Hepworth, and Elizabeth Frink set off the foaming azaleas in the spring. I once arrived from the airport when the Ambassador was presenting the great pianist Horowitz with a medal from his British admirers in front of a glittering audience. The old man was overcome by emotion and said he would express his thanks in the only way he knew. He sat down at the piano. We all waited in rapture, expecting at least one of the more brilliant Chopin Études. He played one verse of 'God Save the Queen' and that was that.

San Francisco is the most attractive of all American cities to live in, at any rate for a European. I used to stay on a street sloping steeply down to the Bay with its prison island of Alcatraz — a scene familiar to all film-goers since *Bullitt* and *Point Blank*. My host, philosopher and friend in the city was Paul Jacobs, a radical anti-establishment journalist who at various times worked for the British *Economist*, *Playboy* magazine, and a journal of the New Left called *Mother Jones*. My children loved him when he stayed with us in London because he wore space boots and went to bed in a strait-jacket sold by *Mad* magazine. He gave me one of the best meals I have ever had in America — Hangtown Fry and delectable little Olympia oysters at Tadich's Bar. His wife Ruth

was lawyer for the condemned murderer Caryl Chessman who was finally executed after many years of waiting in the death cell for his appeals to be heard. Paul and his wife died of cancer within a few months of one another in the late 1970s.

My last visit to San Francisco was in 1966, when I went round the world in ten days to explain the decisions of our Defence Review to all the Governments concerned. Our RAF Britannia broke down there and because the Consul General was waiting for the Prince of Wales to arrive we all stayed in a hotel downtown. The hotel notice board announced a performance that evening by a Mrs Spiegelbaum, 'The Only Topless Mother of Eight'. Unfortunately we were too tired to see this prodigy.

The White House, from the Lafayette Memorial

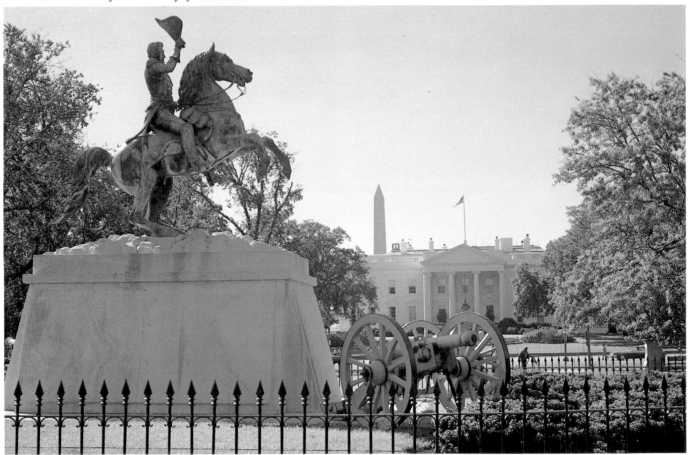

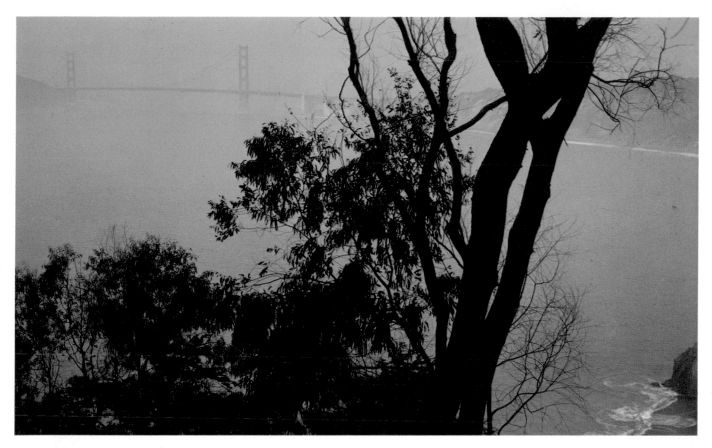

The Golden Gate Bridge, San Francisco

Los Angeles is far less attractive than its northern rival. It is still a hundred suburbs in search of a city, and in the years when I used to go there it suffered appallingly from smog which made breathing painful from ten in the morning until six in the afternoon. But between Los Angeles and San Francisco is some of the most beautiful country in the United States, particularly the Monterey peninsula, made famous by John Steinbeck's stories. When I spent a weekend there for a conference one spring, the ground was covered with millions of brightly coloured asters, the air was like iced wine, and you could watch a colony of seals disporting themselves in the dark blue sea.

I have seen little of the Southern states apart from a couple of visits to Atlanta, Georgia, where I could see the progress which was made in fighting racial segregation when Jimmy Carter was Governor. My first visit to Atlanta was after a conference on St Simon's Island in 1957 when the Suez affair was just over. Some of the Americans present were criticising the British for not carrying the operations through to a successful conclusion. Their attitude to the Arabs was like their attitude to the blacks in their own country. They were superbly answered by a languid British Air Marshal, Sir William Elliot; he told the story of one of his Egyptian friends who, when asked how he spent his afternoons in London, replied, 'Oh, I just sit in the window of Claridges and watch the natives passing by.'

As Chancellor of the Exchequer I went to the West Indies several times for meetings of the Com-

monwealth Finance Ministers. There the physical beauty of the islands and their inhabitants is tainted by the contrast between the luxury in which the white tourists live and the squalor of many of the towns. But the coast is spectacular, the dark green of the palms contrasting vividly with the dazzling white sand and the pale fiery turquoise of the sea itself.

In Jamaica I met an old friend from Oxford days, Henry Fowler, who produces the great annual pantomime in Kingstown, an extraordinary mixture of song, dance and political satire based on the true story of the 'White Witch' who was a slave owner in the nineteenth century.

Georgetown, the capital of Guyana, is more beautiful than most West Indian cities since it was laid out by Dutch designers with broad and orderly boulevards running along canals. The ditches are choked with blue lotus and with lily pads so large that a child can stand on them without risk of drowning. A lake in the main park has a colony of Manatees — weird amphibian animals which are supposed to have inspired seamen's talk of mermaids.

We made an attempt in Guyana to see the Falls at Kaietur, which are the highest in the world but very difficult to reach except by light aircraft. On the day we flew there, the weather was too bad for us even to see them from the air, still less to land. One of my officials still talks with horror of the experience.

At the end of our conference Prime Minister Burnham provided us with a magnificent open air buffet on the main dock in the harbour. There were steel bands and more rum punch and John Collinses than I have ever imagined. Some of the delegates fell into the river during the boat trip which followed; but Guyanese hospitality seemed to have given them charmed lives.

Barbados

8 Behind the Iron Curtain

As International Secretary of the Labour Party I went a good deal to Eastern Europe in the first five years after the war, when the Socialist parties were fighting hopelessly for survival. It was not a time for photography. I returned to Poland in 1959 in happier circumstances soon after Gomulka had asserted his independence of the Soviet Union. The country was in a ferment of cultural freedom, although the political situation was still tightly controlled by the Polish Communist Party. Blood is far thicker than water in Poland. During a visit to the medieval capital, Cracow, I went to a concert given by the pianist Malcuzynski, to celebrate the return of the crown jewels to the old royal castle of Wawel. Under the tattered banners of forgotten wars sat the three aristocracies of modern Poland — the ancient nobility, the new Communist elite, and the Catholic hierarchy. They dissolved in tears together as, hectic with influenza, Malcuzynski played the great heroic Polonaises.

I went one day from Cracow to the concentration camp at Auschwitz, which has been preserved in its wartime state. Walking round those deserted barracks in the snow was the most searing experience of my life. The horror of Auschwitz tells you something not about the Germans — indeed some of its first inmates were German anti-Nazis — but about man's capacity for inhumanity to man. The most moving thing in Auschwitz is not the piles of human hair and teeth which were taken from the corpses in the gas chambers to contribute to the Nazi war effort. It is wall upon wall of identity photographs of all the men, women and children who died there, as they were before arrest.

The same year I went to the Soviet Union with Hugh Gaitskell, Nye Bevan and David Ennals, then my successor as International Secretary of the Labour Party. Although Krushchev was then sitting in Stalin's chair, Stalinism lingered on in a thousand ways. One was always conscious of the omnipresence of the secret police. The poor quality and lack of variety in the shops reminded me of Western Europe in 1945. Women wore their hair either in a bun or in the shingle which had been popular in Britain twenty years before. Clothing was drab and shoddy. When I returned only four years later the clothes were bright and varied, the women were experimenting with the latest Western hairstyles, and some of my Russian friends talked with a freedom inconceivable in 1959. In later visits I found the women wearing costume jewellery and angora hats, and the great new shopping streets could have been transplanted from Birmingham or Chicago.

On every visit my most vivid impression was of the warm emotional nature of the Russian people. Edna found it difficult to engage in conversation with a Russian woman for more than a few minutes without the lady dissolving into tears on her shoulder, not from sorrow but from depth of feeling. The children in the schools we visited — I suspect they were mainly for the sons and daughters of top party functionaries — were straight out of a novel by Turgenev. In 1959 jazz was immensely popular with the young, but was played in public only as background for the clowns in a variety show or circus act. But even then we were surprised to find a chorus of semi-naked ladies prancing on the stage in ostrich plumes. If you stood for long in the Red Square you were liable to be approached by a furtive but smartly dressed young man who would say to you in English, 'I am a businessman — in a small way, of course. I would like to buy your suit.'

We had a long meeting with Krushchev at his office in the Kremlin. He was a boisterous personality, one of the last world statesmen who relied on

Auschwitz

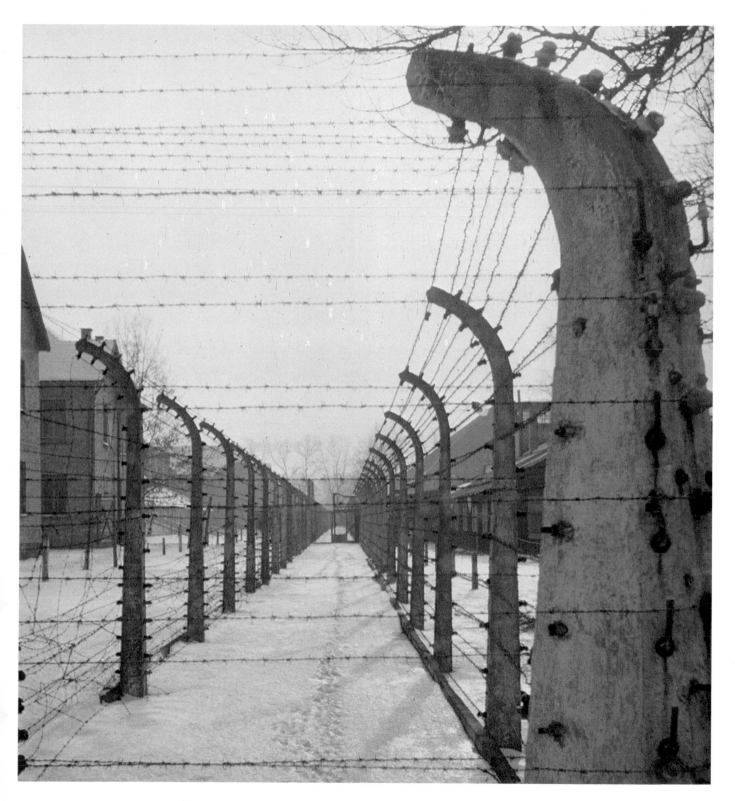

the spoken word rather than on reading for his knowledge. Gromyko, his Foreign Minister, sat on his right, and did not hesitate to correct him on points of fact or policy. Krushchev deferred to him without embarrassment on such occasions. On the other hand, when he was interrupted by Ponomarev, the *apparatchik* in charge of international relations between parties, Krushchev would dismiss him rudely. This was a source of some satisfaction to me as I had been a major target of Ponomarev's vituperation when I was his opposite number at Transport House.

I took many photographs at the theatre, ballet and circus. You can learn a lot about national character at such performances. The Moscow circus was then at its peak. The chief clown, Popov, was a modern Grock, with a curious uptilted nose rather like Gromyko's. He was one of the great clowns of all time. As we left the performance I had a long talk with a young Russian who was studying at the college for clowns, which like the ballet school in Russia provides a lifetime education for its members. We saw Prokofiev's ballet 'The Stone Flower' at the Bolshoi Theatre, followed by a modern ballet based on a novel by Peter Abrahams about racialism in modern South Africa. The white man was represented as a sinister figure with a long red beard, a stock whip, and a peculiar nineteenth-century tropical uniform. Nye Bevan had a furious argument with our hosts about the crudity of their propaganda.

Often I could take the photographs I wanted only by breaking away from the official party — on the underground or in the Red Square for example. This always led to frantic screams of 'Mr Gealey, Mr Gealey,' from our schoolmistress guide — the Russians have no letter 'H'.

While we men were seeing Krushchev Edna went with Dora Gaitskell to visit his wife at their flat on the Moscow Hills. She took my small automatic half-frame camera with her, in case there was a chance to take a picture. In fact Mrs Gromyko asked if anyone

Hugh Gaitskell and Nye Bevan at the Kolkhoz

had a camera so that a photograph could be taken to commemorate the occasion. Edna obliged with alacrity. Somehow or other the British journalists who had followed them to the Moscow Hills heard about the photograph and pestered us for the rest of our visit to let them have it for publication. We refused because it had been a private occasion. As soon as we got back to England, I rushed up to my dark-room to develop the film. For the first and only time in my life I poured in the fixer before the developer and wiped the celluloid completely clean of any image. So I shall never know what the Krushchev flat looked like.

In those days you took it for granted that your room would be bugged by the secret police. One afternoon when we returned early to our hotel in Leningrad we startled a couple of men who were doing something to the skirting board. When we asked them what they were up to they said they had come to tune the grand piano — but they disappeared immediately without further explanation or apology.

This made us exceptionally wary when a large wicker hamper appeared in our bedroom one after-

noon. We asked the hotel to open it and found it full of dirty clothes. It had been sent down to us by Hugh and Dora Gaitskell, who thought it was part of our luggage — a somewhat offensive suggestion, I thought. In fact it was Hugh's laundry which had been picked up by accident when our taxi called to take them from Hampstead to Heathrow.

My second visit to Moscow, in 1963, was to an unofficial international conference with George Thomson — now Lord Thomson of Monifieth — and Bill Warbey, a left-wing Labour MP. It gave me a good deal more personal freedom than my first. The conference itself was a tedious propaganda exercise, but it was interesting to meet Ilya Ehrenburg who,

though a reluctant conformist in cultural politics, still had some of the bohemian vitality which had made him an idol of literary Paris in the early 1920s. Ivan Maisky, Ambassador in London at the beginning of the war, appeared at the conference after a long period in eclipse during the anti-semitic phase of Stalinism. Although he would express no opinion on Zionism as such, he showed an intense interest in Israel and questioned me ceaselessly on my impressions of it.

One morning we were taken by our young student interpreter to the open air swimming baths in Moscow. The temperature was twenty below zero but the water was heated, so the air was full of steam. It

In the steam with Bill Warbey (left) *and George Thomson*

was not comforting to be told by a voice through the mist in the middle of the baths that a series of murders had recently been carried out in the pool by members of some religious sect and that the other bathers became conscious of the murders only when the water round them turned pink.

In Russia as in several other countries there is political as well as economic competition between the capital in the centre of the country and the seaport which looks to the outside world. Leningrad is to Moscow what Shanghai is to Peking or Hamburg to Bonn. With its beautiful eighteenth-century houses, Leningrad reminds you of the Hanseatic Ports in Western Europe. Its people suffered appalling privations during the siege of 1941–3. The Russians are rightly proud of the care with which they have restored Peter the Great's summer palace outside the city after its total destruction by the Germans. Apart from the great series of golden cascades which descend from the palace to the Gulf of Finland below, the gardens are full of the trick fountains adored by Peter the Great, which squirt water on you if you sit on a particular seat or stand on a particular stone.

We were able to visit only one Kolkhoz and that in the countryside only just outside Moscow. As a farmer himself Nye Bevan found both the pigs and the poultry most unimpressive. Our visit ended with a massive feast at midday. When we got back to our hotel we found that Harold Macmillan had just called the General Election in Britain. The press was of course besieging the hotel to hear Hugh Gaitskell's comments. For the only time I or his friends have known it happen, he had found the hospitality of the Kolkhoz too much for him, and try as I might I could not get him up. So Nye Bevan took the conference instead and never afterwards revealed the reason why Hugh was not available. So far as I know the story appears for the first time in Hugh Gaitskell's

A sweeper outside Moscow University

111

Left, *the Cathedral of the Assumption, inside the Kremlin;* above, *Cossacks outside my hotel, Moscow*

own official biography by Philip Williams.

One of my most interesting Russian encounters took place not in Moscow but in Sussex. At Wiston House in the shade of Chanctonbury Ring, the Foreign Office had organised a meeting between Soviet and British politicians. Krushchev's son-in-law, Adzhubei, was present. He was then editor of the leading Russian newspaper, *Izvestia*. A fair-haired, blue-eyed young man, he was as ebullient as his father-in-law. We had a long conversation one night until four in the morning, lubricated by Foreign Office champagne. I felt rather like a nineteenth-century British traveller talking to a chieftain in Bokhara.

Adzhubei was a great gambler. He first asked if I would swap watches with him. I refused. A little later, when he discovered I was a photographer, he offered to exchange his Japanese Minolta for my East German Exakta. I refused. Hours later, when the interpreter's eyes were glassy, he asked me who would be the leader of the Labour Party if anything happened to Hugh Gaitskell. I said I would tell him on condition he told me who was likely to succeed Krushchev. He agreed. I told him that Harold Wilson was Hugh Gaitskell's most likely successor and why. He told me that Krushchev's most likely successor was a man not well known to the public who was a specialist in military strategy and arms production, and gave me his name. But next morning I could not remember the name, and Adzhubei himself was too ill to be asked again. It was only some time later, when I was able to go through a list of leading Soviet personalities, that I found it — Ustinov, the same name as the British actor, who is now Russia's Minister of Defence. I was a better prophet than my Soviet friend.

9 The Dark Continent

It was the civil war in the Congo which first took me to Africa in 1959. Landing in Elizabethville, I crossed the swollen river by ferryboat and made my way slowly along the coast up to Dakar in Senegal. The United Nations forces in the Congo were then commanded by the Irish, and Nigerian troops were policing the roads very efficiently. After a few days of political discussions there I flew to Nigeria where the High Commissioner was Lord Head, who had resigned as Minister of Defence in the Macmillan Cabinet after Suez and to his horror found Duncan Sandys taking his place.

His residence in Lagos was a handsome new building on the lagoon. Lunch there was an odd experience as great ships moved slowly past the windows a few yards from the lawn, and dripping children were liable to streak through the dining-room in their swimming costumes to reach the bedrooms opening off the balcony above. The garden was full of animals and birds which Antony Head had collected in various parts of the world. I remember in particular a revolting Maribou stork called Beauty with a bloodshot eye and a mottled brown pouch below its vicious beak, rather like a Peter Arno clubman. It chased any visitor in sight to inflict a merciless pecking.

It was in Nigeria that I came to realise the full importance of tribalism in African politics. In the western region the dominant Yoruba tribe are handsome and imposing figures, the women clothed in a particularly attractive blue. The Hausa in the northern region are a desert people belonging more to the Sahara than to the tropical jungles in the south. The inhabitants of the eastern region are smaller and of great intelligence like the Kikuyu in Kenya. After my short visit in 1959 the tragedy of Biafra came as no surprise.

I paid a call on one of the tribal chieftains, the Oyo of Ife. My arrival was announced by a relay of tom-toms as I approached his compound. The proudest of the trophies in his throne room was a dentist's chair. When the elders of his tribe felt a chief had outlasted his usefulness, he would be given a dish of parrot eggs for breakfast. This was a sign that he should commit suicide.

From Lagos I travelled by road through Dahomey and Togo to Ghana. I had time in Dahomey to visit the marshes where the stone-age village of Gannvié is built on wooden piles in the middle of a vast inland sea. The children have their teeth filed to sharp points, not for ritual or cosmetic reasons, but to enable them to eat the tough lake fish.

Under Kwame Nkrumah, its first President, the new nation of Ghana was throbbing with economic and political vitality. I spent a most enjoyable day at the university arguing socialism with Amoaka Attah, one of the left-wing triumvirate who then dominated the Government. In later years I have several times met diplomats who were present as students at this encounter.

The contrast between French and British West Africa was striking. The British view of the imperial mandate was to respect local traditions so that the colonial people could develop their own model for independence. The French aimed to assimilate the Africans into French culture, with great success so far as a handful of political and administrative elite were concerned. At the time I thought the British system was demonstrably superior. Now I am not so sure.

Of all the Africans who had assumed power in French West Africa the most assimilated and conservative was the new President of the Ivory Coast, Houphuet Boigny. Yet he had been famous as a Communist in the French Assembly after the war. When I reached Dakar, the Speaker of the Senegalese

In Gannvié, Dahomey

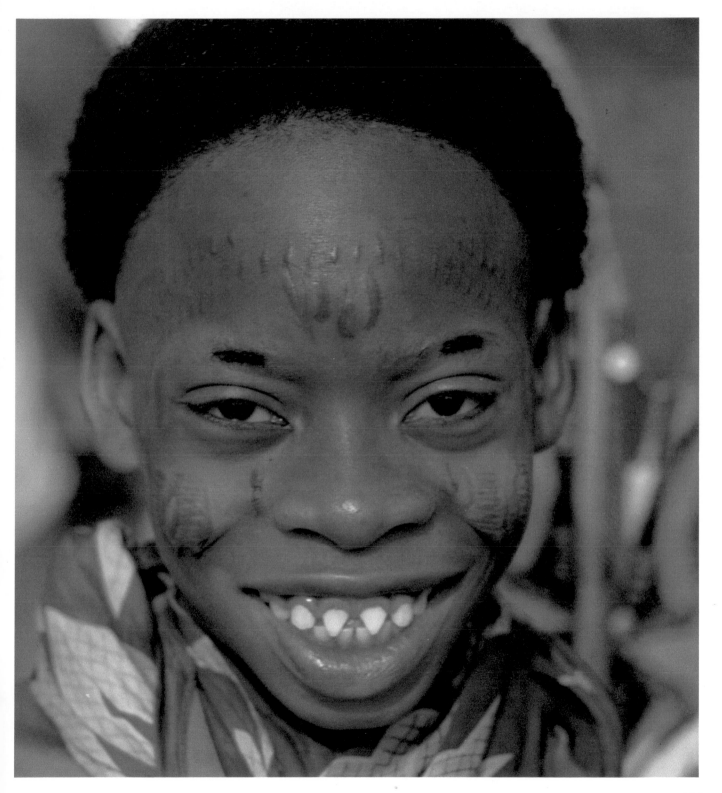

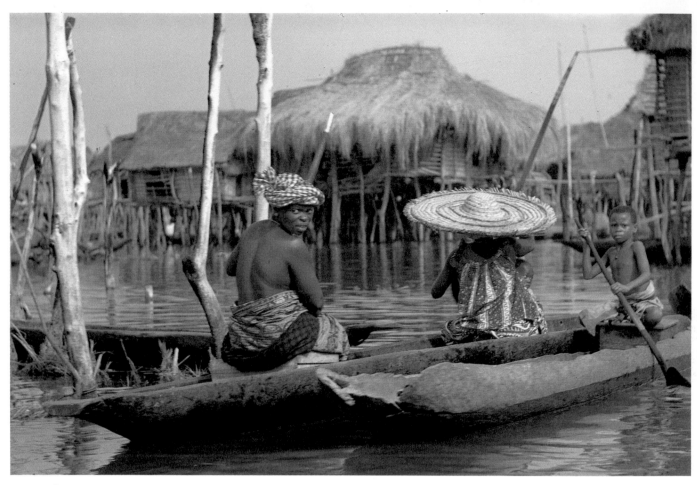

Gannvié

Parliament, an impressive old man called Lamine Gueye, told me the reason. When the war was over and elections had taken place, the new African deputies met in Paris to consider how they should conduct themselves. Coalition Governments were then the vogue in the Third Republic. So the Africans decided that some of them would join each party, drawing lots to decide who should go where. Houphuet Boigny drew the Communist Party. Western politicians who get over-excited about Communists in Africa should remember this story.

Guinée was a sad and very xenophobic country at the time of my visit. When Sekou Touré refused to kow-tow to France after independence, de Gaulle treated Guinée rather as Krushchev treated China after the Sino–Soviet split. He not only withdrew all French administrative assistance and economic aid, but removed anything left over from the French colonial period which might be of value to the new regime. So the administration was inevitably a mess. A field outside the capital, Conakry, was stacked with thousands of bidets which some unfortunate official had been tricked into buying.

Not surprisingly, the Russians moved in, hoping to benefit from France's behaviour. But they themselves behaved so crudely and interfered so directly in Guinée's affairs that Sekou Touré expelled their Ambassador. I called on his successor who had been

weeks waiting for agrément in a hotel with no air conditioning at all. He was pathetically glad to see me since some years earlier we had lectured together at the Quaker school for diplomats at Clarens in Switzerland.

Guinée was the only African country I have visited where the people did not smile on meeting a stranger. Indeed I was arrested for taking photographs near the port and had some difficulty in arguing my way out of it. It was a disagreeable experience since I had no confidence I would be allowed to contact the British Embassy if necessary, and the local police spoke French worse than I did.

Dakar, the capital of Senegal, is a magnificent and well-planned French city, a striking contrast with the dingy muddle of most British colonial towns in West Africa. It still had a very large French population. But the most striking feature of the city was the Wolof women, who did most of the marketing, and wore superb costumes of gauze and chiffon modelled on French styles of the Second Empire.

One of the things which surprised me in West Africa was the complete absence of animals. There are no game parks, for example, and comparatively few birds. The reason of course is that the large population has to eat all the animals it can find. It is a very different matter in East Africa where the population is small and the game has to be kept down by regular culling.

Edna and I had a couple of days in the Queen Elizabeth Game Park under the Mountains of the Moon in Uganda just before the country received its

Below, *cheetahs eating an impala in the Nairobi game park;* following pages, *Wolof women in Dakar*

117

independence, and I have twice been to the game park outside Nairobi, which can be reached from the middle of the city in a quarter of an hour by taxi before breakfast.

A photographic safari with a Land Rover and a good guide is a wonderful experience. A long lens is essential. With my 225mm Dallmeyer I found that I could easily take close-ups of cheetahs eating a newly killed impala. Edna and I reached the Queen Elizabeth Game Park some hours before our fellow guests. I asked my African driver if he would take us into the bush so that I could do some photography before sunset. I spent an hour or so wandering on foot through the deep grass in search of pictures. Hippopotami lumbered past me on their way to their evening bathe. On one occasion I moved rather too close to an elephant which raised its ears and trunk and began to advance towards me. The speed with which I returned to the car was an all-time record — a fortunate thing since the driver himself was in some hurry to escape. It was only when I returned to the hotel that I discovered you should never leave the car during a visit to a game park, and that on no account should you ever put yourself between a hippopotamus and its pool.

In Kampala, the Ugandan capital, we stayed with an Indian family whom I met later in London after they had been expelled by the new regime.

The independence celebrations themselves were packed with photographic interest. The different tribes held boat races on the lake outside Kampala, and Oginga Odinga and Jomo Kenyatta addressed enormous political meetings in the surrounding countryside.

I never had a chance of visiting Central Africa, but when the Labour Government was defeated in 1970 I was invited to South Africa by the National Union of South African Students. After some time in black Africa it was a shock to be in a country which practised apartheid and where the contrast between the treatment of black, white and coloured was so great. The coloured shanty-town at Elsie's River was even more depressing than Soweto, where the blacks had a political organisation and at least the hope of running the country some day.

The political police were as active everywhere as in a Communist state. When I talked to Bishop Zulu, for example, he insisted that we went into his garden where there was less risk of our conversation being bugged. The same was true when I visited the coloured university outside Cape Town. I was compelled to walk round the playing fields with my student hosts so that the Afrikaner staff had no chance of hearing what they were telling me.

The morning of my arrival in South Africa I was taken from the airport at Durban five hundred miles by car to the heart of Zululand to meet Chief Gatsha Buthelezi, the impressive grandson of the great Zulu chief Cetewayo whose warriors defeated the British Army nearly a century ago. He has shown outstanding courage and skill in representing his people.

I managed to get permission to visit the leader of the African National Congress, Nelson Mandela, in prison on Robben Island in the bay off Cape Town. I

Opposite, *at Badagri, Nigeria;* below, *Steve Biko*

Elsie's River, outside Cape Town

had known him in London when he wore an impressive beard. On Robben Island he was clean-shaven, pale and thin, but his spirit and intelligence were unbroken, and he was remarkably well informed about the latest political news in the outside world. Our conversation took place in the Warden's office and was inevitably guarded.

One of the most impressive of all the Africans I have ever met was Steve Biko who had then just resigned from the white NUSAS to form his own organisation for black students alone. He was a handsome young man, rather like the film star Sidney Poitier in appearance, with immense political intelligence and total dedication to his cause. We talked at length about the coming political struggle in South Africa as we lay on the grass in a small township on the edge of Zululand — black and white were not allowed to sit together in a café or restaurant. A few years later he was brutally beaten in a South African prison, thrown naked and bleeding into the back of a Land Rover and driven 750 miles to die in hospital in Pretoria. His murder has created a martyr of great political power. But the death so young of a man so gifted is an irremediable loss for democracy throughout the world.

10 Desert and Palm

My first contact with the Middle East was when I visited Israel in 1953. The new state was then only five years old and some of the roads were still littered with burnt-out tanks, the relics of famous battles. Colonisation of the Negev was just beginning and Beersheba was like a frontier town in the Wild West. The country was still facing difficulties in assimilating the flood of new immigrants — particularly the Yemenis who had lived in a medieval Arab environment for over a thousand years, and the Russians, the younger of whom had spent their whole lives under a Communist dictatorship.

Israel contains some major shrines both of the Muslim religion and of the three main Christian faiths, as well as of Jewry — a stupendous cultural inheritance which has been a political misfortune. Although the Christian shrines have been somewhat debased by commercialisation, the natural beauty of Lake Galilee and the Mount of Olives still has a luminous quality, and the buoyancy of the Dead Sea is at least equal to my own.

Afloat in the Dead Sea

I recall the American delegate to the United Nations in 1946 appealing to the Jews and Arabs to behave like Christians. But the Christians did not set a good example in Palestine itself. Because the Catholic, Protestant and Orthodox Churches could not agree on which of them should look after the most holy shrine in Christendom, the church of the Holy Sepulchre in Jerusalem, they had to appoint an Arab caretaker. His descendants still look after it. When I met President Nasser, on a visit to Egypt in 1960, I used this story as a parable for Britain's role in the Gulf.

Nasser was a handsome man of great ability and charm whose influence was dominant throughout the Arab world. I found his picture prominent in a Soukh far away in the Hadramaut. And when I visited the great ruin of Ctesiphon in Iraq the local villagers were singing a song in his praise as they marched round. But he suffered from what Montherlant has called '*le démon du bien*'. He could not resist the flattery of an appeal for help and grossly over-extended Egyptian power in the Middle East; the union with Syria, for example, never made political or economic sense. He told me of his shock on finding how primitive were the Arabs in Yemen, where his troops had recently intervened, and described the civilising mission of Egypt in terms which I told him were last used by Lord Lugard in Nigeria. He laughed and said, 'Ah yes, but these Yemenis have brown skins like us.'

I tried without success to see the temples at Abu Simbel before they were moved to escape the rising waters of the Nile, but I did watch the building of the Aswan Dam. It was a task comparable with the building of the Pyramids, which rise from the desert just outside Cairo as if planted overnight by visitors from another planet. Cairo itself contains some of the most beautiful buildings in the Muslim world, in particular the early mosque of Ibn Tulun, the chaste simplicity of which contrasts strikingly with the baroque magnificence of other mosques in Cairo.

At the cataract on the Nile

The Egyptian Museum with its staggering display of treasures from the Tutankhamun tomb is a photographer's paradise.

My first sight of the Gulf, which was to occupy so much of my time and energy as Secretary of State for Defence, was on the same journey. The great oil boom was just under way. A tiny island off Abu Dhabi was already producing oil, but Abu Dhabi itself was little more than a desert fort surrounded by wattle huts. Sheikh Shakhbut was away in Buraimi during my visit, but I visited his son Prince Sultan in the fort. His first question was to ask me for the latest news of Nye Bevan's illness. Yet the British Agent in Abu Dhabi, whom I had known at Oxford, told me that one of the Sheikh's brothers, after being taken from one great hospital to another on both sides of the Atlantic in the hopeless search for a cure to his cancer, had died a few weeks earlier in a tent outside the palace, making the desert hideous with his screams, as the witch doctors beat him with chains to exorcise the evil spirits.

As no one was available for me to see in Tehran over Easter, I flew from Abu Dhabi for three days' holiday in Isfahan. Those three days were a high point of my life as a traveller and a photographer. At that time there were no grand hotels in Isfahan, only a modest inn by the river run by a Swiss family. The city itself shares with Florence the claim to be the most beautiful in the world. Its surroundings were even lovelier at Easter, with the grass a vivid green, the apple trees covered with blossom, and everything just bursting into leaf. The air was icy clear under a brilliant sun, the blue sky patterned with fleecy clouds. Besides visiting the incomparable buildings in Isfahan I made several expeditions into the countryside, to see a village which made carpets and look at some of the older mosques. The children everywhere were particularly beautiful, with great lustrous black eyes, cheeks the colour of a russet pippin and jet black hair, wearing tunics and trousers of multi-coloured cotton.

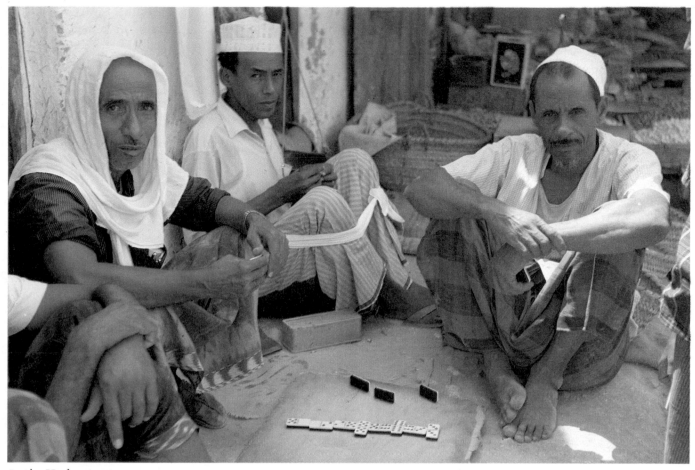

In the Hadramaut

The climax of this elysian break in a busy political journey round the Middle East was a flight to Shiraz in the south of Iran so that I could watch the Qashgai migration on my way to the ancient ruined city of Persepolis. The Qashgai were at that time a tribe of half a million people with three million livestock — camels, sheep, goats, donkeys and dogs — who travelled five hundred miles from the shore of the Gulf into the mountains for pasture every year and back again. As we climbed the pass outside the city, I found myself in the middle of a vast sea of Qashgai stretching in all directions as far as the eye could reach, all striding or riding towards Persepolis, gorgeous in their gypsy raiment. When I returned to

Iran fifteen years later I found that the migration had ceased and the Qashgai themselves had been decimated by the Shah's Government, although I did see one or two in the bazaars of Shiraz.

Persepolis is one of the great monuments of a vanished civilisation, best visited early in the morning or late in the evening when the declining sun casts shadows to make the reliefs stand out. Shelley perfectly conveys the impression it makes:

'My name is Ozymandias, king of kings:
Look on my works, ye Mighty, and despair!'

A few miles away are the gigantic rock tombs of the Sassanid dynasty which ruled some centuries later.

125

The sculpture in the sandstone cliffs about these tombs, however, is of a vulgar mediocrity unmatched outside Sunset Boulevard.

My two visits to Iraq were far less agreeable. The first was during the rule of Colonel Qasim, a half-crazed dictator who kept his blood-stained shirt in a glass case in the room where he gave audience, as a reminder that an attempt to assassinate him had failed. The hospitals were full of men and women whose noses and ears had been cut off during the fighting in Kurdistan. On my second visit I attended a revolution. I was woken up in the morning by what appeared to be a pneumatic drill in the road outside my hotel. In fact it was gunfire. There was a mutiny in a military camp just outside Baghdad. When I met the young Foreign Minister later in the day he told me that he had accidentally been captured by the mutineers, but escaped with his life because they did not recognise him.

The Hanging Gardens of Babylon require a well-trained imagination to convert their sewer-like trenches into one of the Seven Wonders of the World, although the reconstructions of Babylonian buildings are beautiful at dusk. What did surprise me with its grandeur, however, was the ruined palace at Ctesiphon in the desert outside Baghdad — a gigantic vault of clay bricks, with a blind beggar singing epic songs to the music of a medieval instrument in the sand below.

In 1974 I visited Saudi Arabia for the first time as Chancellor of the Exchequer. It was then a country just coming to terms with its stupendous oil wealth after the first OPEC price increase. What struck me most of all was the honesty and dedication of the young top officials with whom I had to deal. They were fired by a sense of mission the equal of which I had met nowhere else in the Arab world. Unlike so many intelligent young men from the Third World who had gone to the West to study, they had re-

Right, *the Royal Mosque in Isfahan;* following pages, *outside Isfahan*

126

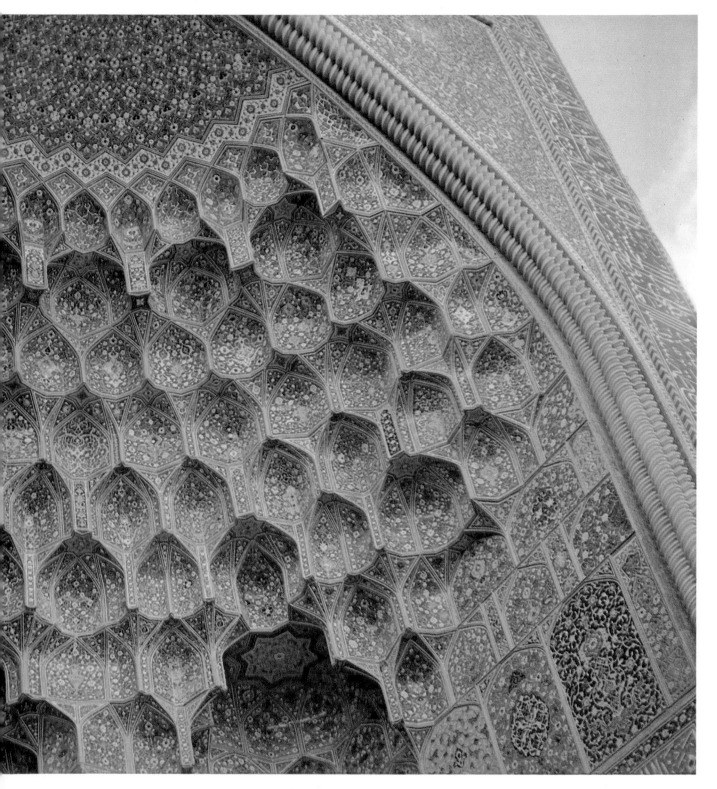

128

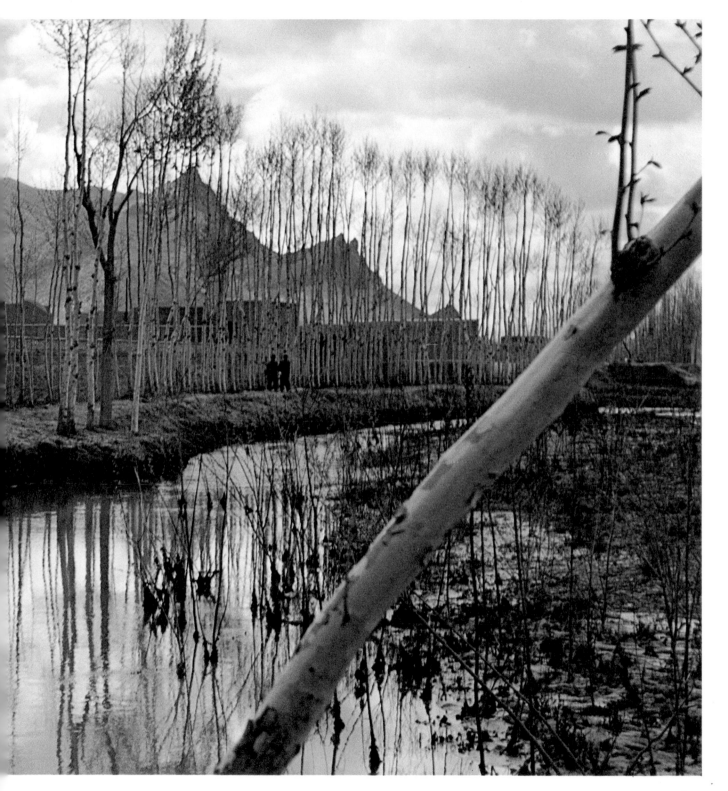

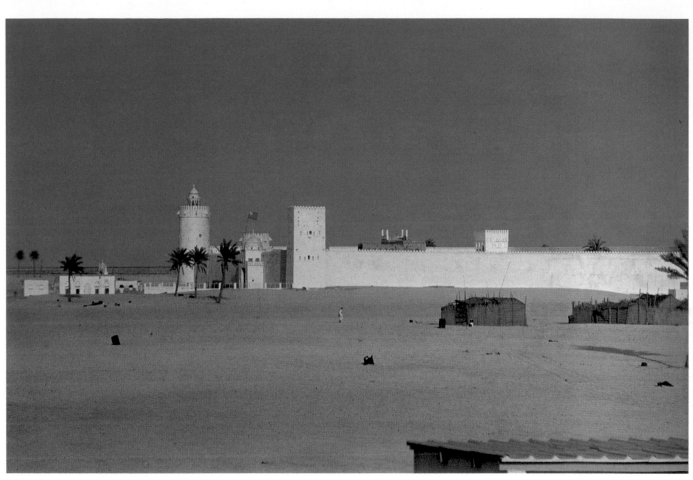

The Sheikh's palace, Abu Dhabi

tained the moral principles of their own people and lived in unassuming bungalows very different from the marble palaces I had seen in Tehran. Nevertheless the speed of change in Saudi Arabia is alarming. You can still see in the wooden gate to the ancient royal palace the point of Ibn Saud's sword, which broke off as he was trying to force an entry when as a desert chieftain he took power only fifty years ago. This type of contrast strikes one again and again in the Middle East. In my visit to Kuwait in 1959 I actually saw a Cadillac in the desert outside a Bedouin tent.

In some respects the contrast was greater still in South Arabia, which I visited regularly as Defence Secretary. My military aide-de-camp was Colin Mitchell, later famous as Mad Mitch of the Argylls. The Scots have a natural affinity for the tribesmen of the South Arabian mountains, whose endless feuds recall the clan wars in Scotland two centuries ago. On one of my visits to South Arabia I spent two days in the Hadramaut, a fertile valley sunk below the desert in a canyon about three hundred miles from Aden. Life has changed little there in the last two thousand years. Until Freya Stark visited it some fifty years ago it had been almost inaccessible to Western travellers. When Aden became strategically important, a British Agent gave it a modicum of law and order for one generation. Its three towns, Shibam, Tarim and Sayun, all consist of lofty buildings made entirely of mud; the more prosperous are whitewashed. As you

approach Shibam from the landing strip its sky-scrapers look like Manhattan island from the Statue of Liberty. Sweet water abounds in the valley and many of the houses have one room flooded to a depth of about four feet; the water is used for bathing in the afternoons, and flows out to irrigate the surrounding gardens. Edna and I slept on the roof of the British Agent's house in Tarim, where we watched the sun climb over the canyon wall in the pearly dawn, slowly raising the air to furnace heat. While I roamed the markets and the alleyways in search of photo-graphs, Pat Nairne, my Private Secretary, no less passionately addicted to water-colour than I to photography, made sketches with his portable paint-box.

The men of the Hadramaut are great sailors who have voyaged regularly over the centuries to In-donesia in search of trade and wives. The coast of Arabia must have been a rude shock to these In-donesian women, used to the lush vegetation of their islands, and the valley of the Hadramaut a blessed relief after over a hundred miles' journey through rocky desert.

As Defence Secretary I also paid several visits to Libya just before the revolution which displaced King Idris. I tried to guess which of the middle-ranking officers I met would carry out the military coup which already seemed inevitable. I finally de-cided it must be a certain young colonel whose political interests were evident even to a foreigner. I was wrong. I heard later that the colonel had been woken by his orderly on the morning when Gadaffi took power. 'Sir,' said the orderly, 'pardon me for waking you, but I think there is a revolution going on.' 'Don't be silly,' replied my colonel, 'it's tomorrow.'

Abu Dhabi: the sun setting over the British Empire

11 Jungle and Temple

During the 1960s my work took me many times to South East Asia. Its people, monuments and scenery make it one of the most beautiful parts of the world. But in those years it was gripped by war. I saw Vietnam once only, in the summer of 1964 just before I became Secretary for Defence. It was a depressing experience. In the tree-lined boulevards of Saigon, bombs claimed their victims every day while the politicians plotted to win American support. In the countryside war was an ever-present reality. The peasants were being uprooted from their villages and concentrated into new strategic hamlets, each surrounded by ditches in which stakes of razor-sharp steel and bamboo waited to impale the intruder. At this time the Americans were still trying to win the war on the ground, and their troops were protected by helicopters which were extremely vulnerable to ground fire. I did a short tour of the fighting areas in one of those helicopters, near the Cambodian frontier and in the Mekong delta. The weather was as sullen and depressing as most of the villages I saw. Before long the Americans had switched to saturation bombing and defoliation. The agony continued.

Within months I myself was involved in a war in South East Asia when I became Secretary of State for Defence, and our troops were fighting in Borneo during the war of confrontation with Indonesia. The contrast with the American campaign in Vietnam could not have been more striking. The Americans relied on overwhelming air power and the most sophisticated scientific weapons. The British in four years of fighting never once dropped a bomb from an aircraft. The death roll in Vietnam, both military and civilian, was one of the most appalling in history. In Borneo there were fewer casualties in the whole campaign than are caused by road accidents on the average Bank Holiday weekend in Britain. And we won.

The war in Borneo was won by soldiers patrolling on foot in the jungle. Besides British infantry battalions, the Gurkhas and the Special Air Service played a vital role, with invaluable assistance from helicopters of the RAF and Navy. They gave overwhelming importance to winning the friendship and confidence of the local tribesmen, many of them head-hunters. For example, every SAS patrol consisted of three men, one of whom was a trained doctor, whose job was as much to give medical help to the local people as to assist his comrades. I was immensely impressed by the quality of our troops at every level. Young men from all parts of Britain adjusted to this type of warfare with calm efficiency. Many of them had no previous service in the tropics, still less in the sort of jungle found in Borneo, where it was sometimes difficult to move more than a few hundred yards a day. A few months earlier some of them had been chasing Arab tribesmen across the stony mountains of South Arabia, where they might spend days without seeing a tree. And before long many of them would be patrolling the streets of Belfast and Londonderry, targets for abuse, stones and bullets from the people they had come to protect — always with the same practical professionalism and imperturbable good humour.

During one of my visits to Borneo Edna and I spent a superlative day with the Commander in Chief Sir John Grandy and the General in charge of operations, George Lea. We went by helicopter from Brunei on the coast to a clearing in the jungle near the source of the river Limbang where the tribesmen gave us a friendly welcome in their longhouse. They fired a rifle and sacrificed a cock in our honour before treating us to glasses of *tuak* — cider and honey laced with gin. Then we travelled for two hours down the river in longboats — hollowed-out

Vietnam

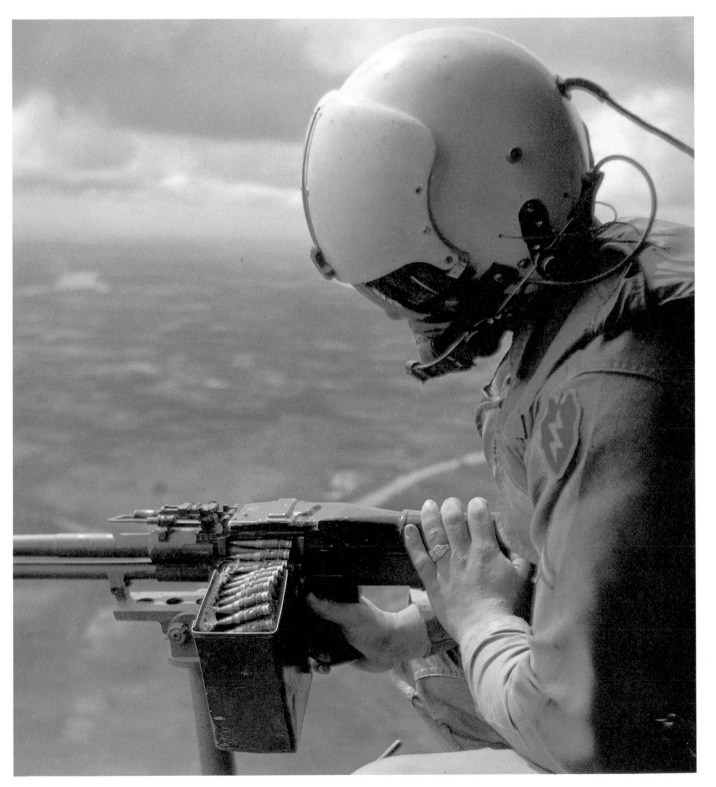

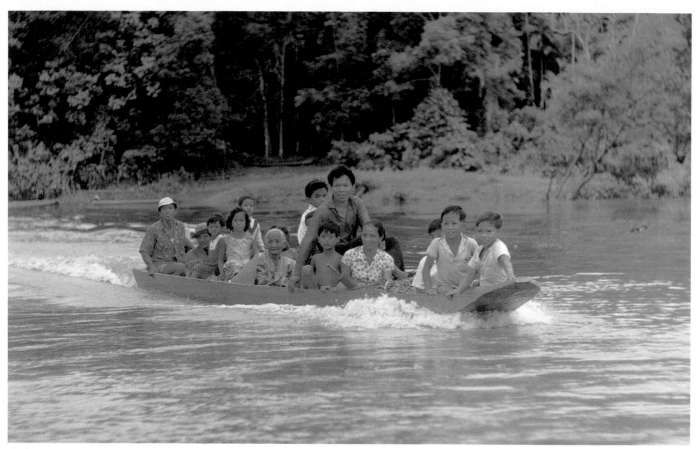

On the river Limbang, Borneo; above, *a family returning from market;*
below left, *our boatman in the bows;* below right, *Edna in the stern;* right, *the headman's daughter*

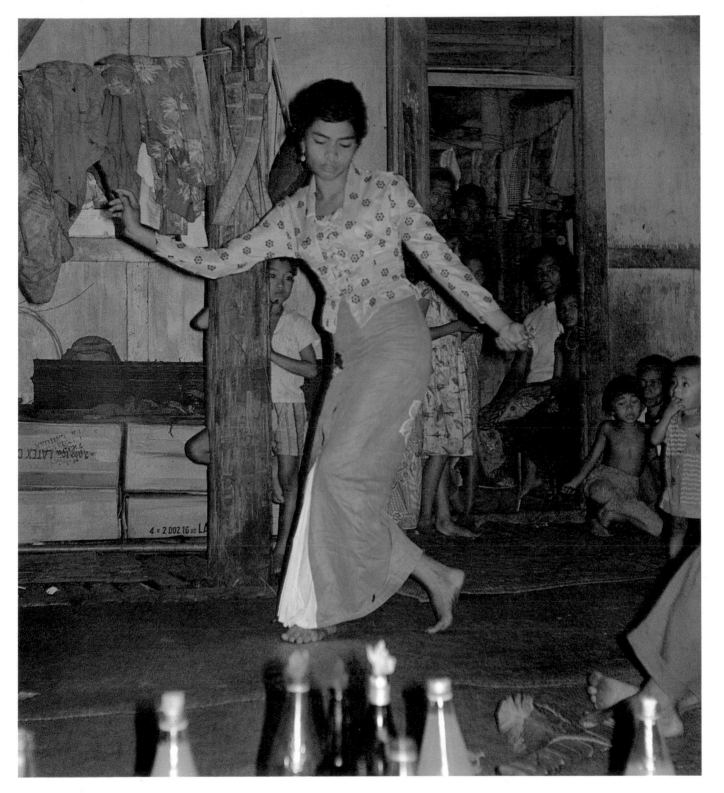

trunks of trees which had been fitted with outboard motors. The presence of British troops had made these the normal means of travelling in the area, since it was very difficult to move through the jungle. Again and again as we descended the river we would meet another longboat travelling upstream, with a whole family of tribespeople from grandparents to little children returning from the market. We finally stopped at another longhouse where we were received by the headman, who had been decorated for his service when he fought against the Japanese with Tom Harrisson, the founder of Mass Observation in Britain, who had organised the resistance in Borneo during the Second World War.

A longhouse is in fact a whole village of tribespeople, living in a long wooden hut raised on piles above the ground. We drank *tuak* in enormous quantities as by then it was midday and extremely hot. Unfortunately we had nothing to eat except dry biscuits. The headman's pretty daughters entertained us meanwhile by dancing. Then a ceremonial sword was brought out of the shadows and each of us had to attempt a sword dance — including Edna and Cecile Grandy, the wife of the Commander in Chief.

The headman was so impressed by our performance that, as we were about to leave, he ordered one of his companions to lower a large rope net from the ceiling of the longhouse. Thirty or forty small round wicker baskets rolled out of it along the floorboards. He picked one up and offered it to Edna. She received it with every show of delight, somewhat taken aback to find it contained the head of a Japanese soldier, who had been killed twenty years earlier. It was not shrunken as is the case in some parts of the world, but simply smoked. The interpreter told her that the stock of heads represented the tribe's capital and that it was a singular honour to

Bangkok: right, *the Temple of the Emerald Buddha;* far right, *in the Klongs.* Following pages, *the coral island of Gan*

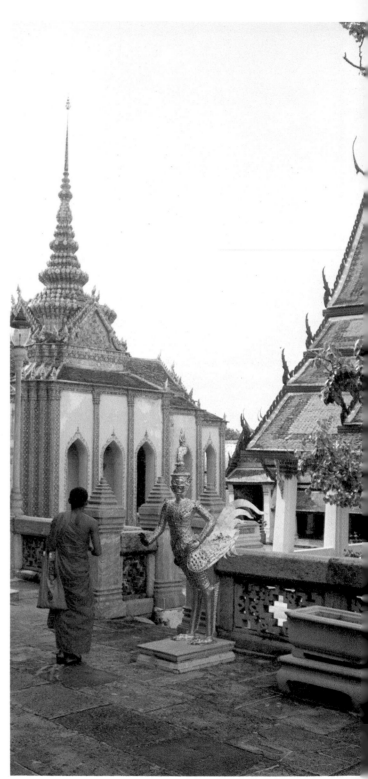

137

be given one. So she gave the headman her wrist-watch in return.

We declared the head to the customs officer on our return to England. He could find no regulation forbidding its import, so we took it to Admiralty House. It lay in a white plastic bag behind the sofa in our bedroom until one of the cleaners found it. I then felt it wise to hand it over to my office in the Ministry of Defence for safe keeping. I regret to say it has since disappeared.

During this period I often flew to Singapore, the main British military base in the Far East, and to Kuala Lumpur, the capital of Malaysia, of which the Borneo territories were part. In Kuala Lumpur as in so many parts of the Far East, much of the most important business is transacted on the golf course. So I had to get up at five in the morning — it was too hot to play later in the day — for a round of golf with the Tengku and his leading Ministers on a course still dripping wet with dew. The detectives guarding the Tengku were responsible for retrieving any balls which went into the rough, as mine did all too frequently, and spent the following five minutes picking leeches off their legs.

Since Bangkok was the capital of the South East Asian Treaty Organisation, I paid several visits to Thailand. As a major base for the American war in Vietnam, and a centre of rest and recreation for the American troops there, Bangkok became increasingly commercialised during the years I knew it. But besides the Klongs, which I have described elsewhere, it possesses some of the most remarkable Buddhist temples in the world — the Wats. Many of these are concave cones towering a hundred feet into the sky and studded with multi-coloured porcelain which on close examination turns out to be the broken fragments of cups and saucers. The Temple of the Emerald Buddha is particularly beautiful; its terraces are populated by gilt statues of women with the legs of birds, and patrolled by Buddhist monks with shaven heads and saffron robes.

Since over-flying rights could not be guaranteed for military aircraft using the civilian route to South East Asia, Britain built a major air staging post on the coral island of Gan in the middle of the Indian Ocean, where the only woman was a Welfare Officer from FANY. The hundred or so RAF men stationed on the island learned to make everything for themselves. But the bulk of the manual labour was done by men from another island in the atoll, who sailed over in their multi-coloured dhows every morning and back at sunset. I used to spend the hour when the aircraft was refuelling floating in the sea across the coral reefs with a schnorkel, so that I could watch the fantastic beauty of the tropical fish. I once got the fright of my life when I found a giant turtle swimming at me, its cruel mouth agape as if to gobble me up.

12 Computer and Chrysanthemum

In 1964 when I first visited Japan, it was still suffering from the hangover of its stupendous post-war boom. Tokyo was a chaotic muddle with many of the roads up since they were building the subway. The surrounding countryside was like the waste land between Liverpool and Manchester. My most striking impression was of the enormous preponderance of young men and women in the streets. I was too busy with my political talks and lectures to see much of the country — though I had a few hours in Kyoto and took a good picture of a peasant escaping from the bustle of Tokyo in the gardens opposite my hotel.

When I returned in 1979 with Edna for a conference run by the newspaper *Asahi Shimbun*, the whole country seemed more spruce and comfortable. Living standards were obviously among the highest in the world. Even in the smaller towns the big stores rivalled those in Düsseldorf or Stockholm. On this visit I was able to learn a little more of the Japanese people and their culture.

Just before the war, the American anthropologist Ruth Benedict wrote a classic book about Japan called *The Chrysanthemum and the Sword*. It would have to be rewritten now as *The Chrysanthemum and the Computer*. Memories of defeat and Hiroshima, combined with the economic advantages Japan has enjoyed through relying on America to defend her, have robbed the military tradition of popular support. The martial virtues now survive mainly in an endless series of films about the Samurai, of whom the gunfighters of the American West are our equivalent; indeed Hollywood turned *Seven Samurai* into *The Magnificent Seven* with scarcely a change in the shooting script.

What makes the peaceful challenge the Japanese

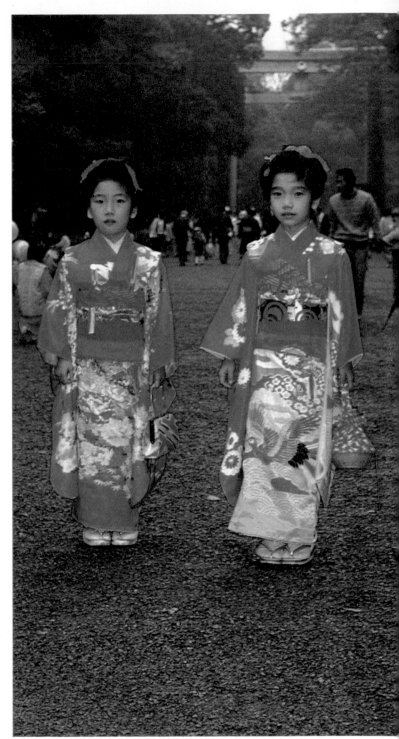

Above, and following pages, *the Shi Chi Go San festival, Tokyo*

141

now present so formidable for the West is their ability to solve their most difficult problems by applying reason and science within a framework of social unity. They stopped simply copying the West a long time ago. Their cameras are now the best in the world, and for many years every new photographic invention has been Japanese — except the Polaroid Land camera. Their trains too have no equals.

Although their society is more rigidly hierarchical than many in the West, those at the top have an obligation to obtain the consent of those below them before they take a decision. The complicated process of consultation to achieve consensus often leads to decisions which are ambiguous — 'Tamamushi' — like the iridescent wing-cases of a local beetle. Then it is the duty of the clever executive to decide what the decision means.

The other side of this coin is the difficulty which the Japanese find in achieving agreement with foreigners outside their system who are used to reaching compromises through a process of dialectical argument rather than through a type of consultation in which disagreement is rarely openly expressed. The Japanese are much better at reacting to a fait accompli created from outside than at co-operating with other countries to improve the international system in which they live.

The Christian concept of charity, for example, is meaningless to the Japanese who believe a family must look after its own and no one has responsibilities outside his family or firm. So the idea of an international community in which all men are brothers is difficult for them to understand. At my conference in Tokyo even the former Foreign Minister of Japan simply could not believe that there were countries in which the income tax system was progressive, so that richer people paid a higher percentage of their income in tax, and that this principle might be applied in international affairs.

Resting outside the Imperial Palace, Tokyo

After the ceremony

Ancient and modern coexist in Japan in innumerable ways. On a clear day you can still see the sacred mountain of Fuji from the heart of Tokyo. In many households the husband changes from his constricting Western suit and shoes into a loose kimono and sandals as soon as he gets home from work. The day after we arrived it was the festival of Shi Chi Go San when children who are three, five and seven years old put on their best clothes and go to the Shinto shrines to give thanks and pray for healthy growth. It was a day of lowering grey clouds and misty drizzle. But inside the Meiji Park hundreds of families were walking under the dripping trees towards the shrine. Most of the children were dressed in the

145

traditional kimono but a few of the girls were wearing Western party frocks. They bought offerings outside the shrine, sometimes twigs with a paper prayer tied to their branches, and queued nervously until they were escorted inside. A Japanese friend arranged for Edna and me to undergo the purification ceremony ourselves. We were brought into a spotless room of polished wood and given evergreen branches to place in offering on the altar. The assistant priest waved a white wand with paper streamers on it to chase away the evil spirits. The main priest pronounced a prayer and as we left we were given a paper satchel with a description of the shrine and ceremony in Japanese and a piece of dry cake. Our friend admitted it was the first time he had ever been to a Shinto shrine.

The Japanese are not in fact a religious people. Shinto in any case is not so much a religion as a system of social and family observances. It is no longer a religion of the State and Emperor as in previous days. Many Japanese are Buddhists as well as professing Shinto. But the Buddhist temples are having a hard time of it, relying more and more on tourism for their upkeep. Although Buddhist monks are now allowed to marry and have children — and to drink alcohol — the number of new postulants is scarcely sufficient to keep the church going.

The most beautiful temples are far from Tokyo in the ancient capitals of Nara and Kyoto. The great complex of buildings which forms the Todai-ji shrine outside Nara is scattered across a wooded hillside over which thousands of tame deer roam freely. The great wooden shrine of Daibutsuden houses one of the largest Buddhas in the world — over fifty-three feet high. The thumb alone is more than five feet long. The lower surfaces of the statue are covered with beautiful line engravings from which artists were taking rubbings as we watched.

In Kyoto — the Isfahan or Florence of Japan — we were taken by the Abbot himself round the Sennyu-ji Temple, the main temple of the Imperial family. He gave us a delicious lunch, made as Buddhism prescribes exclusively from vegetables and fruit, and washed down with Saké, or rice wine. Saké is served warm in cups little larger than thimbles, so there is no risk of over-indulgence.

For a Westerner, Japanese meals present some problems. Apart from the physical discomfort of sitting for hours cross-legged, or at best with your legs stuck out in front of you under the low table, the Japanese love raw fish, raw meat and raw snails, with little or no sauce or seasoning. Although the food always looks enchanting, since it is served in enticing shapes, with colours of pink and emerald, a long meal can be an ordeal. To me as a Yorkshireman by far the most attractive food was Tempura — thin slices of fish, meat or vegetable dipped in a light batter and cooked in boiling oil in front of you. It was fish and chips turned into a fine art. I was not surprised to learn that the basic ambition of a modern Japanese is to marry Japanese, eat Chinese, and live in a Western-style house.

At a large banquet the guests may be entertained during the meal by traditional Japanese dancing, and the playing of a large stringed instrument called the Koto, or by conjuring. The food and drink are served by hostesses in kimonos whom the Western guest may often mistake for geishas. In fact the true geisha is the product of many years' professional training in all the arts of polite society.

Edna and I were taken to a tea-house in Gion, a part of Kyoto which is the only place in Japan where geishas are still trained. We had a long talk with a girl of twenty who after four years' training as a Maiko-san, or apprentice geisha, was about to launch out on her own as a fully qualified member of the trade union. She was an intelligent and spirited girl of great independence, and looked forward greatly to leaving the school and earning money for herself. The money can be very good indeed — a

A geisha on her way to an assignation in Gion

146

148

hundred pounds for a minimum of two hours' entertainment is quite normal and a famous geisha can earn much more even for a single dance. Most geishas marry — the others usually retire to run a tea-house or restaurant, or to train young geishas themselves. We also talked to a younger Maiko-san who was not yet sufficiently qualified to paint her upper lip: the clothing, hairstyle, and make-up of a geisha depend very much on the degree of training she has received. Edna tried repeatedly to find out what would happen if a girl wanted to abandon the career before she had finished her apprenticeship.

Left, *two geishas displaying their obis;* below, *a bride in Nara*

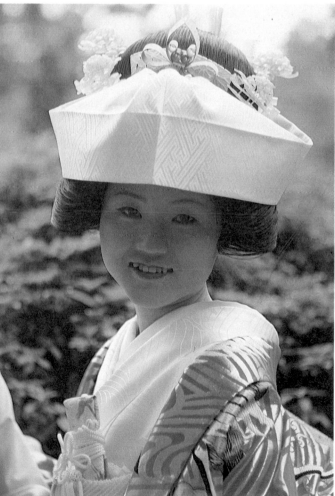

The Katsura garden, Kyoto

She got no answer; the very idea seemed too strange to contemplate. But we did learn that the discipline and training are so arduous that fewer girls are now entering the profession.

In Japan the garden is a major art form of symbolic and religious significance as well as visual beauty. Space is so scarce in Tokyo that a garden is a luxury only the very wealthy can afford. The cultivation of dwarf trees, or Bonsai, and the art of flower arrangement, Ikebana, are substitutes. Even a window-box can be used to make a miniature landscape. Miniaturisation is an important element in garden design even where space is available. The stone garden in the Temple of Ryoan-ji, in Kyoto, consists of a courtyard in which gravel has been raked to resemble the waves of the sea round a number of rocks representing islands. In the large Katsura garden a dwarf pine has been planted at the end of a path above the lake to represent a well-known promontory.

Even the most untrained Western eye must see the Katsura garden as one of the most beautiful in the world, particularly in autumn when the maples are crimson and gold. It is the garden of a seventeenth-century Imperial palace, itself a unique architectural masterpiece, in which squares and rectangles are assembled with classical precision, as by the Dutch Constructivist painter Mondrian, so as to set forms of abstract intellectual purity against the irregular and ever-changing shapes and colours of water, trees and sky.

13 Confucius and the Communists

I have been fascinated by China ever since as a boy in the 1930s I saw the great exhibition of Chinese art in London. My interest increased when I learnt something of the Chinese themselves from my visits to Singapore and Hong Kong. Both are startling examples of what an intelligent and hard-working people can achieve in very adverse circumstances.

At the end of the war, the population of Hong Kong numbered only some six hundred thousand. Twenty years later it was six million and still growing, partly as a result of massive immigration from the mainland, which at times threatened to swamp the city almost to the point of sinking it. The prosperity and stability of Hong Kong today is a tribute not only to the hard work and common sense of its Chinese inhabitants, but also to the dedication of its British administrators and to the restraint of Peking.

In the 1960s the British in Hong Kong still treated it very much as a colony. The white merchants and traders were reluctant to meet their Chinese colleagues on equal terms in their clubs, and the Governor made his Residence the last outpost of our Edwardian Empire. Male and female guests were formally paired before going in to dine on overcooked mutton and lumpy mashed potatoes such as I have never eaten since I was a little boy at school — and this in one of the culinary capitals of the world.

Most Western countries treated China as an enemy in those years. There was continuing anxiety in case a new wave of immigration from the mainland should destroy the precarious economic and political stability which had been so painfully achieved. The garrison was strengthened at the Chinese New Year in case Communist and Kuomintang supporters started fighting one another. I used to visit the frontier and examine with my binoculars the Communist villages on the other side, which were sometimes the scene of awkward incidents, particularly during the Cultural Revolution.

The indigenous population of Hong Kong is mainly of the Hakka people, who harvest the rice or plough the fields in the New Territories wearing broad-brimmed hats with fringes of black cloth to discourage the flies. But the great majority of the Chinese in Hong Kong are immigrants who left their homes on the mainland primarily in search of food. Many live permanently in boats moored wherever there is some chance of shelter from the hurricanes which regularly devastate the colony.

The Victorian virtues of hard work, cleanliness and devotion to family prevail wherever in the world the Chinese settle. Despite gross overcrowding in many parts of the city there is none of the stench so common in other parts of Asia. And each morning the little children leave their boats, their shanties or their tenements, scrubbed spotless and resplendent in their blue school uniforms. In my time businessmen expected to recover all their capital investment within at the most five years — and often two. One day when I was touring the New Territories I had to take shelter from a tropical storm in a medieval walled village. Each of the little cottages inside the walls contained two or three families who were busily wiring plastic berries on to plastic holly for the Christmas trade in Britain.

The view from the peak on Hong Kong island over the bay and the New Territories is one of the most beautiful in the world, particularly at night. On clear days you can see well into China itself, the great reservoir which supplies Hong Kong with water from the Pearl River just visible on the horizon.

Contact with the Chinese people in Singapore and Hong Kong increased my determination to visit mainland China as soon as possible, though I had to wait for two years after ending my stint as Defence Secretary before Edna and I spent a fortnight there. We went in October, when the air in North China is

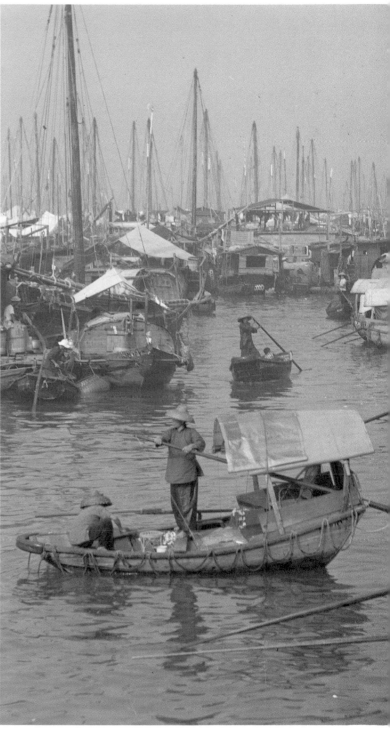

Hong Kong: left, *the harbour from the Peak by night;*
above, *Aberdeen*

153

'Wrens' in Peking

plined but with a very English sense of humour. In the many parks and theatres they behave very much like Europeans, although at the time of our visit the social ethos forbade boys and girls to be together in public. The only time we saw a pair of lovers, in a park near Hangchow, they sprang apart guiltily when we appeared and ran off in different directions.

1972 was the year of the camera in China — everybody seemed to have a small camera and to be busily snapping his family. Indeed a camera had become the most prized possession after a bicycle, a sewing machine, a radio and a wristwatch. The Confucian tradition which combines authoritarianism

Peking: below, *the Forbidden City;* right, *father and son;* following pages, *the rush-hour*

clear and brisk with the first chill of autumn and the trees are beginning to change colour.

China has a land area larger than most continents, extending from the tropics almost to the Arctic Circle. Its many peoples differ as much in appearance from one another as Moors from Norwegians, and now number a thousand million. The oldest civilisation on earth, China has monuments of great beauty. We saw the Forbidden City, which was the old Imperial Palace in Peking, the Great Wall protecting the frontier only fifty miles away against Mongol invasion, the tombs of the Ming Emperors and many ancient temples in the beautiful lake district round Hangchow. But the people themselves are more interesting still: highly intelligent and disci-

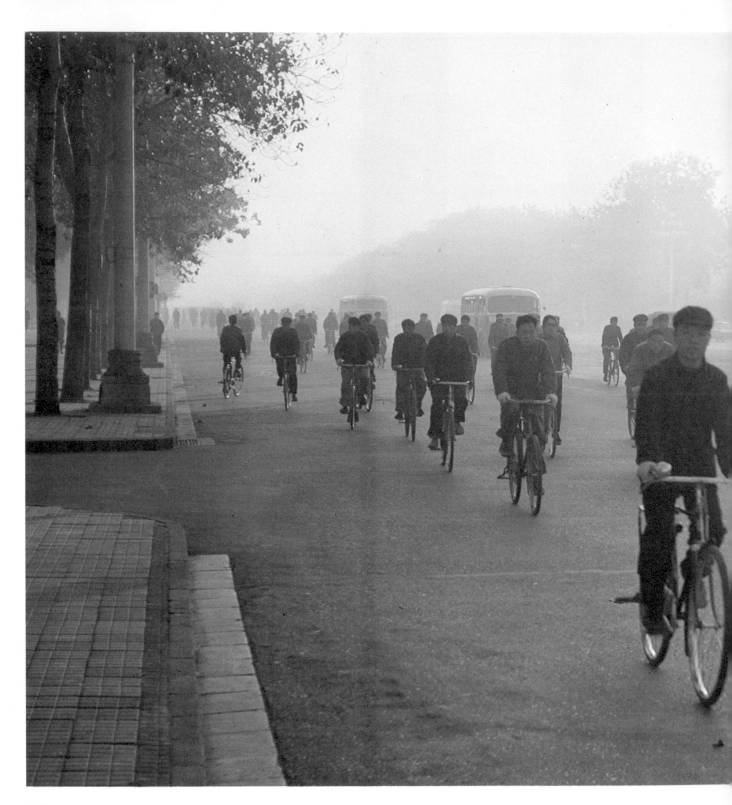

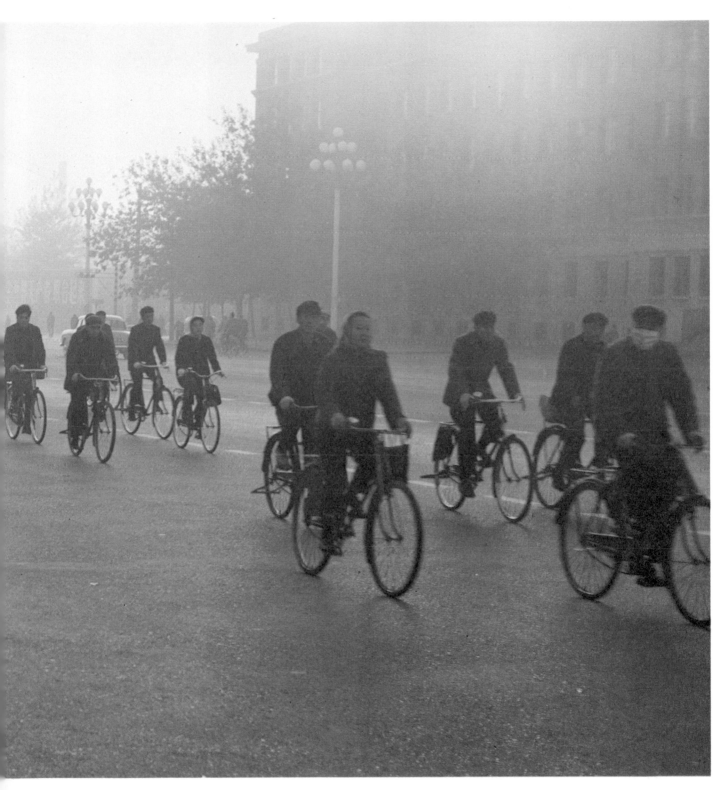

In Peking *Near Nanking*

with scepticism has contributed much to the success of Communism in China. It lays great stress on conformity and the team spirit. The Communists have added the cult of physical fitness; as we drove round the streets of Shanghai after sunrise we saw people shadow-boxing on their way to work. It was a bit too much like an English public school. I came to the conclusion by the time I left China that it was a country of Wykehamists led by Balliol men.

The Peking Hotel where we stayed was a gaunt, ill-furnished and dusty building. We were waited on by charming students who studied foreign languages between serving courses. But the food, like all food in China, was excellent.

Outside the main square and the Forbidden City,

Peking was a sprawling modern metropolis, very dusty as the autumn wind blew in from the surrounding plains, but shaded by delightful tree-lined avenues. It was a city of bicycles. Cars and lorries were rarely to be seen. The parks were delightful — crowded with weekend sightseers on the warm Sunday afternoon when we first looked around. Little boys played ping-pong on stone tables. The older men played chequers. Girl walked demurely with girl, and boy with boy. There was never the feeling I had so often in the Soviet Union of an omnipresent secret police.

The Cultural Revolution really was a revolution. Almost a generation of Chinese children missed their school because they were sent to work on the land —

158

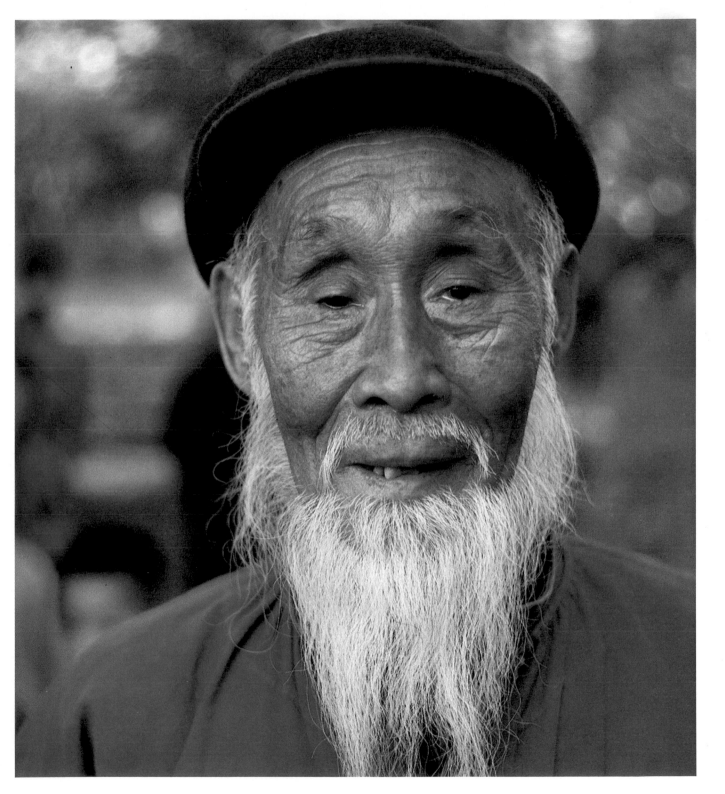

sometimes a thousand miles from their homes. Peking University had been completely closed for four years and in 1972 still had only four thousand students as against the ten thousand it was built for. During our visit we met a class studying English literature. Seeing they were engaged on the Brontë sisters I told them that my home in Yorkshire was only a few miles away from Haworth and sang, 'We're all down in't cellar oil wi't muck slats at' winders'. They concealed their bafflement politely.

In the factories proletarian origin and revolutionary fervour were then seen as more important than ability or effort. Piecework was banned and production bonuses were distributed equally among the whole work force. But the differentials were nevertheless quite wide — they were proud that the gap between the lowest- and highest-paid worker was only one to six as against one to thirty in the Soviet Union, but since there is no income tax in China the gap was much the same as in the average British firm. With no income tax, no inflation and deep hostility to borrowing, the China of 1972 was the envy of old-fashioned conservatives.

We visited several People's Communes. Each family was allowed a little private allotment of its own, and the commune could sell surplus output freely after making its planned contribution to the official market. Health was largely the responsibility of the so-called 'barefoot doctors' — a core of young men and women with minimal medical training who travelled from commune to commune rather like parish priests.

The May Seventh Cadre School was a special type of commune where bureaucrats and teachers were given refresher courses in real life, by being made to live like peasants for a period of months. Earlier, during the Cultural Revolution, the period could be as long as two years. All the students professed immense satisfaction in having started by cleaning

Young Pioneers on the march in Peking

out the latrines. With gloomy pride each of them described in great detail and in the same words the most unpleasant features of this ordeal. After the fourth such account it was difficult to keep a straight face. Edna enjoyed seeing the headmistress of a school calling the hens to her with the same whistle as she must have used to call her pupils to order in the playground.

The cult of Mao Tse-tung was clearly on the wane. We saw the Little Red Book only once, when at the end of an opera in Shanghai the whole of the cast advanced on the audience waving it as they sang. Some of the main public buildings still carried a silk banner on which one of Mao's poems was written in his own calligraphy. My guides were somewhat embarrassed when I asked them to translate one for me; none of them could even read it. Many of the old men wore their beards long in the traditional style, their wives hobbling by their side on feet deformed by the barbarous practice of binding which was common before the revolution. The robust self-confidence of the children was a striking contrast. I was heavily defeated at ping-pong in the Children's Palace in Shanghai by an urchin only seven years old.

The climax of our visit was a tour round a hospital in Peking so that we could watch operations using acupuncture anaesthesia. Acupuncture has been used in China for thousands of years to cure nervous as well as physical disease, but its use for anaesthesia was developed only under the Communist regime. A team of French doctors went round with us to learn the technique, reminding me that Berlioz's father had practised acupuncture in a small provincial town in the French Alps a hundred and fifty years earlier. We watched a sterilisation operation on a young woman who remained smiling and fully conscious throughout. She got out of bed on her own when it was over. A thyroid operation, however, required the patient to be totally unconscious, and a young man having a cartilage removed from his knee looked far from comfortable. Finally we saw a dentist

Rapid recovery after acupuncture anaesthesia

remove a tooth with so-called finger acupuncture, anaesthetising the jaw for a few seconds by pressing a spot below the ear with his finger alone. Neither the Chinese nor the French doctors with us were able to give any medical explanation of how acupuncture works — the traditional Chinese theory of 'channels' fits the facts as well as any Western theory of the nervous system. Acupuncture anaesthesia is now widely used on animals as well as human beings.

At every level we found a hatred and contempt for the Soviet regime, which had treated China so barbarously after the split in 1958. In Nanking for example the Russians left the great bridge over the Yellow River only a quarter finished, took the plans away with them and refused to supply the rest of the special steel required. But there was no hatred for the Russian people — in fact Stalin took his place on the hoardings as one of the four great leaders, alongside Marx, Lenin and Mao Tse-tung. The focus of their hostility was Krushchev. Although many of them had been a little shocked by the Nixon visit they seemed to have no hostility for the Americans either. But memories of wartime brutality were too recent to allow them to be objective towards the Japanese. War and revolution were still the theme of nearly all their films and plays.

14 Painting with Light

That is a rough sketch of my life as a photographer so far. Perhaps I should now explain why I believe a 35mm camera is the most suitable for an amateur like me, and why I find a single-lens reflex the best type of 35mm camera. For me, the choice of camera is partly a matter of convenience and price, but depends above all on understanding the limitations and opportunities presented by a camera as a tool for making pictures compared with, say, pencil or paint.

A good camera can produce in black and white or colour exactly what your eye sees in front of it. In fact it works in exactly the same way as your eye. Its lens throws the image on to the film just as the lens of your eye throws the image on to your retina and the camera lens has an iris like the lens of your eye to make its opening bigger or smaller according to the brightness of the light.

But a camera does not reproduce what you see. Before the impression on your retina is printed on your consciousness your brain has modified and adjusted it in a million ways to reflect your personal knowledge, experience and feeling. A mother 'sees' in her baby a beauty no one else can see. The sun 'looks' ten or a hundred times bigger when it is setting behind a tree on the horizon than it does in the noon-day sky. A church spire or a human figure 'appears' as the most important point in a landscape though it may be only a minute element in the total scene. You are much more sensitive to the slightest movement in the human mouth than to the movement of a great cloud. That is why it is so difficult to paint a convincing portrait. In fact a portrait has been described as 'a picture where the mouth is wrong'.

One portrait can look quite different from another which is equally valid. A landscape painting will look different from a photograph taken from precisely the same spot and from another painting of the same scene. It is not just that the painter may put in a tree where no tree existed in order to make the picture more harmonious, or may ignore a building because its shape or colour spoils the scene. Even a so-called topographical painter like Edward Lear, who set out to reproduce what was in front of him with as little personal interpretation as possible, was influenced by his feelings about the scene, by his knowledge of what it contained and by what people of his time thought a painting should look like. So, consciously or unconsciously, he would emphasise the significant feature, eliminate the meaningless detail, and change the relative scale of elements in the scene before him so as to reflect his view of their importance.

In a painting the artist has total control over the final picture, subject only to the limitations imposed by his technical proficiency and the nature of his medium — pastel, water-colour, oil or gouache. In a photograph, unless you change what is on the negative in the process of developing and printing it, there is far less scope, because the lens itself is compelled mechanically to reproduce precisely what is in front of it.

So the photographer must first learn to see as his lens sees, not as his mind interprets what his eye sees. When the beginner photographs a family group, for example, he is liable to make it pose in an open space and to retire far enough back to make sure he includes the whole of every person. He is then disappointed to find that his photograph shows a tiny huddle of figures in a vast expanse of lawn, too far away for any of the faces to be clearly distinguished. That is because when he looks at the group his mind ignores the surroundings and concentrates on the faces. The lens cannot do that unless it is made to. Many photographs have been ruined by the sprouting of a tree out of the top of the subject's head; the mind did not notice the tree when

the photograph was being taken but the lens could not ignore it.

When you have learned to see as the lens sees then you can begin to make the lens see what you see. This means choosing a position from which to take your photograph in which the inessential or distracting is already eliminated — in which, for example, the ugly building is hidden by a tree, in which the subject which interests you fills the full camera frame, and so on. And if the subject or any part of it is moving, it means choosing that precise hundredth of a second when everything is in exactly the right position.

We all come across this problem when we are photographing a group. It is difficult to be sure that no one is blinking at the moment when you click the shutter, that everyone is smiling and relaxed at the same split second. On the other hand, press photographers when dealing with politicians sometimes take pains to choose precisely the wrong moment, so as to catch the face with an ugly or comical expression. That is why at a press conference the photographer will take hundreds of photographs in a few minutes in the hope that one or two will look peculiar. Once they caught me wiping a piece of grit from the corner of an eye. That photograph appears regularly whenever the editor wants his readers to think I am exhausted.

It is the ability to choose precisely the right spot at exactly the split second which matters which distinguishes the great photographer from the rest of us. A great photograph taken from the right spot at the critical moment will not only convey the meaning the photographer sees in his subject, it will do so in a way which produces a beautiful picture, in which the shapes and colours are attractive in themselves.

The greatest of living photographers, perhaps the greatest photographer of all time, is Henri Cartier-Bresson. His art depends wholly on choosing the

Lake Lucerne near Vitznau, using a long lens

164

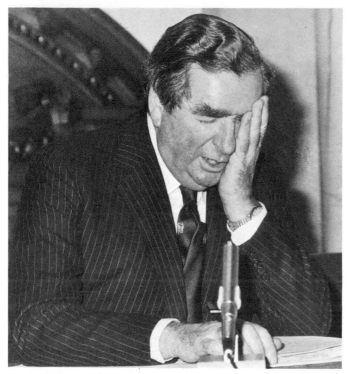

Entitled 'Now the Good News?' (Press Association); in fact I was wiping a piece of grit from my eye

right place and moment. He does not manipulate the negative or the print in processing. All his photographs reproduce the whole of the negative frame — he does not cut out the bits he wants afterwards by cropping the image. He uses only one lens, the standard 50mm lens on his Leica Rangefinder 35mm camera. But he has an uncanny genius for conveying both human meaning and formal beauty in his photographs. Here is how he describes it himself:

There are those who take photographs arranged beforehand and those who go out to discover the image and seize it. For me, the camera is a sketch book, an instrument of intuition and spontaneity, the master of the instant which — in visual terms — questions and decides simultaneously. In order to give a meaning to the world, one has to feel oneself involved in what one frames through the view-finder. This attitude requires concentration,

a discipline of mind, sensitivity, and a sense of geometry. It is by great economy of means that one arrives at simplicity of expression. One must always take photographs with the greatest respect for the subject and for oneself.

To take photographs is to hold one's breath when all faculties converge in the face of fleeing realities. It is at that moment that mastering an image becomes a great physical and intellectual joy.

To take photographs means to recognise — simultaneously and within a fraction of a second — both the fact itself and the rigorous organisation of visually perceived forms that give it meaning. It is putting one's head, one's eye and one's heart on the same axis.

His approach was put in a nutshell by the poet Blake:

He who bends to himself a joy doth the winged
 life destroy
But he who kisses a joy as it flies lives in
 eternity's sunrise.

Cartier-Bresson's is the view of a purist and he lives up to his principles. But like any artist he is the creature of the age in which he lives. Many of his best photographs are influenced by the painting of his time — particularly in the surrealist juxtaposition of incongruous elements in the same picture, and the handling of geometric shapes to make an abstract pattern. What is striking about the great photographers is the extent to which their personal sense of style imposes itself on their vision, so that when they make a mechanical reproduction of a scene it is marked as indelibly with their personality as is the painting of a great artist.

When photography first began in the nineteenth century someone said, 'From today, painting is dead.' But in fact painting and photography have nourished one another ever since. Corot, a close friend of some of the leading photographers of his

time, sometimes drew etchings on a black photographic plate, and in his later years developed a way of painting foliage which was derived from the fuzzy image of moving leaves in a photograph. Degas broke away from the traditional style of composition by adopting unusual viewpoints, like camera angles, which allowed the picture frame to cut off half of a face or a body. Many painters from Delacroix to David Hockney have used photographs as the basis of their work. The Impressionist School of Painting attempted to reproduce the physical impression of a scene on the retina with the minimal interpretation by the brain. That is why modern colour film can produce photographs which resemble the paintings of the Impressionists.

Colour slides, which are normally developed by automatic processes and must be projected as a whole, compel the photographer to follow the principles of Cartier-Bresson more closely than black and white films, which can be manipulated by the photographer himself both in developing and printing. But unless you aspire to the technical puritanism of Cartier-Bresson there is everything to be said for taking advantage of the many ways in which a photograph can be made to express your feelings about the subject by the best choice of lens, aperture, and shutter speed. And there is no reason why you should not improve your picture further in developing and printing if you wish.

Choosing the right place and moment is the key to good photography. Technically the most important thing is to use the right exposure.

The word photography means 'painting with light'. A photograph is made when light reflected from the subject passes through the lens of the camera and falls on a sensitive film which turns black where the light strikes it. The black is denser when the light is greater; that is why the film is called the negative. The same process is repeated to make a paper print: light is shone through the negative and directed by a lens on to sensitive paper so that the areas on the negative which were transparent now turn black and vice-versa. With the film used for colour slides the processes of developing and printing are combined to produce a positive colour image on the film itself.

The most important technical responsibility of the photographer is to make sure that the right amount of light falls on the film. If the film is exposed to too much light, dark objects will appear light. For example, the skin of a black man will appear pink like that of a white man. If the negative is under-exposed a man with a light suntan will appear as dark as an Indian. But sometimes an incorrect exposure can be used deliberately to create a desired effect. For example, the easiest way of taking a scene by 'moonlight' is to photograph it in daytime when the sun is casting strong shadows but to give the film only about a tenth as much exposure as would be normal.

Some films need less light than others, but you pay for their extra speed with a grainier image or less accurate colour. For the great majority of amateur photographs the instructions given with the film are an adequate guide to exposure; but in some cases such rule-of-thumb advice can be misleading. For example, if you are photographing a person with the sun behind him and you want the colour of the face to look normal you will have to increase the exposure anything up to four times. In such cases, or when you are taking a photograph by dim light or indoors, you will find an exposure meter invaluable for measuring the amount of light falling on the subject itself. The exposure meter can be built into the camera body, operated by hand or automatically, or may be separate from the camera altogether.

I myself prefer a separate exposure meter since on the occasions when one is necessary a built-in meter often has disadvantages.

An exposure meter operates by measuring the average light falling over an area which is usually slightly larger than that covered by a 35mm lens — that is to say, it works on the assumption that light

167

areas and dark areas are equally distributed so as to average a medium grey. But often the light and dark areas in your subject are not equally distributed. For example, a snow scene will have an average brightness which is white rather than grey; so if you use the reading shown by the exposure meter your snow scene will come out far too dull. On the other hand if you use the meter to tell you the exposure for a twilight scene it will look as bright as day.

An ideal moment for a picture is when dusk is beginning to fall and the lights have come on, but you can still see to the horizon. I used this moment for my picture of Venice. I had to give an exposure of about a second, which made the figures blur. But you may feel that their ghostly appearance adds to rather than detracts from a scene in which the buildings are centuries older than the people who visit them.

In taking a sunset I find it a good idea to point the meter directly at the sun and then reduce the indicated exposure by two or three stops. A long lens is invaluable for photographing sunsets so that the sun looks larger in relation to the objects below it — as in my picture of a sunset on Lake Lucerne.

A portrait will tend to look more dramatic against a dark or even a black background, like the picture of my father in his armchair (page 31) or the driver in Montenegro.

In that case you need to measure the light falling on the face alone rather than the average for the scene as a whole. The easiest way of doing this is to measure the light falling on your hand, providing your hand is held in the same relation to the source of the light as the face you want to photograph. Sometimes this is easy, but if you yourself are in the shade you will have to go up to the subject and measure the light falling on the face directly with your meter. If this is impossible — for example, when you are in the balcony photographing a figure

St Mark's Square

169

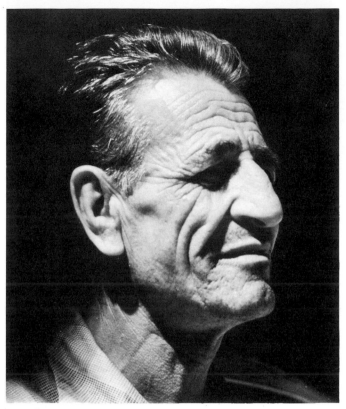

Our driver in Montenegro

on the stage — you will have to rely on guesswork, or use a specialised meter which enables you to measure a small area a long distance away. A meter capable of taking such 'spot' readings tends to be very expensive.

A circus is an excellent place for photographs. The light is usually brighter than in a theatre, and closer to daylight, so that you can use colour film. In the theatre the lighting will often make the colours on normal daylight film look yellow, and it is rarely strong enough to allow you to photograph action, so you have to wait for a moment when the characters are still. Whatever the temptation, you should never use flash in a theatre or you will infuriate the rest of the audience.

Choosing the appropriate exposure for your subject is only half the problem. The light is projected on to your film through an iris in the lens which can

be made larger or smaller by twisting a ring on the outside of the lens mount, and the time over which the light is allowed to fall on the film can be varied from a tiny fraction of a second to several minutes by altering the interval between the opening and closing of the shutter — the shutter speed. There is thus a wide variety of combinations between lens aperture and shutter speed which will produce the right exposure. You can use more light for a shorter time or vice versa.

Several factors will help to influence your choice of aperture and shutter speed. One is the depth of focus you want. No lens will show all the objects in front of it, from a few inches away to the distant horizon, with equal precision. You therefore have to focus the lens on that part of your subject which most needs to be precisely defined. This is done either by using a coupled range-finder which requires you to bring two images together until they form one, or by using a focussing screen, as in a reflex camera, on which you adjust the image until it is no longer blurred. But round the point of maximum precision there is a zone in which objects appear to be almost as sharply defined as the one on which you are concentrating — this zone is called the depth of focus. It is greatest when you focus on the horizon; for example, with a 50mm lens open at f.2.8 everything from twenty feet to infinity is sharply defined. The depth of focus becomes smaller as the point of focus moves closer to the camera or as the lens aperture becomes wider. Wide-angle lenses have a greater depth of focus than telephoto lenses. Moreover, most fast lenses have their maximum precision of focus two or three stops below the maximum aperture.

So if you want substantial depth of focus you will have to choose a small aperture and a slow shutter speed. If, however, you want your subject to stand out sharply against a foreground and background which are out of focus, you will have to use a wider aperture and a faster speed.

In other situations the shutter speed may be more important to your picture than the depth of focus. For example, if you want to photograph a rapidly moving object you may need a shutter speed as fast as 1/500 or 1/1,000 second. The same may be true if you want to take a photograph from a fast-moving vehicle or aeroplane. Most people find it difficult to hold their camera absolutely still when they are taking a photograph. In that case it is wise to use a shutter speed at least as fast as 1/100 second so that there is less chance of blurring the picture. On the other hand you may want to have the moving part of your subject blurred by contrast with the still parts,

in which case you may deliberately choose a slow shutter speed.

In dim light you may have no choice but to use the widest aperture and the slowest speed your camera allows. But I find that in normal sunlight with Kodachrome 64 colour film an aperture of f.11 with a shutter speed of 1/100 second is a convenient average to start from.

A lot depends not only on choosing the right exposure but on choosing the most suitable sort of lighting. In colour, things often photograph best with the minimum shadow, because the shadow tends to come out as deep black. Bright cloud or hazy

Circus at Earls Court

In Notre Dame, a 5-second exposure without flash *… and with flash*

sun is better than bright sunlight. If the sun is bright then you should try to have it behind you so that it shines full on your subject — providing it does not make him squint! Black and white film, on the other hand, makes its best effect through the contrast of light and shadow so it is usually better to have the light shining at an angle on the subject.

But here too every rule has its exceptions. Sometimes you get the best photograph when the subject is lit from behind so that it is fringed with a bright line. Constable regularly used such back-lighting to give his landscapes more vitality. Back-lighting can also work well with portraits — but you must take care to measure the light falling on the face itself or you will under-expose badly, and you must see that the light does not fall directly on your lens or you will find the negative spoilt by a bright flare.

Never assume that bright sunlight makes the best pictures — in fact it should normally be avoided for portraits. Colour film is excellent for capturing the dramatic cloudscapes in bad weather, when perhaps a single shaft of sun picks out a castle or a flowery hillside against an indigo sky — as in my picture of Bonaguil, on page 39. Sometimes colour film is best used when there is hardly any colour in the picture at all — as in my photograph of the dawn landing of

Vevey: above, *at dusk;* right, *in sunlight*

the islanders at Gan, on pages 138–9. Or compare my
picture of the statues in the lake at Vevey against a
grey sky at dusk with the very mediocre picture of
the same scene on a sunny afternoon.

For portraits the diffused light from a window can
produce a picture with the beauty of an oil painting;
Rembrandt himself often painted his subjects illumi-
nated by window-light. I believe it is always better
to use the light already available, whether natural or
artificial, than flash or floodlight. Flash can, how-
ever, be invaluable when the subject is moving in
dim or artificial light, or you want to photograph
something for the record — for example in a museum

Above left, *near Tellaro;* below left, *an Arab village in Israel;* above, *in a Parisian café*

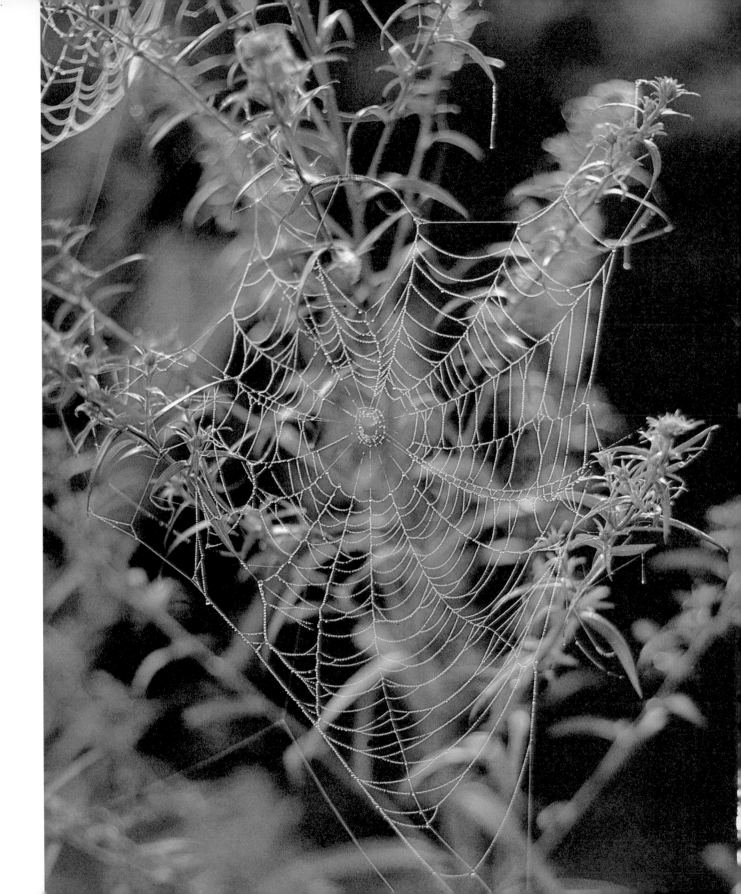

— and you have no time to erect a tripod. You can get a more natural picture with flash if you hold it some distance away from your camera so that it casts a larger shadow, or bounce it off a white wall or ceiling so that its light is diffused — though this substantially reduces the strength of the light.

It is difficult to get a natural-looking close-up portrait unless your subject is fairly unused to being photographed and therefore does not assume an artificial expression. The Dahomean boy with filed teeth, the Cypriot peasant woman and the old man near Nanking all knew they were being photographed, but they reacted in a natural way — with delight, amusement or composure, according to their personalities. But that is less often the case in the sophisticated West. A professional portrait photographer may have to spend hours chatting to his subject in the studio in the hope of getting two or three natural-looking photographs. On the other hand if you can use a telephoto lens to catch your subject engaged in some activity, even if it is only reading, you may get just what you want — as in my picture of the old man in a French café. I find some of the most attractive pictures of people occur when several are together and more interested in one another than in your camera, like the Arab women in Israel or the children playing in a mountain village above Tellaro, Italy. A picture like the latter usually

Left, *a spider's web with back-lighting;* below, *a housefly, using a 50mm lens and extension tube*

177

Seen from my hotel window in Malcesine

owes more to luck than good management, since a fraction of a second earlier or later the composition would have collapsed. Cartier-Bresson has taken many brilliant photographs of this nature but he will sometimes take three or four rolls of film in the hope of finding one negative worth printing.

By taking a series of photographs of the same subject in quick succession — you do not need a motorised rewind for this — you can tell a story or a joke. I tried to do this one dull Sunday afternoon from my hotel bedroom in Malcesine, when I took pictures of a group of the local men coming to life as they watched a girl walk past.

The angle at which the light falls on the subject

can also make a big difference. A face lit from below looks mysterious or sinister. A landscape lit by a sun low in the sky can look more dramatic because its colour will be more golden.

Dappled sun falling through a screen on a face or body can produce a beautiful effect — as in my photograph of a statue in Delos. If you are photographing sculpture you will find that marble, such as the Greek head from Olympia, always looks better in natural light, whereas my picture of Poseidon shows how flash brings out the irregularities of tone and texture in bronze or terracotta to better effect. It is always worthwhile taking your camera to a museum since your photographs will probably be better than

those you can buy at the bookstall, or else something you desperately want a record of may not be available at all — as in the case of the little boy's head at the National Museum in Washington. Some museums charge a small extra fee to photographers and you are rarely allowed to use a tripod — I suppose in case you are planning to compete with the museum itself.

Some books recommend photographers to use filters in front of the lens so that whatever the colour of the light the colour of the photograph will look the same. This seems to me perverse in the extreme. Photographers should take advantage of the precision with which colour film reproduces exactly

what the scene looks like, to obtain without effort effects which the Impressionist painters took years to master. See how the colour of the façade shifts from hour to hour in Monet's great series of paintings of Rouen Cathedral. There is every reason why photographers should learn from Monet.

The only filter which you may need as an amateur colour photographer is a blue filter which enables you to use daylight colour film in artificial tungsten light. Without it your pictures will look much too yellow. A polarising filter is sometimes useful to eliminate reflections in glass or to deepen the blue of the sky. In black and white photography, on the other hand, filters can produce impressive effects,

though even here they are not strictly necessary.

If your standard lens will focus down to eighteen inches or a foot you will be able to take excellent pictures of flowers. They are best photographed against a simple surface of a neutral colour or black, which is out of focus, so that they stand out properly. Deep shadow also makes a good background. Otherwise photograph them from below against the sky — this is where a waist-level view-finder is useful — or put a piece of card behind them.

For smaller objects which are closer still to the lens you will need an extension bellows or extension tubes. These fit between the camera and the lens and will require you to increase the exposure. Even an extra inch between the lens and the film will allow you to photograph an object as small as a daisy so that it fills the whole of the frame. For a fly or small insect you will require something like an extra four inches. It is worth carrying one or two extension tubes in your pocket when you are walking in the country. A bellows is more suitable for indoor work particularly if you want to photograph your colour slides so that you can make black and white prints out of them. Close-ups offer an immense variety of excellent subjects. A spider's web with the dew on it will sparkle in the sun like a tracery of diamonds.

You can take photographs off your television set providing you use a speed lower than 1/25 second — 1/10 or 1/5 second is best — and put your camera on a tripod about three feet away from the screen, using a cable release to press the shutter. With the same speed you can take pictures at the cinema. In both cases use your exposure meter to discover what aperture fits the speed.

Nowadays, when a fast colour film will give you good quality, most amateurs use nothing but colour. But black and white photography is an art in itself. It can produce results quite as valid and attractive as colour — it is like pencil drawing compared with oil

Above right, *at Olympia*; right, *in Delos*

180

In the National Museum, Washington

The bronze statue of Poseidon, Athens, using flash

painting, or the piano compared with the orchestra. In some respects black and white has advantages. Using the right film and developer you can photograph anything which the eye can see in any light. You can manipulate the picture in printing so as to increase or decrease the contrast, or make the dark parts lighter and vice versa. You can pick a tiny part of the negative to enlarge — indeed a single negative may give you a dozen or more separate pictures. And if you are interested in producing a picture of formal beauty, it is easier to control an image in black and white than one with the added dimension of colour. One patch of inappropriate colour can ruin a picture and there is usually nothing the photographer can do about it.

Some of the greatest photographers refuse to use colour at all. We are now so used to seeing the real world photographed in black and white that we often find a black and white picture more 'realistic' than a colour photograph. Every colour or combination of colours has a subconscious impact on your emotions which may be at variance with what the picture is trying to say.

The tools of the trade

The average 35mm camera has a standard lens with a 50mm focal length. This covers an angle of vision a good deal smaller than the range of the human eye, but it does cover most of what we look at, as distinct

181

from what we see out of the corner of our eye. So it is adequate for the great majority of photographs. There are advantages, however, in having a camera which can take more than one lens and for buying in addition to the standard 50mm lens one wide-angle lens of, say, 35mm and one telephoto lens of, say, 100mm or 135mm. The wide-angle lens will not only enable you to get more into your photographs — this can be particularly useful when you are photographing buildings or landscapes — but also offers a greater depth of focus. Moreover since it makes objects close to the camera look disproportionately large it enables you to use mild distortion for emphasis. If a press photographer wants to make your cottage look like a palatial mansion he will use a wide-angle lens from low down. Similarly very short people can look very tall when photographed from below — Humphrey Bogart and Alan Ladd would not have been successful film stars without this trick, and Mussolini managed to get both his stature and his chin increased by it.

It is possible to buy lenses with a much wider angle than 35mm. There was recently a fashion for so-called 'fisheye' lenses with almost a 180-degree angle of vision. But I find that as a rule the distortion involved in the use of very wide angle lenses is senseless and displeasing.

A long or telephoto lens enables you not only to fill the camera frame with objects some distance away but also to emphasise scale by, for example, making the mountain look bigger in relation to the foreground or the moon huge in relation to the earth. Because it has less depth of focus you can highlight your subject by blurring its surroundings. Lenses longer than 135mm can be very useful in photographing big game. I used my secondhand 225mm Dallmeyer lens in the game parks of Africa and at a bullfight. Anything larger than this is difficult to handle without a tripod since the maximum aperture tends to get smaller as the angle of vision narrows so that a slow shutter speed is required, and the longer the lens the more every tremor of your hand or body is magnified when you are taking the photograph.

It is this combination of considerations — the need for a variety of speeds and apertures and for at least three lenses — which has led me to conclude that a 35mm camera is most suitable for the enthusiastic amateur. The 110mm camera has recently acquired great popularity, primarily because it is a little easier to load a 110mm cassette than a 35mm roll film. But the size of its negative is too small to allow substantial enlargement — and few 110mm cameras so far have interchangeable lenses and a wide variety of speeds and apertures. If I were a professional I would like to have a larger format camera like a Hasselblad. But the cost of film, lenses and accessories for larger cameras is prohibitive for the average amateur, and the extra weight makes them inconvenient for travel.

Many amateurs prefer a 35mm camera with a coupled range-finder, like the Leica, because it tends to be lighter and quieter in operation than a single-lens reflex. But the view-finder of such a camera must cover a larger area than what finally appears on the film, and as the subject gets closer to the lens the view-finder is less and less accurate in showing what the lens itself will see, because of the distance between them. Moreover, the view-finder is often suitable only for a 50mm lens.

A good single-lens reflex camera, on the other hand, will show the photographer through the view-finder almost exactly what will appear on the film, irrespective of its distance from the camera or the type of lens in use. Focussing on the screen of a reflex camera's pentaprism is not quite so easy or accurate as with a coupled range-finder, but a good compromise can be achieved if a split-image range-finder is inserted in the middle of the screen. My own Exakta Varex 2A has this facility, together with the ability to replace the pentaprism with a waist-level view-finder which is particularly useful for taking extreme close-ups at ground level of objects less than

Close-up of a newt, with a 50mm lens and extension tube

six inches from the front of the lens, such as flowers or insects.

I bought my Exakta Varex in Warsaw in 1959 after experimenting with several cheaper 35mm cameras. It cost me £30 at a special Government shop where only foreign currency could be used. Though it was made in East Germany ordinary people in the Communist countries were then unable to buy it — which I suppose is why Krushchev's son-in-law wanted to swap his Japanese camera for my Exakta.

When I returned from Poland and declared my camera I was charged £60 duty and purchase tax, because in those days the Customs officers charged whatever was necessary to bring a foreign camera up to the retail price of the same camera in England. In fact the courts later found that they were acting improperly in not charging the appropriate percentage on the sale price of the camera abroad. But by that time the statute of limitations prevented me from getting my money back.

With a reasonably fast film and normal light you will rarely need a tripod but you may find it essential for photographing in very dim light or at night. The important thing for an amateur is that it should be light and readily portable. I can never understand a photographer in Parliament Square photographing Big Ben at midday with a miniature camera on a massive tripod which is vibrating visibly with the thunder of the traffic, when a hand-held camera would do so much better.

In my experience a camera clamp is often more useful than a tripod. This is a small metal clamp four or five inches long with a ball and socket head for holding the camera, which can be fixed on to any object less than two inches wide — such as a seat or a fence — or which can be screwed into a tree. It can

also be turned into a tiny tripod which is perfectly adequate on a solid surface like a wall.

If you have a camera with a couple of extra lenses, an exposure meter and a tripod the question arises of how to carry your equipment around. Some sort of gadget bag is probably necessary to keep everything safe on journeys. But it can become very heavy on a walk. When I was Defence Secretary I used to take a gadget bag with me containing two cameras — one for colour, one for black and white — three lenses, a tripod, an electric flash and an exposure meter with of course the invaluable camera clamp. If I was visiting Borneo or South Arabia it was the responsibility of my Private Secretary to carry the bag while I was reviewing the troops or talking to the officers in charge. One day in Singapore the Navy laid on a heavy programme in which I had to travel in every sort of vessel available from a rubber dinghy to an aircraft carrier, and ended up being winched from the deck of a submarine in the Indian Ocean into a helicopter. My Private Secretary, now Sir Patrick Nairne, Permanent Under-Secretary of the Department of Health and Social Security, was a man of immense ability, unquestioning loyalty and great physical courage. He had been awarded the MC as a Seaforth Highlander in the Eighth Army. But he had no head for heights. He asked nervously, 'Are we taking the big bag today, Secretary of State?' I was able to assure him we were not and we were winched into the helicopter without a hitch.

In fact, if you are out on a walk or on a journey when you expect to be taking photographs at very short notice, it is better to dispense with the gadget bag and to carry the minimum of equipment on your person. After many years in which my wife's tolerance approached breaking point as she saw my pockets torn and my trousers and jackets bulging with bulky items of camera equipment I finally found the ideal clothing for my purpose — an immensely tough and wholly weatherproof jacket originally developed for Arctic explorers and lifeboatmen by a small firm called Functional Clothing. It has a series of large pockets both inside and outside, and fastens in front not only with a large plastic zip but also with velcro tapes. Thus I can carry everything I need immediately available and am warm and dry in all weathers.

I carry my camera over the left shoulder and under the right shoulder so that the strap tightens when I lift it to my eye, giving it additional support. Professional photographers tend to oppose the use of the so-called 'ever ready' camera case on the grounds that it is an unnecessary obstacle to the rapid use of the camera. I have not found it so. In any event, the risk of damaging an unprotected camera is greater than the disadvantage of taking an extra second or two to unclip the top part of the case. And if you cannot afford those seconds you can temporarily remove the top part of the case and the lower half will still give you substantial protection against casual knocks.

Epilogue

Since its earliest days people have worried about the status of photography. Is it art or reality? To begin with, a photograph has a direct physical relationship with its subject which none of the arts can claim. The negative is made by light reflected from the subject itself; when Europeans first took their cameras to China a century ago, the Mandarins they photographed saw their portraits as a physical emanation of themselves. The photographer can doctor his negative in various ways when he is developing or printing it; but essentially his job is to choose his position, his lighting and the decisive moment for pressing the button. Then he lets the light *make* the picture — he only *takes* the photograph.

A painter on the other hand actually *makes* the picture himself. However faithfully he aims to represent his subject, he has to choose his medium, mix and lay on the colours; in deciding how to do so he will be influenced by what he knows and feels about the subject as well as what he sees. He must confront his subject for hours, days and even years, learning as he looks and paints, and thinking all the time about what it means to him. Compared with a painting, every photograph is a snapshot even if the shutter is open for a few minutes rather than 1/100 second.

For Cartier-Bresson, taking a photograph should be like firing an arrow in Zen Buddhism — you only hit the target when you do not aim at it. You should never think while you are actually taking the photograph, but 'kiss the joy as it flies'. Other great photographers such as Yousuf Karsh or Edward Weston spent hours arranging their model or waiting for the one moment in the day when the shadows fell exactly as they wanted. But however you approach photography, in the end the picture is made by the light reflected from the subject when the machine opens the shutter.

Then is a photograph more realistic than a painting? Contrary to the old saying, the camera can lie as easily as the paint brush — and more effectively, because so many people believe it reproduces reality. It does not. It reproduces appearance, which, as we all know, is quite a different thing. Philosophers have argued for centuries about the relationship between appearance and reality. Ordinary people know that the appearance of a person depends on all sorts of factors which have nothing to do with reality at all — the mood of the person at the time, the mood of the observer, clothes, make-up, lighting, position and so on. As I have already pointed out, a photograph does not even represent the appearance of an object to the human being who sees it; it reproduces a mechanical image of the object at one fraction of a second out of millions which might have been chosen, from one particular viewpoint out of hundreds, and in one particular light. It takes a three-dimensional object which exists in time, freezes it and flattens it out on a piece of paper.

But even when we know that the photographer has done his work of selection so as to produce the particular effect he wants, we also know that the image itself is a mechanical reproduction of what the image really was in that split-second. That is why old photographs have such a fascination for us. As Susan Sontag says, if we could choose between an authentic painting of Shakespeare and a contemporary photograph, most of us would choose the photograph because in this sense at least it is more 'real'. So perhaps the African tribesmen who turned their faces away from my camera and the Arabs who chased me through the Soukh in Damascus were not entirely wrong in seeing a photograph as capturing something of themselves which no one else should have. There is an element of theft in taking a picture — and of aggression too. It is no accident that people

talk of shooting pictures. A photographic safari is, after all, a substitute for shooting a lion with a rifle.

But problems begin when you see photographs as a substitute for reality. The pianist Artur Schnabel used to say that when good Americans die they form a queue to go to paradise. At a certain point the road forks: the left-hand signpost says, 'This way to Heaven', while the one on the right says, 'This way to a lecture on Heaven'. Most of the Americans turn faithfully to the right.

Once you are bitten by the camera bug there is a real danger of preferring the photograph to reality and of seeing everything as an object to be shot. A tourist was describing a beggar he had seen in Cairo, blind, without arms or legs, and covered with flies. 'What did you give him?' asked his friend. 'A hundredth of a second at f.11,' was the reply. I do not think my wife has ever quite forgiven me for taking a photograph of the doctor's jeep arriving when she had broken her ankle while we were camping in the Alps.

There is no doubt that the constant stream of sensational photographs of violence and war you see in the newspaper or on television does tend to dull your sensibility and make you accept what should be unacceptable. It is like the wartime battle schools which tried to inure you to bloodshed by emptying bucketfuls of animals' blood and intestines on your head. Too many tourists are so wedded to their camera that they cease to respond directly to the beauty of the places they visit. They are content to take home a dozen rolls of exposed film instead, like a bank full of Monopoly money.

Some photographers have attempted to escape from the ambiguous relationship between photography, art and reality, by breaking the link with reality altogether. For example Man Ray and Moholy-Nagy, whom I once invited to talk to the New Oxford Art Society, made pictures by putting objects on sensitive paper and shining light on or through them. Others used photographs as the raw material for fabricated pictures made by sticking bits of different photographs together; this type of 'collage' was used by John Heartfield to great effect for political caricature. Photography has often been used for the surrealistic effects to which it is so well suited, by putting people or objects in unfamiliar or impossible relationships to one another. In fact it lends itself to this type of fantasy better than painting, precisely because its images are 'real'.

Making a hobby of photography does involve risks and temptations — what does not? But you can avoid them providing you keep your humanity. Ansel Adams described his camera as 'an instrument of love and revelation'; his work justifies the phrase. In the photographs he took of his friend Georgia O'Keeffe over thirty years, Alfred Stieglitz produced a work of art as lovely as a sequence of sonnets. The comparison springs naturally to mind; if photography is to be put among the arts, it is as close to poetry as to painting. Its images, like the words in a poem, derive their power from the innumerable associations they bring consciously or subconsciously to mind. It is almost bound to be 'literary' in a way painting is not.

In any case, photography is enormous fun.

Some Books on Photography

Books and magazines on photography are breeding like rabbits. Any enthusiastic amateur will find it worth while to look at one of the photographic magazines such as *Amateur Photographer* or *Photography*, and leaf through the yearly anthologies of photographs, *Photography Annual, Photography Year Book* or *U.S. Camera.*

The best overall account of photography is *The Picture History of Photography* by Peter Pollack, revised and enlarged in 1969 and published by Abrams, New York; it includes separate chapters on the work of the greatest photographers. Another good general survey is *A Concise History of Photography* by Helmut and Alison Gernscheim, published in 1965 by Thames and Hudson.

The best book I have read on the techniques of photography is *The Joy of Photography*, published in 1980 by Kodak Ltd. It covers all aspects of taking and processing photographs and is exceptionally well illustrated in colour and black and white.

For the advanced amateur, I recommend *Total Picture Control* by Andreas Feininger, published in 1961 by Crown Brothers, New York. Susan Sontag's *On Photography*, published by Penguin Books in 1978, is a brilliant if erratic series of essays on the relationship of photography to life and art.

One of the most stimulating descriptions of how a photographer looks at things is Paul Theroux's novel *Picture Palace*, published by Hamish Hamilton (1978) and Penguin, although some readers may find the plot unsavoury.

Too many anthologies have been published of the works of the great photographers for me to list them here, though I make an exception of *Henri Cartier-Bresson, Photographer*, published in 1980 by Thames and Hudson.

In a class of its own is *Georgia O'Keeffe — A Portrait by Alfred Stieglitz*, published in 1978 by the Viking Press for the Metropolitan Museum of Art, New York.

The Photographers Gallery in Great Newport Street, London WC2, has a comprehensive bookshop and holds exhibitions of photographs.

Index

Page numbers of illustrations are in italics

189